Severini futurista: 1912–1917

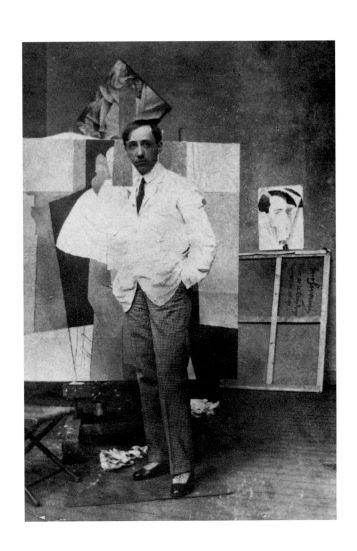

ANNE COFFIN HANSON

Severini futurista: 1912–1917

YALE UNIVERSITY ART GALLERY · NEW HAVEN, CONNECTICUT

Published on the occasion of the exhibition
Severini futurista: 1912–1917

Yale University Art Gallery, New Haven, Connecticut
18 October 1995–7 January 1996

Kimbell Art Museum, Fort Worth, Texas
11 February–7 April 1996

The exhibition and catalogue have been supported in part by a grant
from the National Endowment for the Arts, a Federal agency, and
the Robert Lehman Endowment Fund.

Cover: *Dancer = Helix = Sea* (cat. 26), 1915.
The Metropolitan Museum of Art, New York.
Back cover/frontispiece: Gino Severini in his Paris studio, 1916, with
three works included in *Severini futurista: 1912–1917. Dancer = Helix =
Sea* (cat. 26) is hung in its correct lozenge position on the wall behind
Severini's head. *Woman and Child* (cat. 34) rests on the easel directly
behind Severini. *Self-Portrait* (cat. 35) rests on the top of a canvas facing
the wall to the right. Severini's signature and the title of the work are
visible on the back of the canvas, allowing it to be identified as *Red Cross
Train Crossing a Street*, now in the Solomon R. Guggenheim Museum,
New York.

Library of Congress Cataloging-in-Publication Data
Hanson, Anne Coffin.
 Severini futurista, 1912–1917 / by Anne Coffin Hanson.
 p. cm.
 Exhibition catalog.
 Includes bibliographical references.
 ISBN 0-89467-071-9 (alk. paper)
 1. Severini, Gino, 1883–1966 — Exhibitions. 2. Futurism (Art) —
Italy — Exhibitions. I. Severini, Gino, 1883–1966. II. Yale University.
Art Gallery. III. Title.
 N6923.S495A4 1995
 759.5 — dc20 95–24939

To Marianne with gratitude

Table of Contents

Lenders to the Exhibition

Art Gallery of Ontario, Toronto

The Art Institute of Chicago

Mr. and Mrs. George S. Coumantaros

Fisk University, Nashville

Fogg Art Museum, Harvard University Art Museums, Cambridge

Dr. and Mrs. Martin L. Gecht, Chicago

The Jorge and Marion Helft Collection, Buenos Aires

The Hope and Abraham Melamed Collection, Milwaukee

The Metropolitan Museum of Art, New York

Munson-Williams-Proctor Institute Museum of Art, Utica

The Museum of Modern Art, New York

National Gallery of Canada, Ottawa

Philadelphia Museum of Art

Richard S. Zeisler Collection, New York

Anonymous Lenders

Directors' Foreword

It seems fitting that the exhibition *Severini futurista: 1912–1917* is being presented by the Yale University Art Gallery and the Kimbell Art Museum in two buildings designed by Louis I. Kahn, an architect whose work offers a particularly appropriate setting for Gino Severini's light-filled canvases. The spaces in Kahn's buildings vibrate with light from sources seen and unseen. This is especially true of the Kimbell Art Museum, where the visitor, moving through Kahn's galleries, seems to enter into the luminous and ever-changing world depicted by Severini. At Yale the exhibition winds about the core of Kahn's circular stairwell, leading viewers on a spiral path that mimics the geometry embedded in so much of the artist's work.

Severini futurista concentrates on the artist's exploration of a new vision of the future, one filled with noise, light, energy, and speed. Severini was uniquely able to conjure up these forces through his empathic response to new technologies and their observable impact on many aspects of everyday life. Together with his young Futurist colleagues, Severini signed *The Manifesto of the Futurist Painters* in 1910, which urged modern man to "glory in our day-to-day world, a world which is going to be continually and splendidly transformed by victorious science."

No element of the important transformations of the period escaped his attention: cities, trains, war machines. Severini was a participant in the tango-crazed world of Parisian night-life, and he briefly joined in the conquest of the air by learning to fly. As a young man he read widely, and in Paris quickly became part of literary and artistic circles, developing a strong theoretical stance of his own. The new paintings that resulted "put the spectator in the center of the picture" — to use the Futurists' own words. *Severini futurista: 1912–1917* brings together a number of his most vibrant works.

Anne Coffin Hanson, the John Hay Whitney Professor Emeritus of the History of Art at Yale University, is the Guest Curator of the exhibition and the author of the catalogue. Her determination to see this project through to completion galvanized the entire Yale University Art Gallery staff and won over reluctant lenders. To all who lent we extend our warmest thanks, recognizing in many, many instances

the considerable sacrifice they have made. Especially generous were the Art Institute of Chicago, the Museum of Modern Art, and the Metropolitan Museum of Art, without whose many loans the exhibition would have foundered. *Severini futurista: 1912–1917* has been funded in part by the Robert Lehman Endowment Fund. Lastly, crucial financial support was awarded by the National Endowment for the Arts, a Federal agency which continues to support and encourage the very best efforts of museums nationwide.

Susan M. Vogel
Yale University Art Gallery

Edmund P. Pillsbury
Kimbell Art Museum

Introduction and Acknowledgments

In November 1912 Severini wrote to F. T. Marinetti, the Italian poet and founder of Futurism, "I am enclosing a registered letter: offer exhibition New York" (Marinetti Archive, Letter 9). This invitation to take part in the Armory Show in New York had come from the American painter Walter Pach to Severini, then living in Paris. Marinetti and the artists who signed the Futurist painting manifestos of 1910 (Balla, Boccioni, Carrà, Russolo, and Severini) had agreed that all such plans would be made by the group as a whole. Hence the tempting invitation was promptly sent on to the *"governo centrale,"* in Milan.

Severini explains it more simply in his autobiography (*La Vita* 1983, 124–25): "The American painter Walter Pach, my friend and a student of Matisse had had the idea of organizing in New York a huge exhibition of modern art, beginning with the Impressionists…ending with the Cubists. Naturally he invited me, and I accepted on condition that the other Futurists would all be invited.…But Marinetti, because of his own exhibition projects, did not want to discuss the matter. Thus my friends had to renounce it reluctantly and, for solidarity, I went along with them.…Today it is plain to see what a mistake it was not to be present at that magnificent international display."

The reasons for the mistake were complicated. The first major exhibition of Futurist works outside of Italy had taken place at the Bernheim-Jeune gallery in Paris in February 1912. With the help of Herwarth Walden, director of Der Sturm gallery in Berlin, Marinetti was organizing a tour of the pictures to various European cities. His plans were complicated by the fact that a German collector, Wolfgang Borchardt, had bought many of these pictures on speculation and was apparently trying to take over the exhibition schedule. On hearing of the offer from New York, Marinetti and the Milanese Futurists assumed that it was another plot of Borchardt's. Their constant demands for a Futurist room and even a Futurist entrance sprang from their fears that Walden and Borchardt were showing Futurist works with Expressionists and "others who have nothing to do with our movement" (15 November 1912, *Archivi* 1, 253). They urgently felt that Futurist art must be presented separately and judged on its own terms.

Their fears were groundless. Toward the end of 1912 the organizers of the Armory Show were indeed planning a Futurist room. Such a room was even indicated in an early tentative layout of the exhibition, and news reports in late December confirmed this plan. In the end, however, no agreement was reached; and the international complement of the Armory Show remained primarily French, as did the American conception of modernism. Nevertheless the term Futurism had become so common that visitors to the Armory show talked about seeing crazy Cubist *and Futurist* pictures when no Futurist pictures were there to be seen (Burke 1986, 51–53).

In the eighty years that have intervened since the Armory Show, Italian Futurism has not been well represented in the United States. It is tempting to imagine how history might have shaped itself had the Futurists exhibited their light-filled canvases to a fascinated (or horrified) public at this highly publicized event. Since then a few museums have acquired individual works of art, but they often remain in storage, not seen as compatible with French painting and not understood as important to the development of modernism.

Fortunately there have been notable exceptions to this neglect. A few Futurist works were included in *Cubism and Abstract Art*, at the Museum of Modern Art in 1936. Again in 1949, Alfred H. Barr, Jr. and James Thrall Soby held a memorable exhibition, *Twentieth Century Italian Painting*, which included five Severinis, four of which are in the present exhibition. Meanwhile, in the 1950s, enlightened dealers such as Rose Fried and Sidney Janis frequently presented important Futurist works to the American public.

Finally, in 1961, the Museum of Modern Art organized a large and carefully selected exhibition of the works of the original Futurists, including twenty-two paintings and drawings by Gino Severini. Joshua C. Taylor produced an informative catalogue — the first extensive and reliable resource on Futurist art in the English language.

Only slightly earlier Lydia and Harry Lewis Winston had consolidated their formidable collection of Futurist painting and sculpture and other related works. They allowed them to be exhibited throughout the United States on many occasions, and Lydia Winston Malbin was unfailingly hospitable to students and scholars who visited her home to see the collection and consult her files. Sadly this magnificent collection was dispersed in 1989 when Mrs. Malbin died, but the Lydia Winston Malbin Papers are still available for consultation at the Yale University Art Gallery. One of her last acts of generosity was to loan many of her prize works to *Boccioni: A Retrospective*, which opened in the fall of 1988 at the Metropolitan Museum of Art .

Rather than following the usual approach of exhibiting the Futurists as a group, the Boccioni exhibition presented a clear and forceful review of the work of an individual artist. A handsome and informative catalogue by Ester Coen accompanied this impressive exhibition.

The idea of a similar exhibition of Severini's work presented an entirely different challenge. Boccioni's production ended with his tragic death in 1916 at age 34, while Severini lived another half century. The exhibition in New York offered a focused view of Boccioni's development from his Divisionist roots to his powerful mature style. By contrast, recent Severini exhibitions have tended to be surveys, covering the many changes that took place in his thinking and his pictorial style over a period of years. Furthermore, Severini had already been introduced to the American public in a solo exhibition at Alfred Stieglitz's "291" Gallery in New York in 1917. That time he had not made the mistake of refusing a tempting offer, but had sent to New York twenty-five drawings and paintings from the previous three years. Many of these works remained in the United States and could be shown together again.

Thus it was decided that *Severini futurista: 1912–1917* should be a similarly focused exhibition, made up of paintings and drawings that Severini himself had chosen to show in the Bernheim-Jeune gallery in 1912, in Alfred Stieglitz's exhibition at the "291" Gallery in New York in 1917, and in several other important exhibitions that intervened (see List of Exhibitions below). To the extent possible these works have been borrowed from American collections.

In practical terms this project was made feasible by the availability of information in Daniela Fonti's recent publication, *Gino Severini: Catalogo ragionato* (1988). It was Daniela Fonti who first suggested the possibility of a Rome/New Haven collaboration on an exhibition of the Futurist Severini. Unfortunately many logistical problems and an ocean dividing us made an active collaboration impossible. However, through our many discussions about Severini and my constant use of her masterful catalogue, she has always been present in this endeavor.

The selection of the works for exhibition and the preparation of the catalogue could not have been accomplished without Piero Pacini's many publications. I am most grateful to have had at hand his facsimiles of early Futurist catalogues. I have learned much from his many inspiring articles and from our informative conversations. He has been a true friend to this project.

I have depended heavily on the research of Joan Lukach. Many years ago she discovered important information about Severini's exhibition in New York in 1917, including lists of the works displayed (figs. 31, 32), in the Stieglitz Archive of the Beinecke Rare Book and Manuscript Library at Yale University. She has been generous with advice and encouragement. Patricia Willis, Curator of the Collection of American Literature, Beinecke Library, and Donald C. Gallup, Curator Emeritus and Georgia O'Keeffe's agent for the Stieglitz Archive, have generously given permission for the display and reproduction of several of these precious documents.

The Marinetti Papers, also housed in the Beinecke Library, include a number of letters from Severini to Marinetti written during the period covered by this exhibition. They tell its story in Severini's voice. Selections from these letters had been translated in 1981 by Anne D'Harnoncourt and Marianne Winter Martin in conjunction with the exhibition, *Futurism and the International Avant-garde*, at the

Philadelphia Museum of Art. Since it was not possible to publish them at that time, permission was obtained to do so on this occasion and to translate them in their entirety. Laura Harwood Wittman skillfully translated the letters from the originals and offered her advice for many of the notes that accompany them. Although fragmentary, the earlier translations proved helpful in deciphering difficult passages. We thank Diane Kelder and Joseph La Palombara for their specialized language skills. Vincent Giroud, Curator of Modern Books and Manuscripts, Beinecke Library, has facilitated this large project in every possible way, and has mounted a parallel exhibition of Futurist documents at the Beinecke Library.

It has been a great pleasure to meet the members of the Severini family. I feel particularly fortunate to have enjoyed several long conversations with Severini's wife Jeanne, who, in her nineties, was still hospitable, witty, and informative. She succeeded in recreating the past for me in many ways. My warmest thanks to other members of the Severini family, Gina and Romana Severini, Sandro and Jennifer Franchina, for their helpful advice and for generously permitting me to publish Severini's writings and illustrations of his works.

A year as Kress Professor at the Center for Advanced Study in the Visual Arts at the National Gallery of Art in Washington offered the productive environment that enabled me to explore many leads in the preparation of the catalogue text. I am particularly indebted to Henry A. Millon, Dean of the Center, for making my stay both comfortable and stimulating, to Steven A. Mansbach, Associate Dean, for his encouragement and astute advice, and to my research assistant Karin Alexis for her good company and special skills in finding lost paintings.

Locating works of art, obtaining photographs, and collecting elusive information have all been major tasks, and there would be no exhibition if it had not been for the generous assistance of many collectors, dealers, curators, and friends. Among them: Rachel Adler, Doris Ammann, Troels Andersen, Lesley Baier, Ida Balboul, Paolo Baldacci, Maria Brassel, Paolo Catani, Judith Colton, Phillippe Daverio, Jeffrey Deitch, Massimo di Carlo, Douglas Druick, Maria Teresa Fiorio, Simonetta Fraquelli, Ivan Gaskell, Neal Guma, Kate Heston, Martin Klein, Laura Mattioli, Stephan Mazoh, Susanne McCullagh, Philip Ottenbrite, Judy Ringer, Eleanore Saidenberg, Elizabetta Seeber, Esperanza Sobrino, Charles F. Stuckey.

This project was begun in the Department of European Painting of the Yale University Art Gallery with valuable assistance from Chad Coerver, Renata Hejduc, Anna-Beth Martin, and Samantha Hentschel. I am especially indebted to Deborah Goodman for her help in the early stages of organization and for her insightful research. She has generously allowed me to publish here some of her fruitful observations about the visual sources for Severini's war paintings (cats. 19, 28; figs. 27, 29).

The exhibition has continued under the supervision of John McDonald, Associate Director of the Yale University Art Gallery. I am particularly grateful for his

intelligence, patience, and good common sense. As interim director of the Gallery Jules D. Prown helped keep this project on course. Elise K. Kenney wrote the chronology, assisted mightily with difficult translations, and accomplished a heroic job of editing. I appreciate her devotion and her tenacity. Patricia Barratt, Coordinator of Exhibitions and Loans, stepped into this project with aplomb and efficiency. Louisa Cunningham, Business Manager, Carolyn Fitzgerald, Security Supervisor, Susan Frankenbach, Registrar, Richard P. Moore, Operations Manager, and Marie Weltzien, Public Relations Coordinator, have all gone beyond their normal responsibilities to support this project.

While the exhibition was organized at Yale, we have enjoyed the enthusiastic cooperation of the staff of the Kimbell Museum. Our special thanks go to the Director, Edmund P. Pillsbury, and Senior Curator, Joachim Pissarro.

I have John Gambell and Julie Fry to thank for the beautiful design of this complex catalogue. They have shown extraordinary sensitivity and understanding in turning what might have been a nightmare into a productive challenge.

Luce Marinetti, known fondly by many of us at Yale as *"Luce elettrica,"* has enlightened this project as she has many others. My friend and colleague, Richard R. Brettell, has played a very special part in the realization of this exhibition. I am deeply indebted to him. Bernard Hanson has enabled me to endure the last two years of serious surgery and serious crises with something verging on equanimity. I owe him warm thanks for inventive research, first class editing, loving encouragement, and excellent meals.

While books on Futurism have recently become more numerous, it is still difficult to find primary information in English. Marianne W. Martin's *Futurist Art and Theory* of 1968 still stands as a singular exception. Built on direct observation of the works, study of the original documents, and personal contacts with the artists and their families, it remains a complete and reliable source. Her enthusiasm for her work and her unstinting generosity toward her students and colleagues won her the appreciation and gratitude of a generation of scholars. *Severini futurista: 1912–1917* is dedicated to her memory.

A. C. H.

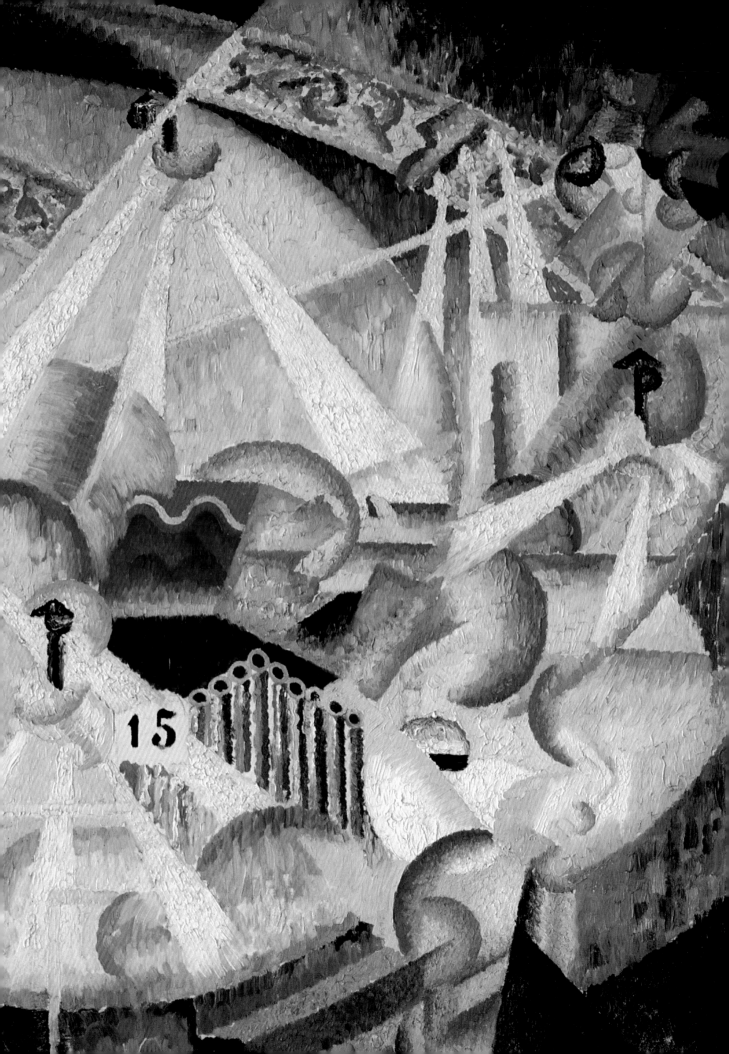

The Futurist Exhibitions, 1912–1917

Italian Futurism, by taking its name from the word, "future," signalled its intentional international scope. This energetic new movement was suddenly presented to the world, not as a groundswell of the bubbling issues of modernism, but as a calculated program of world conversion. It was at first the product of a single visionary, the gifted poet and entrepreneur, Filippo Tommaso Marinetti, who announced its inception in Paris, art capital of the world, on the front page of *Le Figaro* on 20 February 1909. It was a program to free the future from the darkness of the past: light was an essential ingredient. The very first words of that first manifesto had originally read "I stayed up all night…," but although his cohorts were not yet assembled, Marinetti recast the entire enterprise when he changed the words to read, "We stayed up all night…," and thus posited a Futurist group.

It was a bold strike. The publication of manifestos about the new movement was F. T. Marinetti's first line of offense in the conversion of the world to a new set of modern beliefs and behaviors. Second only to his rapid-fire publications was the untiring production of special events and art exhibitions, all intended to attract the international press, and ultimately to convert the public. Marinetti exerted considerable control over all these activities, alternately baptizing and excommunicating his colleagues, as he held up each individual effort against his new Futurist ideals. His role was clearly spelled out in his stationery, identifying a Futurist movement, "directed by" F. T. Marinetti (fig. 1).[1] There are many variations on the basic design, but most letterhead was printed in a rich orange-red that seemed to announce the optimistic aggressiveness of the movement. As the address of the stationery indicates, Marinetti operated largely from his residence in Milan, where he had the assistance of Umberto Boccioni, Carlo Carrà, and Luigi Russolo, all of whom lived in that city. Giacomo Balla in Rome and Gino Severini in Paris, while considered important members of the founding group, necessarily remained apart but were constantly informed of decisions made. Letters from Boccioni to Severini carry messages from Marinetti, and firmly state that all plans for exhibitions must

Festival at Montmartre (cat. 7), 1913, oil on canvas, 88.9 x 116.2 cm (detail). Richard S. Zeisler Collection, New York.

fig. 1
Letter Severini to Marinetti, 12
March 1913. Letter 15, Marinetti
Papers, Yale University.

pass through the *"governo centrale,"* reminding him that the entire group had agreed
not to hold solo exhibitions since group exhibitions better represent the movement
as a whole.[2]

Marinetti's control extended not only to communications and activities but pre-
cisely to the style in which they were presented. It was important to Marinetti to
mark Futurist publications with a visible stamp that tied them together as products
of a united Futurist brotherhood, and he controlled the format to be used for each
type of project. The manifestos, though often printed in established publications,
were originally issued as separate sheets of the same size and design; so also, cata-
logues of the many Futurist exhibitions were produced as small books of the same
format, with variations in design and color (fig. 2).[3] The catalogues have made
it possible to trace and to identify a great many specific works of art that were
displayed in the same years in which they were created. Thus they have served
as important tools for the reconstruction of an authentic oeuvre.

The first Futurist manifesto warmly recommended the destruction of museums
which it characterized as cemeteries. Even Severini, more attuned to the past than
his Futurist colleagues, declared during a visit to London that he would not go to
the National Gallery "because the sight of dead things is always unpleasant for
anyone who is full of strength and life."[4] By contrast the commercial art gallery was
to be the perfect vehicle for the dissemination of the products of Futurist sensibility
to a waiting band of artists and critics, and to a baffled public.

The sheer number of exhibitions, and the speed with which groups of works
were moved from country to country, must be attributed to the rare combination

fig. 2

Five exhibition catalogues:
Der Sturm, Berlin, 1912;
The Sackville Gallery,
London, 1912; Bernheim-
Jeune, Paris, 1912; Galleria
Gonnelli, Florence, 1913–14;
Marlborough Gallery,
London, 1913. Marinetti
Papers, Yale University.

of Marinetti's focused energies and the rapid production of the new Futurist artists. Marinetti did not hesitate to remind them that he was putting all his time and much of his fortune into the movement, and that he expected similar sacrifices of them.[5] Such manufactured excitement and enforced production does not usually promote considered thought or provide the artistic immersion normally connected with creativity. In this case, however, it had just the right effect. The Futurist platform generated not only a set of commands, but many of the technical solutions for carrying them out. The young Futurists indeed had conquered the darkness, and their infectious enthusiasm spurred on by cosmic promises of a new world was enough to ensure the production of a considerable body of important theory and a surprising number of master works. Their pictures travelled from exhibition to exhibition like brilliant shafts of energy and light.

Futurist painting burst into the consciousness of the world of art with the opening of *Les Peintres futuristes italiens* at the Bernheim-Jeune gallery in Paris on the fifth of February 1912. Thirty-five works were exhibited, including ten Boccionis, eleven Carràs, five Russolos, one Balla, and eight important works by Severini. The single Balla was to leave the show after the first venue (if it was ever shown at all), and an additional Russolo took its place. The organizers of the exhibition were powerfully motivated by a fierce competition with French Cubism and it became one of the grandest propaganda efforts in the history of modern art. Orchestrated with Marinettian speed and skill, the exhibition went to the Sackville Gallery in London, where it attracted considerable attention from the press and was extended on popular demand.[6] It then went to Berlin,[7] to Brussels and on to twelve or fifteen other venues — exactly how many is not known. The original catalogues that survive establish the dates and places of some of the exhibitions. Contemporary news reports fill in some of the blanks, but large gaps between them suggest that some have been lost or that catalogues were not produced for every occasion. One small volume published in Berlin by Herwarth Walden lacks any indication of place or date for the exhibition. It includes Marinetti's Futurist manifesto printed in German, and comments for each catalogue entry in German, English, and Danish,

suggesting that it may have been intended as an all-purpose document to serve more than one venue.[8]

It is not yet possible to determine how long the first exhibition was on the road, but we are aided by the Futurists' penchant for self-congratulation. The catalogue for an exhibition of entirely different works that took place in Rotterdam from 18 May to 15 June 1913 includes a section that lists all the works in the original exhibition under the title: "First Series of Futurist Paintings Exhibited in Paris, London, Berlin, Brussels, Hambourg, Amsterdam, The Hague, Munich, Vienna and Budapest and sold."[9] By February of 1914, a self-laudatory introduction to yet another catalogue added Dresden, Zurich, Rome, and Rotterdam to this list and suggests that the exhibition had continued into a second year.[10]

The vaunted success of the exhibition tour depended on words as well as images. The catalogues were like propaganda bombs offering a fast dose of ideology to accompany each exposure to energy and light. The initial Paris catalogue included the *Futurist Painting: Technical Manifesto* of April 1910, and a new essay called "The Exhibitors to the Public" which explained things with a bit more logic and less fire. The London exhibition catalogue also included Marinetti's first manifesto in English, but without the introductory section called "The Founding." The packages of text varied somewhat from venue to venue but all of the catalogues of group exhibitions offered a focused introduction to a Futurist position, and most of them included "The Exhibitors to the Public." Although this essay was signed by all five original Futurist painters (and after 1914 by Soffici as well), it was undoubtedly written by Boccioni alone.[11] Remarks in the catalogues were repeatedly cited by the press, often in scorn, but sometimes in sincere efforts to make the pictures understandable, or if that proved impossible, to make them seem at least serious.[12]

The second year of Futurist activity was no less intense than the first. A second series of Futurist works began its tour in Rome at the Galleria Giosi in February 1913. Severini showed six works, all painted in 1912 in a full-blown Futurist style. This exhibition went unchanged to Rotterdam in May and June. Five of the six works (*The Bal Tabarin*, cat. 6, was removed) were shown in Florence during the following winter, 1913–14, with the addition of five recent works of 1913, which then went on to other exhibitions in Rome, Naples, and San Francisco.

Severini had hoped to take part in the Armory Show in New York in 1913, but because of Marinetti's other projects, the Milanese Futurists decided to decline.[13] Similarly Severini had wanted to show with the Paris Indépendants, but had been discouraged from doing so.[14] Soon after, however, Severini was offered a solo exhibition in London which he felt he could not refuse, even at the cost of opposing Marinetti and the other Futurists.[15]

An exhibition of thirty works opened at the Marlborough Gallery in London on 7 April, Severini's birthday. The show was to have closed on 26 April, but Severini

wrote to Walden in Berlin on 5 May saying that because there were so many visitors the exhibition was being kept open for a few more days.[16] Picture postcards were made of works in the Marlborough exhibition (fig. 3), and the same images were recycled in standardized format for the next venue in Berlin.[17] From June through mid-July the exhibition was shown in Berlin at the Der Sturm gallery, and Severini made several new works to replace those sold in London.[18] This exhibition did not duplicate any of the works in shows in Rome and Rotterdam, and it is impressive that Severini was able to put together such a large number of important works in so short a time.

This frantic activity continued into 1914. The exhibition in Florence was still on view through January: a new exhibition of nineteen pictures was on display in the Galleria Futurista in Rome during February and March, then all but five of these pictures went on to the Doré Galleries in London in April. Severini's letters enable us to follow his shifting plans and help to identify which works were paintings and which drawings or studies (fig. 4).[19] Directly overlapping the London exhibition there was a mammoth group show at Sprovieri's Galleria Futurista in Naples in

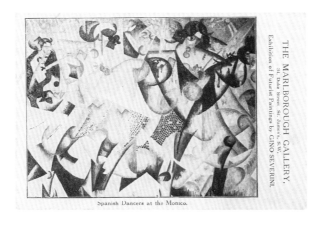

fig. 3
Postcard Severini to Marinetti, 24 January 1914, showing *Spanish Dancers at the Monico*, displayed at the Marlborough Gallery, London. Postcard 33, Marinetti Papers, Yale University.

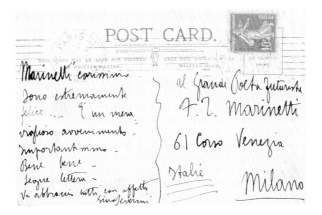

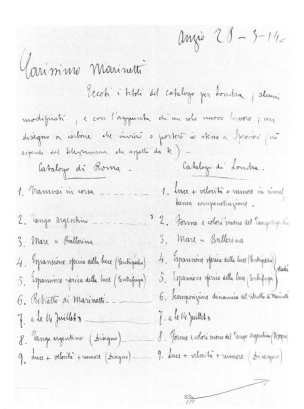

fig. 4
Letter Severini to Marinetti,
28 March 1914, comparing
works for the Rome and
London exhibitions. Letter
38, Marinetti Papers, Yale
University.

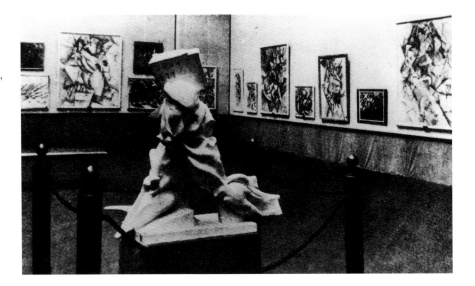

fig. 5
View into Gallery 141, The Annex, International Section, Panama-Pacific Exposition, San Francisco, 1915, showing Severini's *Argentine Tango* and works by Carrà and Boccioni.

May and June, to which Severini sent thirty-eight works.[20] The Naples show included all the members of the basic Futurist group plus Soffici, who had been officially invited to join them. Severini was understandably concerned that he would be taking more than his share of space, but apparently Marinetti was quite willing to bend his own rules and to exhibit them all.[21]

A first glance at the catalogue suggests that Severini had included a number of new works in the Naples exhibition. Actually, when these works came from Berlin Severini had made several title changes that shift the viewer's interest from the thing displayed to its abstract forces, and thus to its place in Futurist doctrine. For instance, *Danzatrice a Pigal's* (F109) becomes *Musica + ambiente + danza*, and *L'Autobus* (F129), *Velocità + rumore*. Fortunately a letter survives from Severini to Sprovieri which provides a key to the correct reading of many of the titles by showing them in both forms.[22]

With the declaration of war in August 1914, the whirlwind travelling exhibitions were curtailed, and the Futurists turned to the dramatic task of encouraging Italian intervention in the war. Italy finally joined the Allies on 23 May 1915. In spite of the war, the Futurists had been able to send a representative selection of their recent works to the Panama-Pacific Exposition of 1915 in San Francisco.[23] For Severini this demanded no new effort. He simply packed off all the works from his 1914 exhibition in London. Balla, Boccioni, Carrà, and Russolo sent representative works as well, and Boccioni wrote a short essay to explain the Futurist position, or so it seemed. Actually the article, credited to "Umberto Boccioni. (Member of the Futurist Group in Milan.)," was the familiar "The Exhibitors to the Public" under a new title.[24] Little critical response to the Futurist works has been found, a rare exception being Christian Brinton's discussion of the avant-garde in *Impressions of the Art at the Panama-Pacific Exposition.* Brinton, who reports having seen the first

fig. 6
Ettore Tito, *The Procession*, as
illustrated in Christian Brinton,
*Impressions of the Art at the
Panama-Pacific Exposition*, New
York: John Lane, Co., 1916, 172.

Futurist exhibition not in Paris, but in Hamburg and Copenhagen, apparently had
extensive familiarity with the international avant-garde. While he can hardly be
considered a champion of the new movements, he offers a great deal of unpreju-
diced information. "Amid a vast amount of violence and bombast there lurk, at the
basis of Futurism, certain valuable and invigorating truths," he says. "These men
are striving one and all to destroy the traditional fixity of impression. They aim to
demolish the theory that a given scene is unalterably focused in the eye. Their art
typifies not unity but diversity, not that which is dead and immobile, but that which
is vital, fluxional, and dynamic."[25]

The lack of more extensive published criticism may have been due to the fact
that the Futurists were shown in the Annex (fig. 5), rather than the Palace of Fine
Arts where generous space was given to modern Italian art of a more conventional
sort. Again Brinton wrote an informative page. He praised major figures like Segan-
tini and Morelli who were *not* in the exhibition, and he complained of the complete
absence of works from the Divisionist School, while generously commenting on
the exhibited works of a number of lesser talents.[26] There were no illustrations of
Futurist works in any of the published catalogues of the Panama-Pacific Exposition,
but several portraits, landscapes, and figure paintings from the main Italian rooms
were reproduced. Brinton gives special praise to Ettore Tito, for *The Procession*
(fig. 6), a realistic example of religious genre. Just such works may have been the
targets of the Futurists in their *Manifesto of the Futurist Painters* when they railed

against "The Portraitists, the Genre Painters, the Lake Painters, the Mountain Painters. We have put up with enough from these impotent painters of country holidays." [27]

Cultural activities in Paris were greatly limited in the war years. [28] Nevertheless, January and February of 1916 saw another large Severini exhibition at the Galerie Boutet de Monvel that signalled Severini's new interest in "the plastic art of war." [29] The catalogue is a single folded sheet with a list of the works exhibited. The back page (fig. 7), however, announces an interesting three-part lecture which suggests new directions in Severini's thinking, just as the style of some of the works exhibited suggested new directions in his practice. By this time Severini had abandoned his attempts to produce a manifesto that would meet Marinetti's requirements and was instead turning over in his mind many of the basic issues involved in the making of art. Nevertheless a genuine shift in style does not become apparent until his next important exhibition.

Sometime in 1916 Severini had written to his friend Walter Pach asking for a New York exhibition. Pach then brought some photographs of Severini's work to Marius de Zayas who forwarded them to Alfred Stieglitz, with the suggestion that Stieglitz might like to give Severini an exhibition at his "291" Gallery in New York. [30] These negotiations were successful, and on 2 October 1916 Severini wrote to Pach telling him that his works were on their way to New York. This letter, discovered by Joan Lukach in the Stieglitz Archive, Yale University, includes a three-page handwritten list of the twenty-five works being shipped for the exhibition: "Canvases," nos. 1–11; "Pastels," nos. 1–3; "Drawings," nos. 1–11 (fig. 31). Severini explained that De Zayas had helped him make arrangements with the American Consulate, and that, thanks to De Zayas and Pach, the works were being shipped with another consignment at reduced cost. Severini also asked if Stieglitz intended

fig. 7
Invitation and exhibition list for
The First Futurist Exhibition of the Plastic Art of War, Paris, 1916.
Marinetti Papers, Yale University.

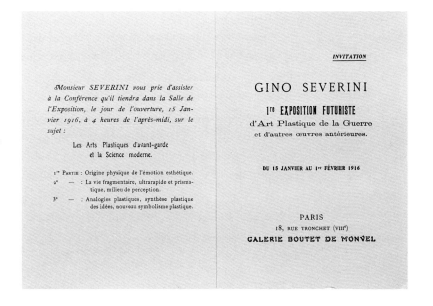

INVITATION

Monsieur SEVERINI vous prie d'assister à la Conférence qu'il tiendra dans la Salle de l'Exposition, le jour de l'ouverture, 15 Janvier 1916, à 4 heures de l'après-midi, sur le sujet :

Les Arts Plastiques d'avant-garde
et la Science moderne.

1ʳᵉ Partie : Origine physique de l'émotion esthétique.
2ᵉ — : La vie fragmentaire, ultrarapide et prismatique, milieu de perception.
3ᵉ — : Analogies plastiques, synthèse plastique des idées, nouveau symbolisme plastique.

GINO SEVERINI

1ʳᵉ EXPOSITION FUTURISTE
d'Art Plastique de la Guerre
et d'autres œuvres antérieures.

DU 15 JANVIER AU 1ᵉʳ FÉVRIER 1916

PARIS
18, RUE TRONCHET (VIIIᵉ)
GALERIE BOUTET DE MONVEL

to have a catalogue, and suggested that he could send a preface by Guillaume Apollinaire. Always aware of costs, he said that if a catalogue were not possible, a simple list of the works hung in a corner of the room would suffice.[31] A possible step toward either a catalogue or a wall label was an annotated copy of a typewritten list of the works in the exhibition with the titles translated into English (not always correctly) and dated March 1917 (fig. 32).[32]

This "catalogue" remains something of a mystery. There seems to be no question that something was written, and written in English. *The World* in its review of the exhibition says that "Mr. Severini has prepared a thesis."[33] "Art Notes" in *The New York Times* refers to a "catalogue," lists a few titles, and says that Severini "has issued a page of explanation concerning his theories.... He tells us among other things that we may discern in his work evidence for a search for a balance between reason and sensibility."[34] Whatever it was that the reviewers consulted, the catalogue seems to be lost without a trace. At least its source is known in a brief essay in French which Pacini found in the Severini family archives and identified as the catalogue preface. This can be fully confirmed by the publication of an extensive quotation in *The Sun* which is, indeed, a direct translation into English of a central portion of that essay.[35]

The exhibition received mixed criticism, but Severini judged its success in more practical terms. John Quinn bought ten of the twenty-five works (fig. 33);[36] one other was purchased by an artist named Davies (probably Arthur B. Davies). Severini ended the first part of his autobiography with the gleeful report of a letter from Stieglitz with the news of his sales, a check, and the promise of a second payment soon to follow.[37] Severini's works remained in Quinn's collection until his death in 1926. They were sold at auction in 1927. Thanks to news reports at the time of the sale, and Quinn's meticulous records (including photographs), these works have been securely identified.[38] As for the others, the war made it impossible for the unsold works to be returned to Severini, and the artist requested that Stieglitz care for them and exhibit them when he could. Thus they remained in Stieglitz's collection until his death and their subsequent donation to various American institutions by Stieglitz's widow, Georgia O'Keeffe.[39]

Many of the new works in the Stieglitz exhibition predicted new directions for Severini. Several were frankly Cubist, having abandoned the swirling color of the Futurist style and developed a planar treatment of forms based on proportionate relations. It could be argued that these almost classical pictures do not belong in an exhibition devoted to Severini's Futurist style, but both Severini and Stieglitz found reason to include them in the New York exhibition. As a group they mark the conclusion of the Futurist moment, just as Severini's early Divisionist works mark its beginning, and together they make a fitting parenthesis around his vivid Futurist production.

Notes

All translations are by the author unless otherwise noted.

Works by Severini are indentified throughout with F followed by the Fonti 1988 catalogue number. See below, p. 187.

1 Severini's letter to his "Amici fratelli carissimi," 12 March 1913. See Marinetti Papers, Letter 15. Severini was not able to be with his friends at the exhibition of Futurist works in Rome. Stationery was supplied to all members of the Futurist group from the central office in Milan. For more on Futurist communications, and for numerous illustrations of elegant Futurist typography, see Scudiero 1986; Enrico Crispolti, ed., *Ricostruzione futurista dell'universo,* exh. cat. (Turin: Mole Antonelliana, 1980), 412–15; and Giovanni Lista, *L'Art postal futuriste* (Paris: Éditions Jean-Michel Place, 1979).

2 Letters, Boccioni to Severini, late May 1912, May–June 1912, and June–July 1912, *Archivi* 1, 243–46, and Marinetti to Walden, 15 November 1912, *Archivi* 1, 253. These letters also demonstrate that exhibition finances were managed centrally. See also the excellent discussions of the Futurist *"governo centrale"* in Fanette Roche-Pézard, *L'Aventure futuriste, 1909–1916* (École Française de Rome, 1983), 181–84.

3 The task of finding the original catalogues and rebuilding the history of this extraordinary propagandistic phenomenon has been accomplished by Professor Piero Pacini who created a boxed set of facsimile catalogues complete with full descriptions, scholarly annotations, information on exhibitions for which no catalogues have been found, and bibliographies of contemporary criticism. Pacini, *Esposizioni* 1977. For further information on the catalogues, see below, List of Exhibitions.

4 Essay by Severini, "Get Inside The Picture: Futurism As The Artist Sees It," *Daily Express,* London, 11 April 1913 (fig. 11).

5 See letter Severini to Marinetti, 26 April 1914, Marinetti Papers, Letter 42.

6 Caruso 1991, 57–63.

7 A large number of pictures were sold from the Berlin exhibition to a Dr. Wolfgang Borchardt. See below, Marinetti Papers, Letter 6, note 4, and Letter 14, note 3.

8 In describing this catalogue Pacini identifies the third language as Swedish (*Esposizioni* 1977, 23). We are grateful to the Danish Embassy in Washington for informing us that it is Danish, with a few spelling mistakes that suggest that it was translated from German. In fact, there was a Futurist exhibition in Copenhagen in July 1912, organized by Walden and shown in Den Frie Udstillings Bygning, undoubtedly a reduced version of the original exhibition. My thanks to Troels Andersen for this information. Christian Brinton apparently saw this exhibition in Copenhagen. See below, note 25.

9 This catalogue also includes a separate priced list of the works sold.

10 *Esposizione di pittura futurista,* Galleria Futurista, Rome, February–March 1914, and Naples, May–June 1914.

11 A note in the London 1912 catalogue on page 19 specifies Boccioni's contribution, and in a letter to Vico Baer, 1 March 1912, Boccioni refers to it as "my preface to the catalogue," *Archivi* 11, 41. The essay is published under Boccioni's name alone in the catalogue of the Panama-Pacific Exposition in San Francisco in 1915.

12 See, for example, *The Sketch,* 6 March 1912, 4, 5; and 20 March 1912, 328, for comments on their color supplement. *The Times,* London, published an excellent short essay on 12 April 1913.

13 *La Vita* 1983, 124–25. See letter, Boccioni to Severini, July–August 1912, *Archivi* 1, 248. For further information on this subject, see Burke 1986, 51–53.

14 Paris, 25 November 1912, Marinetti Papers, Letter 9.

15 *La Vita* 1983, 125.

16 Letter, Severini to Walden, Paris, 5 May 1913, *Archivi* 1, 266; and *La Vita* 1983, 133.

17 Postcards were made of *A Dancer at Pigal's* [sic], *A Spanish Dancer at the Tabarin, The Nord-Sud Railway, The Motorbus, Spanish Dancers at the Monico,* and probably other works. For German and Italian picture postcards, see Scudiero 1986, 60.

18 For the closing date of the Berlin exhibition, see below, Marinetti Papers, Letter 20, 9 July 1913. Severini's 27 May 1913 letter to Walden gave information about the shipping of the London exhibition to Berlin, *Archivi* 1, 269. Two studies of *Der Zug zwischen den Hausern* replaced *A Spanish Dancer* and a *Still Life*. Severini informed Walden that he was sending the London catalogue with corrected titles, and that all the works were signed and numbered on the reverse, with titles in French. This letter also suggests that Severini had not been responsible for the descriptions of his pictures in the London catalogue list. He writes, "In the catalogue I think it would be better to suppress the useless and superficial explanations which I have crossed out with a pen." See also London, 19 April 1913, Marinetti Papers, Letter 19, which says, "the idiotic titles are Sée's work" (R. R. Meyer-See was director of the Marlborough Gallery).

19 See Marinetti Papers, Letter 38, which lists the works in these two exhibitions in two columns. Numbers 13, 14, 15, 18, 19 are omitted from the Rome list because these works were not to go on to London, but to Naples instead. The parallel columns reveal interesting changes in titles. Severini notes that number 15 of the London list, *Barche a vela = uomini sanwich* [sic], or *Sailboats = Sandwich Men,* is his latest work. See note 22 below.

20 The Naples catalogue lists 38 works by Severini, 30 of which were to come from L13 and five from R14. Such arrangements were often changed after the catalogues had been printed. The number of works from L13 was probably only 28 or 29. See letter, Severini to Sprovieri, Anzio, 8 May 1914, *Archivi* 1, 333–34, for a list of 29 works being sent from Berlin. Although listed in the Naples catalogue, *Barche a vela = Uomini samdwich* [sic] apparently never left London. The letter also states that seven drawings had already been sent from Walden to Sprovieri. An earlier letter, Severini to Sprovieri, 16 January 1914, *Archivi* 1, 311, states that Severini's pastels *Polka* and *Waltz* which had been shown in the *Post Impressionist and Futurist Exhibition* in London had already been sent directly from London to Rome.

21 *La Vita* 1983, 125. Letter, Marinetti to Severini, 16 May 1914, *Archivi* 1, 335–36, "In Naples we exhibited all your 38 works. . . . As for the number we have made an exception to the rule, given that some, like Russolo were not able to send anything." Actually Boccioni sent twenty-seven paintings, Carrà nine, Russolo one, Balla six, and Soffici four.

22 Letter, Severini to Sprovieri, Anzio, 8 May 1914, *Archivi* 1, 333, concerning works coming from Berlin to Rome.

23 J. Nilsen Laurvik, one of the organizers of the exposition, had met Marinetti in Venice, and persuaded him to send about fifty Futurist works, Burke 1986, 58–59. See Trask and Laurvik 1915, 1, 138, for a description of the organization of the Palace of Fine Arts and the Annex. The art exhibitions were arranged by the Department of Fine Arts, which included 12 foreign nations, a U.S. section, and an International Section containing works of artists of foreign nations not represented by the Commissioners of Fine Arts or National Committees. Part of the International Section was housed in the Palace of Fine Arts; the rest was in a separate building called the Annex. For plans of

the Palace of Fine Arts and the Annex, see Trask and Laurvik 1915, II, 483–84. The Futurist works, numbers 1130–1179, were shown in Room 141 of the Annex (I, 273–74). The paintings are listed in the catalogue by artist and title only, without dates, media, or measurements which might help in identifying specific works — an invitation to subsequent misrepresentation. A great many works of varying quality claim these catalogue titles.

24 "The Italian Futurist Painters and Sculptors: Initiators of the Futurist Art," appears in Trask and Laurvik 1915, I, 123–27.

25 Brinton 1916, 23–24.

26 Brinton 1916, "Foreign Painting — Part II," 175–76.

27 Apollonio 1973, 26.

28 Pacini, *Esposizioni* 1977, 49–50, notes that Severini showed his work in two exhibitions which took place some time before the summer of 1916, for which we have no catalogues and very little information: an exhibition in the studio of a grand "couturière," Madame Bongard, which was organized by Ozenfant; and an exhibition at the Galerie Barbazange, Avenue d'Antin, 26, organized by André Salmon. See also *La Vita* 1983, 182, 184.

29 See *La Vita* 1983, chap. 6 on Paris during the war.

30 *La Vita* 1983, 124–25, 185, 201. We are indebted to two noted scholars for our knowledge of this exhibition. Piero Pacini published the preface intended for the catalogue in *Critica d'Arte* 1970, 50–53. A year later Joan Lukach found the lists of the objects exhibited in the Stieglitz Archive. For her complete chronicle of the events leading to the exhibition, and her identification of the listed works, see Lukach 1971, 196–207; and Lukach 1974, 59–80.

31 Letter from Gino Severini to Walter Pach, 2 October 1916. See Stieglitz Archive below.

32 The carbon copy has survived as an enclosure in a letter from Stieglitz to Severini, dated 16 May 1917. See Stieglitz Archive below.

33 Frederick W. Eddy, "News of the Art World," *The World*, New York, 57, 11 March 1917, p. T7, here cited from Lukach 1971, 196, note 6.

34 11 March 1917, II.2. A "page of explanation" apparently did exist. A letter from Stieglitz to John Quinn, 19 March 1917, reads, "Under separate cover I have sent you a few copies of the Severini Preface, which you requested me to let you have." Stieglitz Archive.

35 See below, Preface to the Exhibition in New York, 1917.

36 List of Quinn's purchases dated 19 March 1917. See Stieglitz Archive below.

37 *La Vita* 1983, 201.

38 Lukach 1971, 203–04.

39 Lukach 1971, 200.

The Disappearance and Reappearance of the Futurist Object

Shortly before the opening of the Futurist exhibition in February 1912 at the Bernheim-Jeune gallery in Paris, Picasso visited Gino Severini's studio and admired his painting, *Souvenirs de voyage* (cat. 1; F90). A little later when visiting Picasso's studio on the rue Ravignan, Severini saw Picasso's *Souvenir du Havre*, which he described as "naturally painted in an entirely different way. Mine was ultra neo-impressionist, ultra Signac, his was ultra Corot."[1]

With this declaration Severini brought up to date the traditional lines of debate between form and color — lines which he would ultimately merge in productive compromise. Severini's concern with the balance between matter and light, between objects and their emanations, is a thread that runs through much of his writing. As late as 1917 in his preface to the first exhibition of his works in the United States, he stated that "two opposing tendencies…can be defined as follows: as for the Cubists, 'Reaction to Impressionism'; as for the Futurists, 'Continuation of Impressionism.'"[2]

Severini only gradually developed his significant abilities as theorist. He had met Boccioni in Rome in 1900 or 1901. Boccioni had then introduced him to Balla who briefly became their teacher. The two younger men shared readings in art and philosophy, and encouraged each other toward exhilarating, inventive, and courageous thoughts.[3] However, in 1906, three years before the first Futurist declaration, Severini moved permanently to Paris where he was plunged into a second stimulating environment with more vital new ideas to absorb.[4] He enjoyed the enormous cultural resources of his new city, without losing his loyalties to his own country or breaking contacts with his youthful friend, Boccioni. Nevertheless, Severini had no role in writing the *Manifesto of the Futurist Painters* (February 1910), and the subsequent *Futurist Painting: Technical Manifesto* (April 1910), which were written by the three Milanese Futurists, Boccioni, Carrà, and Russolo. The signatures of Balla and Severini on these two manifestos represented not authorship, but their willing adherence to the lively new movement.

Spherical Expansion of Light: Centripetal (cat. 15), 1913–14, oil on canvas, 60.9 x 49.5 cm (detail). Private collection, U.S.A.

Like Marinetti's original Futurist manifesto splashed on the front page of *Le Figaro* a year earlier, the *Manifesto of the Futurist Painters* was intentionally bombastic, declaring in urgent tones that "the young artists of Italy" must assault all *passéist* ideas and energetically initiate a new art — an art that could reflect "the triumphant progress of science [which] makes profound changes in humanity inevitable." This was to be a cultural resurgence for Italy worthy of "the radiant splendour of our future." The subjects of the new art were to be modern objects, "the tangible miracles of contemporary life": transatlantic liners, airplanes, submarines, and "the frenetic life of our great cities."[5] The *Manifesto of the Futurist Painters* offers little practical advice. This was rectified by the appearance of the *Technical Manifesto* in April. In its energetic call to action the problems of representation and illusion are laid out for consideration. A few clear points can be drawn from its sizzling language. First, art must involve dynamism — not motion in a narrative or cinematic sense — but as universal energy. "The gesture which we would reproduce on canvas shall no longer be a fixed *moment* in universal dynamism. It shall simply be the *dynamic sensation* itself."[6] Second, to capture sensation the artist must become aware of the processes of perception, "the doubled power of our sight, . . . the persistency of an image upon the retina," and the perceived continuities between object and atmosphere. The third point is expressed forcibly: "Space no longer exists. . . . The [perspectival] construction of pictures has hitherto been foolishly traditional. Painters have shown us the objects and the people placed before us. We shall henceforward put the spectator in the centre of the picture."[7] This relocation of the spectator, liberated from the controlling eye — or "I" — allowed for an extraordinary expansion of the possibilities for twentieth-century art.

The *Technical Manifesto* offers a specific suggestion for carrying out this ambitious program: sensations heightened by a reinvigorated consciousness of life could now be expressed through multiplied and intensified perceptions of color. To achieve such effects the artist must turn to Divisionism, not just to the particulars of color theory, but to a concept of *"innate complementariness"* and a need to express contrasts, oppositions, and tensions that are so much a part of the fabric of the new mechanized world.[8]

Before Severini moved to Paris in 1906 he had discussed color theory and practice with Balla and Boccioni, but he had little immediate knowledge of French Neo-Impressionism, or even Impressionism for that matter, as compared to his direct experience with Italian Divisionist art and theory. It is significant that the authors of the *Manifesto of the Futurist Painters* praised the Divisionist painters Giovanni Segantini and Gaetano Previati[9] and later, in the *Technical Manifesto*, announced flatly that "painting cannot exist today without Divisionism."[10]

Italian Divisionism was not an offshoot of French Neo-Impressionism. Both movements sprang from the same nineteenth-century research into optics and the physics of light, but their practitioners consulted different authors and their aims

and results often diverged.[11] In practice there are visible differences in French and Italian approaches to the "division" of color. Seurat's method recommended a controlled and ordered composition and required a uniform application of small dots of complementary colors juxtaposed so as to increase their apparent brilliance and to fuse at certain distances. Under some circumstances this approach produced "luster" or a silvery grey surface rather than an effect of intensified color. By contrast, the Italians preferred a less rational and more expressive handling of spectral color, applying the paint in varied dots and strokes, sometimes resembling straw or small threads rather than points of regular shape and size. These painted marks do not remain consistent over the surface of the canvas but can follow the contours of depicted objects or describe their textures, and are often easily recognizable indicators of the hand of an individual artist.[12] It was through this particularly Italian way of applying touches of brilliant color that the Futurists hoped to evoke the sensory impact of their new technological world.

Like most of his contemporaries the young Severini went through an experimental Divisionist phase which lasted until the consolidation of a Futurist style at the Paris exhibition of 1912. A typical example is the pastel portrait of Suzanne

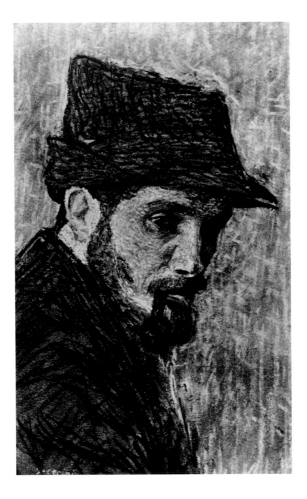

fig. 8
Gino Severini, *Portrait of the Painter, André Utter*, 1910–11, pastel on cardboard, 48 x 29 cm. Private collection.

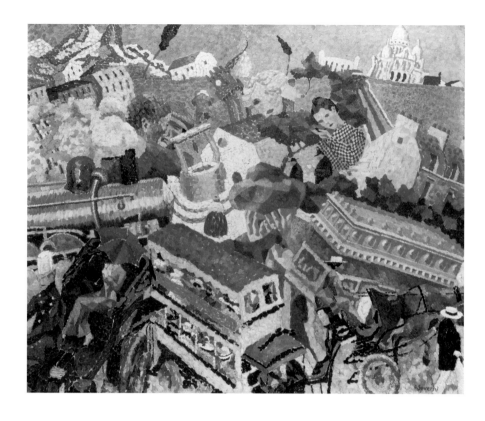

fig. 9
Gino Severini, *Memories of a Voyage* (cat. 1), 1910–11, oil on canvas, 81.2 x 99.8 cm. Private collection.

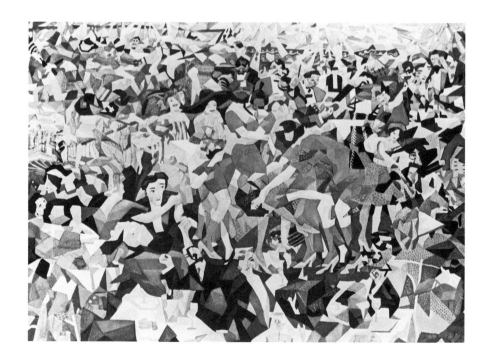

fig. 10
Gino Severini, *The Dance of the Pan Pan at the Monico*, 1911, oil on canvas, size unknown [original lost].

Valadon's friend, André Utter (fig. 8; F88). Although Severini followed Chevreul's principles of the simultaneous contrast of colors, he created a lively and varied facture unlike Seurat's surfaces. Yet Severini tells us in his autobiography that he made the pastel in homage to Seurat who was always much in his mind.[13]

A highly personal statement, Severini's *Memories of a Voyage* (fig. 9; cat. 1; F90) does not follow either of these models. The color is not "broken" or divided like that of a Neo-Impressionist or Divisionist painting. Instead individual areas of separate objects, for instance the purple roof of the double-decker bus, are colored with regular marks of the same hue, giving a lively texture to the painted surface and causing vibrations from one area of color to another, but not allowing for the optical mixture of hues. For all his stated admiration of Seurat and his followers, Severini seems to have committed himself to another path, attempting not to excite optical mixture, but to capture the potential violence of optical sensation appropriate to new Futurist energies.

The division of color was not Severini's only concern: he worked also for what he called "the division of form," by which he meant a breaking up of volumes in order to incorporate motion into the depiction of objects. In a letter to Giuseppe Sprovieri in 1914,[14] Severini described three paintings which marked important stages of this Futurist development. With *Memories of a Voyage*, "I destroyed time and space, reuniting in a single plastic ensemble realities perceived in Italy, in the Alps, in Paris, etc., — Another picture which marks a historical point is the *Pam Pam* [*The Dance of the Pan Pan at the Monico*, fig. 10; F97] — It is the first picture where, in addition to motion, sensations of sound and noise are deliberately rendered — The third is the one you have, *Sea = Dancer*. With this one, the painting and sculpture of plastic analogies was initiated."[15]

In *Memories of a Voyage* linear perspective with its logical narrative has been completely abandoned, and a tumbling mass of dislocated memory images simultaneously arouses different associations and sensations. Severini has effectively destroyed time and space in any traditional sense, allowing his weighty memories to encircle the vortex of the centrally placed Italian well, or self-image. By contrast the *Pan Pan* attempts to "put the spectator in the center of the picture" by conjuring up the bustle, the smells, the sounds, and the noise of a familiar place. Despite the hubbub created by fractured objects and colors, Severini's use of size diminution, a traditional perspective tool, repeats and intensifies the action while containing it in an orderly spatial grid.[16] The third painting, *Sea = Dancer*, marks a later moment when Severini conceived his own synthetic system for combining the effects of disparate objects and ultimately the tangible object disappears entirely.

Memories of a Voyage and the *Pan Pan* were shown in the first major exhibition of new Futurist painting at the Bernheim-Jeune gallery in Paris in 1912. The ideas put forward in the two painting manifestos were again taken up in "The Exhibitors to the Public," an essay composed for the exhibition catalogue. Like the manifestos,

the essay was signed by the same five Futurist artists, Balla, Boccioni, Carrà, Russolo, and Severini, although we know that it was written by Boccioni alone.[17]

It is significant that this exhibition began its lengthy tour in Paris, where the Futurist painters felt a strong need to clarify their antagonisms toward their Cubist rivals, and to establish their claims for their own program. They accused the Cubists of painting objects motionless, while they, on the contrary, sought "a style of motion." Again they emphasized the role of sensation: "*Painting* and *sensation* are two inseparable words."[18] They explained "dynamic sensation" not only as a human experience, but also as a quality of objects — their rhythms, their interior forces, their influences on each other — all forces the artist must learn to express. They declared that rational perspective space must be replaced by a sum total of visual impressions, a "synthesis of *what one remembers* and of *what one sees.*"[19] A new kind of composition must be developed that places the spectator in the center of the picture, that is to say, "*force-lines* must encircle and involve the spectator." How does one look at such a picture? The clashing rhythms enable the artist to paint "states of mind," and the viewer is asked not "to *assimilate* the work of art, but to *deliver one's self up* to it heart and soul."[20]

Although Severini had no hand in these earlier writings it is clear from his later statements that he accepted their major tenets. It was not until April 1913, on the occasion of his solo exhibition at the Marlborough Gallery in London, that he was able to present his own views in his own words.[21] He confirms many of the ideas already stated in official Futurist writings, quoting directly from the *Technical Manifesto*[22] and citing Bergson via Boccioni.[23] Severini introduces a more personal direction in explaining his new tendency toward abstraction as a "characteristic sign of that intensity and rapidity with which life is lived today." He stresses the need for synthesis over analysis and declares that a picture should be a world in itself, not an "anecdotal expression." Again in a more Bergsonian tone, he speaks of our perception of objects in space, explaining that objects do not exist as separate entities, since the lines and planes of one influence the lines and planes of the other.[24] He ends with an idea that will haunt him during his next efforts at painting and at theoretical writing, saying that "every sensation may be rendered in a plastic manner. Noise and sounds enter into the element, 'ambiance,' and may be translated through forms." He raises yet another issue to which he will return. "The Impressionists," he says, "in painting the atmosphere surrounding a body, have set the problem: we are working on the solution."[25] For Severini "the problem" raised by Impressionism is that objects, when bathed in light and rendered in a fractured technique, tend to lose their properties of weight, volume, and solidity.

These issues were much in Severini's mind when he wrote the introduction for his exhibition in the Marlborough Gallery in London. The exhibition stirred some response in the press, and on 11 April 1913, an article by "Gino Severini, Peintre Futuriste" appeared in the London *Daily Express* (fig. 11). It was entitled

fig. 11

Gino Severini, "Get Inside The Picture: Futurism As The Artist Sees It," *Daily Express,* London, 11 April 1913.

Get Inside The Picture.

Futurism As The Artist Sees It.

By GINO SEVERINI.

[People who have visited the exhibition of Futurist paintings at the Marlborough Gallery are frankly puzzled. They find it impossible to make any sort of rhyme or reason out of the works. In this article Signor Severini—one of the most important workers in the new movement—endeavours to make his objects clear, and to explain exactly how a Futurist picture should be looked at.]

I have travelled for the first time in England. I have seen from the train immense coloured poster advertisements representing men, cows, and so on, painted in impressionistic colours, existing in the midst of landscapes of geometrical pattern and forming with the trees, the earth, and the sky a complete unity. And then the hideous prettiness of the panorama (the delight of landscape painters) has been replaced at the end of my journey by the city, the violent affirmation of human activity.

SEVERINI AS HE REALLY IS. SEVERINI AS SEVERINI SEES HIM.

The elements of nature are being overtaken by inevitable destruction, and must give place to the mechanical ingenuity of man. In time we shall get even to new elements of nature, the outcome of the efforts of the human will.

We who are Futurists are nearer to these elements than we are to the sickly beauty of moonlights or sunsets on golden rivers.

Subjects That Are Taboo.

We have no more use for forests and blossoming bushes in our Futurist pictures. We seek for subjects in landscapes that are thick with black factory chimneys, in streets that are thick with moving throngs, in cafés that are thick with the cosmopolitan crowd.

Henceforward we are unmoved by the spectacle of the sea, and of the mountains. But we understand the tragedy and the lyricism of electric light, of motor-cars, of locomotives, and of aeroplanes.

Perhaps one day man will harness sunlight and distribute it at will.

The essentially masculine spirit of the English people ought to understand our exaltation of strength and of energy, and also the inexplicable inner force that drives us to the study of the phenomena of human activity in the modern world.

London is a city where movement and order reign. The architecture of the buildings, albeit without any modernity of character, expresses the individualism, the aristocratic spirit of the Englishman.

Motor-omnibuses passing and re-passing rapidly in the crowded streets, covered with letters—red, green, white—are far more beautiful than the canvases of Leonardo or Titian, and closer, too, to Nature.

I shall not go to the National Gallery, because the sight of dead things is always unpleasant for anyone who is full of strength and life. Now, all museums and galleries are cemeteries, and I have not the time to sob on the tombs of the poor primitives or the charming artists of the Renaissance. For the majority of them, moreover, I feel nothing but contempt. The Renaissance falsified art by enclosing it in a circle of idiotic conventions for centuries.

Art of the Lazy.

At last we have forgotten those conventions, so carefully taught in the schools and demonstrated in the galleries, and we are free from the laws of anatomical design, exterior and static, that paralysed the susceptibilities and prevented the complete expansion of artistic expression. The cult of the static, or, to put it more simply, the motionless fixed object, was an error that was most convenient for lazy people and those whose brains were atrophied.

We are opening up a new epoch in painting. Everywhere, and notably in Germany and Italy, young artists are struggling eagerly to attain to the pinnacles that we have shown them.

A picture will no longer be the faithful reproduction of a scene, enclosed in a window frame, but the realisation of a complex view of life or of things that live in space.

What I call the perception of an object in space is the result of the memory of the object itself, of the experience of our mind of that object in its different aspects.

We want to put ourselves intuitively in the midst of the objects, to form with them one single unity.

We want to represent the heart of things.

The technical manifesto of Futurist painting said:—

"The spectator must be placed in the centre of the picture."

In looking at a Futurist picture you must not try to find out what it is about. You must let yourself be gripped by the emotion, entirely plastic or creative, that emanates from the work.

You must put away your knowledge of the exterior appearance of things, for that knowledge is very far from the ideal and complex truths towards which our efforts tend.

Gino Severini
Peintre - Futuriste -

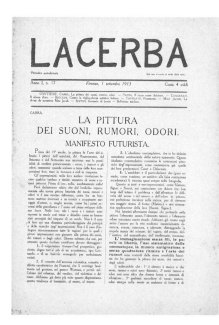

fig. 12

Carlo Carrà, "The Painting of Sounds, Noises, and Smells," *Lacerba*, 1 September 1913.

"Get Inside The Picture: Futurism As The Artist Sees It." The editor's introductory paragraph promised that Severini would explain how to look at Futurist pictures. In the article, Severini expresses his pleasure with the urban landscape, and finds the city "the violent affirmation of human activity." For the Futurists, subjects such as blossoming bushes and forests are taboo. Instead the artist seeks "black factory chimneys, streets dense with moving throngs, cafés thick with a cosmopolitan crowd," and he paints a vivid word picture of motorbuses, decorated with colorful advertisements, passing each other on the London streets. He praises the essentially masculine spirit of the English people, who should naturally understand this exaltation of strength and energy. Severini concludes with the promised advice, "In looking at a Futurist picture you must not try to find out what it is about. You must let yourself be gripped by the emotion, entirely plastic, or creative, that emanates from the work. You must put away your knowledge of the appearance of things, for that knowledge is very far from the ideal and complex truths toward which our efforts tend."

These "ideal and complex truths" were to be developed in Severini's major Futurist statement, often referred to as "The Manifesto." It exists in manuscripts in two languages, in several versions, and under several titles. In fact it was not published in any of its various forms until 1957,[26] but there is ample evidence in the letters Severini wrote to Marinetti in 1913 and 1914 that it was written at that time. Marinetti had encouraged Severini to write a manifesto expanding on some of the ideas he had put forward in 1913 in the Marlborough Gallery introduction, particularly Severini's statement that sounds, noise, and smells can be expressed through plastic means.[27] Then suddenly on the first of September, and apparently without

Marinetti's prior knowledge, a manifesto by Carrà, *The Painting of Sounds, Noises, and Smells*, appeared in *Lacerba* (fig. 12).[28] Pleased with Carrà's statement, Marinetti instructed Severini to avoid the subject and particularly not to use a title similar to Carrà's.[29] Severini later stated in his autobiography that he had never been very interested in this project in the first place since writing manifestos seemed to go against his nature.[30] On the other hand, the story told by his letters was one of persistence and frustration for many more months.

Severini's protracted writing project can be divided into three stages: (1) the writing of a general text on sensations, formal elements, and acceptable subject matter, generally known as *Art du fantastique dans le sacré;*[31] (2) the writing of a second text, *Le analogie plastiche del dinamismo;*[32] and (3) a period of editing and pleas for publication. It is in the second text that Severini confronts the problem of the depiction of the object in Futurist art.

The correspondence shows that there was a manuscript by late August or early September 1913 but that Marinetti found it unacceptable.[33] He was no better pleased by Severini's later submissions, objecting to Severini's use of terms taken from a manifesto by Apollinaire,[34] and to his discussion of religious art. Although some of these issues were resolved by mid-November, Marinetti still complained that the manifesto needed synthesis, emphasis, and a Futurist title.[35] A more serious problem was that Severini had intended to write about sensations, and Carrà's recently published manifesto effectively ruled out that possibility. It was clear that Severini had to start again.

By 7 January 1914 Severini was more optimistic. "I think I have given an exact definition of analogies and their expressive power." Here is a second essay, substantially different from the first, and largely devoted to Severini's new theory of plastic analogies.[36] There follows a lengthy interchange over the next few months. Severini submits several more versions of his manifesto to Marinetti and begs for its publication. Repeatedly he attempts to make the changes necessary to win Marinetti's approval. By April he is worried that Boccioni has begun to use his term "plastic analogies" and that his ideas will no longer have any force.[37] This long struggle comes to an end in August 1914 when Marinetti sends Severini a new book of manifestos by various authors.[38] Severini's manifesto is not included.

At the high point in this interchange, in the end of December 1913, Severini had written an urgent postcard to Marinetti saying, "I absolutely need to talk to you about the manifesto. My latest works are the outgrowth of it and conversely, they foretell its contents."[39] By February 1914 an extraordinary group of new paintings were on exhibition in Rome. Among them was *Sea = Dancer* (cat. 12; F188), which Severini identified as the first painting in a new phase of Futurism: "With this one begins the painting and sculpture of plastic analogies."[40]

Severini presents his new terms in the second version of his manifesto, *Plastic Analogies of Dynamism: Futurist Manifesto.* He does not abandon his interest in the

visual expression of nonvisual experience: sensations of noise, sound, heat, smell, speed, suggesting that such sensations can be evoked through fractured forms and spectral colors. These effects now become more important than the objects depicted, and he can confidently say, "Individual objects no longer exist." [41]

The manifesto offers graphic examples of the disappearance of the object. Severini explains that "certain forms and colours expressing the sensations of noise, sound, smell, heat, speed, etc., connected with the experience of an *ocean liner,* can express by *plastic analogy* the same sensations evoked in us by a very different reality — the *Galeries Lafayette.*" This "complex form of realism" can then be expressed as *Galeries Lafayette = Ocean Liner,* [42] with a mathematical sign indicating the analogical relationship between the two experiences. Having described the basic principle, Severini explains that there are two kinds of analogies: real analogies and apparent analogies. "*Real analogies:* the sea dancing, its zig-zag movements and contrasting silver and emerald, evokes within my plastic sensibility the distant vision of a dancer covered in sparkling sequins in her world of light, noise and sound. Therefore *sea = dancer.*" The "apparent" analogy is built not just on sensation but on association as well. "The plastic expression of the same sea, which in a real analogy evokes in me a dancer, gives me by a process of apparent analogy a vision of a great bunch of flowers.... Thus...*sea = dancer + bunch of flowers.*" [43] Here the objects are reduced

fig. 13
Gino Severini, *The Dancer at Pigalle's,* 1912, oil and sequins on sculptured gesso over fabric coated board, 69 x 50 cm. The Baltimore Museum of Art, Gift of William A. Dickey, Jr., 1957.

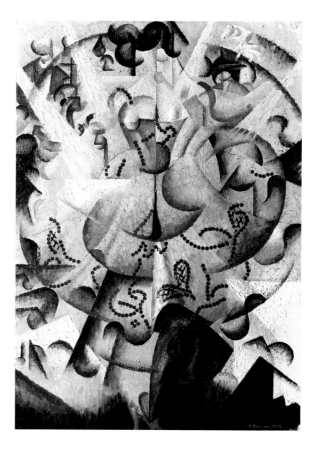

to the effects they produce, transferred from a tangible world to the subjective realization of the spectator's empathic perception.

The sea = dancer motif was the culmination of a series of studies of the swirling energies of nightclub dancers. Paintings like the *Dynamic Hieroglyphic of the Bal Tabarin* (cat. 6; F107), and the *Spanish Dancers at the Monico* (fig. 3; F110), captured Severini's fascination with shafts of artificial light. As the volumetric forms of the dancers were increasingly de-materialized in painted light and repeated motion, Severini sought to retrieve an element of reality by introducing real sequins into the costumes of the fragmented figures. Inserted into the pictorial illusion, these small bits of tangible stuff actually return tiny flashes of reflected light to the eye of the spectator passing in front of it. For the viewer, Severini wittily confounds illusion and reality. *The Dancer at Pigalle's* (fig. 13; F109), also decorated with sequins, further eliminated figural details in order to capture the great curvilinear energies of the dancing figure consumed in light. In *Sea = Dancer* (fig. 14; cat. 12; F188) Severini again used sequins to evoke alternately the light on the dancing figure and the rippling motions of the sea. His large charcoal drawing of this motif (F188A) still retains traditional realism in the images of distant beach cottages along the right-hand border of the composition. Their small size suggests that they are far away and function as part of a narrative setting — exactly the effect that is suppressed in

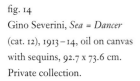
fig. 14
Gino Severini, *Sea = Dancer* (cat. 12), 1913 – 14, oil on canvas with sequins, 92.7 x 73.6 cm. Private collection.

fig. 15
Gino Severini, *Sea = Dancer*,
1913–14, charcoal on paper,
as reproduced in *The Sketch*,
29 April 1914.

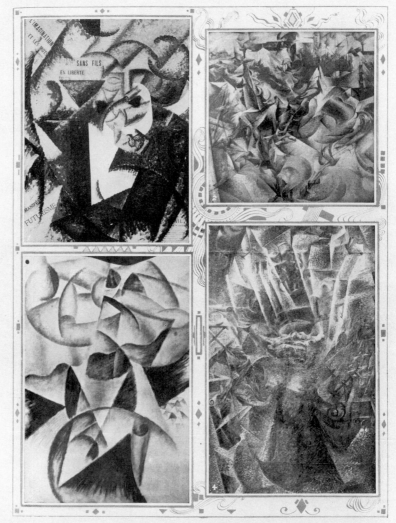

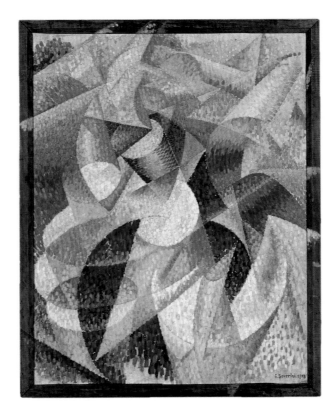

fig. 16
Gino Severini, *Sea = Dancer*,
1914, oil on canvas, 100 x 80.5 cm.
Peggy Guggenheim Collection,
Venice.

the oil painting where shafts of light and color unify the surface and hold the
suggested motion in shallow depth.

The catalogues for the exhibitions in Rome and London early in 1914 list an
oil painting called *Sea = Dancer* and three "studies" of the same title.[44] We know
that the charcoal drawing described above was one of these. It was reproduced in
The Sketch in April (fig. 15), when the exhibition went to the Doré Galleries in Lon-
don, with the caption "During a storm? Severini's 'Sea-Dancer (a study)'." Even
though one might reasonably assume that the oil painting in that exhibition was the
sequined version of the same motif, this is not certain. Another important painting,
also entitled *Sea = Dancer* (fig. 16; F185),[45] might be identified as the exhibited work.
Which version may have been painted first or why both were not exhibited at the
time are matters for speculation, but the differences between the two paintings
can be easily observed. The painting without sequins is more abstract, with fewer
remaining suggestions of the body and arms of a dancer. Instead it appears to be a
dance of lights rather than a dance of solids, its electrical energies spilling over in
painted marks onto the frame, redefining both depicted object and object of art.

The new interest in optical curvatures resulting from binocularity and eye
motion now encourages the development of inventive compositional structures
that further dislodge the traditional spectator. For example, the air view not only
resonates with Futurist aspirations to conquer the skies, but the diminution of forms

fig. 17

(a) Gino Severini, *Spherical Expansion of Light: Centrifugal,* 1914, oil on canvas, 62 x 50 cm. Private collection. Formerly Riccardo Jucker Collection, Milan.

(b) Gino Severini, *Spherical Expansion of Light: Centripetal* (cat. 15), 1913–14, oil on canvas, 60.9 x 49.5 cm. Private collection, U.S.A.

in all directions also creates cosmic curvatures around a central focal point, forcing energies either to converge toward a center or be violently thrust away from it.

Severini's manifesto takes us a step further in this cosmic de-materializing of the object: "All sensations, when they take artistic form, become immersed in the sensation *light*, and therefore can only be expressed with all the colours of the prism.... We will call this new artistic expression of light *spherical expansion of light in space*."[46] In Severini's conception of a curvilinear world this "expansion" can be centrifugal or centripetal, and forces in both directions can be included in a single work such as *Spherical Expansion of Light: Centripetal and Centrifugal* (cat. 14; F199). Now the analogy is not one of sea and dancer, but an opposition of forces set up by artistic means: forms and colors, forcing inward and outward, radiating centrifugally and centripetally. Again Severini uses his manifesto to describe actual works of art: *Spherical Expansion of Light: Centrifugal* (fig. 17a; F198) and *Spherical Expansion of Light: Centripetal* (fig. 17b; cat. 15; F200). These twin paintings, obviously intended as a pair, were shown together in several exhibitions (L14, R14, SF15). They offer a vibrant demonstration of opposites, one swelling from a light yellow center toward its complement in the deep blue boundaries, the other pulling in its bright edges toward a darkened center.

Severini was not alone in exploring this gradual distillation from realistic images to abstraction. Picasso once spoke of a picture he had made of two people: "Though these people once existed for me, they no longer exist. The 'vision' of them gave me a preliminary emotion; then little by little their actual presences became blurred;

they developed into a fiction and then disappeared altogether, or rather, they were transformed into all kinds of problems. They are no longer two people, you see, but forms and colors: forms and colors that have taken on meanwhile, the *idea* of two people and which preserve the vibrations of their life."[47]

While Marinetti had been urging Severini to intensify his manifesto, Severini was intensifying his painting, using alternating forms and complementary colors to capture the "vibrations" of life and matter. His analogical pictures, which depend on active color and abandoned motion for their participatory effects, were adapted by the very process of analogy to pull farther and farther away from the literal identification of the thing, and with the heightening of its effect, to the essence of visual experience itself.

Severini called his new paintings "plastic analogies." "Analogy" is, of course, primarily a literary term and Severini's major source was close at hand. Marinetti had defined his own theory of analogies in his *Technical Manifesto of Futurist Literature*[48] of 1912 which set out a new program in detail. The first requirement was the destruction of syntax — the very structure of written language — an act parallel, in its own terms, with the visual artist's destruction of perspective. Marinetti commanded that the writer destroy the "I" in literature, use verbs in the infinitive, abolish adjectives and adverbs, and replace punctuation with numbers and musical and mathematical signs. One must suppress "like" and "as" and deliberately confound the object and the image it evokes. Nouns should not be modified by adjectives but used in combinations and series such as "man-torpedo-boat" or "crowd-serf." The writer should make chains of analogies, then suppress the first term of a sequence, and make sequences of second terms. Marinetti's originality lay in his daring use of onomatopoeia to bring out certain characteristics of things, and his sense that size, weight, and number could describe more effectively the tangible properties of objects than qualifying adjectival terms. Marinetti thus set out a theory of analogies which depends on the intuitive discovery of affinities between unrelated objects and events. "Analogy is nothing more than a deep love that assembles distant, seemingly diverse and hostile things."[49]

Marinetti's *Technical Manifesto of Futurist Literature* was published on 11 May 1912, and Severini must have read it soon after. On 9 August, three months later, Severini sent Marinetti a brief letter written in a parody of the new style (fig. 18).[50] The aggressive tone of Marinetti's manifesto did not permit him to discuss his own literary debts. As a young man he had regarded Mallarmé as the greatest of nineteenth-century poets, and he later recited and translated his works. In his role of Futurist manifesto-writer-and-chief, however, he declared that the Futurists "hate our glorious intellectual fathers, the great Symbolist geniuses, Poe, Baudelaire and Mallarmé…after having loved them immensely."[51] However, it would seem that Mallarmé was neither hated nor forgotten. In fact he was enjoying a popular revival in 1912. Nijinsky performed in Mallarmé's "Afternoon of a Faun" in that year, and Albert Thibaudet published an important volume on Mallarmé's poetry which

fig. 18
Letter Severini to Marinetti,
9 August 1912. Letter 8,
Marinetti Papers, Yale
University.

attracted a wide readership.[52] Nor was the book confined to symbolist literary circles. Soffici warmly recommended it in *La Voce,* and on 15 June 1913 it was drawn to the attention of the readers of *Lacerba.* In August 1914, just as Severini was putting the last touches on his manifesto of analogies, *Lacerba* published Soffici's translation of Mallarmé's prose poem "Il demone dell' analogia,"[53] the subject of a short chapter in Thibaudet's book. It should be noted that the "demon" was not an attendant to the devil, but rather a mischievous imp, or sprite, that cast a spell over Mallarmé's work, insistently demanding that he return to a single motif. Like Marinetti's analogical structures, the prose poem was reworked so that fewer and fewer words increasingly compressed and intensified the original impressions. Under a new title, "Sainte," the poem shrunk to only sixteen short lines, but it still conjured up the original word picture of a wing playing on the string of a musical instrument, its evocations vastly heightened through analogy rather than description.[54]

Mallarmé may have been a particularly useful model for Severini because of the power of his evocative imagery. Severini read Thibaudet's book,[55] and he seems to have found it reinforcing for his own new directions. Thibaudet's chapter on analogy is followed by a chapter called "The Symbol," which begins with the words,

"From the faculty of perceiving analogies arises in a poetic organization the tendency to construct symbols."[56] It is this transfer from the intuition of analogies to the consolidation of symbols which was to effect a change in Severini's intention and style. But first it would require a reassessment of the role of the object in the Futurist program.

Many years later, when his manifesto was finally published, Severini added a coda to it: "In the Manifesto the suppression of the object is expressed in dialectic and polemic form. I was very naive to believe that one could destroy the object in itself and, as a result, the existential world into which man is thrust and which constitutes part of him; in destroying existential reality, we destroy ourselves."[57]

In 1914, however, Severini was still trying to reconcile opposites: the importance for the Futurists of scientific exploration into life forces on the one hand, and the Futurist passion for new material technology on the other. At this fertile moment in Severini's theoretical development, a second very important force came into play: World War I was declared in August 1914.

As an Italian living in Paris Severini was doubly affected by the war. He was deeply concerned with the mounting campaign for Italian intervention which was noisily supported by the Italian Futurists. When Italy finally entered the war against Austria-Hungary and Germany on 23 May 1915, their aggressive activities for intervention could be channeled to the war itself. Marinetti, Boccioni, Sant'Elia, and other Futurists promptly enlisted. Having returned to Paris in the fall, Severini was both an expatriot, and, because of his recurring lung disease, a noncombatant. However, there was no suggestion that his artistic production should come to a halt. Quite the opposite: Marinetti made it clear to all Futurists that they could serve the cause by redirecting their art to understandable war subjects. He wrote to Severini, "What we need is not only direct collaboration in the splendour of this conflagration, but also the plastic expression of this Futurist hour…an expression so strong and synthetic that it will hit the eye and the imagination of all…intelligent readers…. Try to live the war pictorially, studying it in all its marvellous mechanical forms (military trains, fortifications, wounded men, ambulances, hospitals, parades, etc.)."[58]

Goaded to reintroduce objects, and now armed with a new theoretical project on the function of symbols, Severini was ready for a new course. His subjects were close at hand. Severini and his small family spent the summer of 1915 at Igny where they lived in the middle of a garden near the railroad. On his return to Paris in the fall Severini worked in a small room which overlooked the station at Denfert-Rochereau. Both locations offered him constant views of trains full of soldiers, the wounded, and the materials of war.[59]

In his studies of passing trains, the circular forms of spherical expansion now neatly represent the puffs of light-filled grey-white smoke which seem to hold in check the thrust of a speeding locomotive through fractured landscapes (cat. 23;

fig. 19; F236). The Futurist subject was back, played in several variations: the suburban train, the Red Cross train, the métro, the collapse of a building in the city — all events of daily experience. In this limited sense Severini returned to nature, or to what is seen. However, these animated works displayed a strong tendency to render abstract naturally perceived forms, simplifying their attributes into a kind of code. Severini does not reinstate "nature" at this point, he turns to the "essential": "Although at first I was inspired by the real things that passed in front of my eyes, they eventually became more synthetic and symbolic, until, in the paintings which I made successively in the next winter, they were true 'symbols of war'.... As I noted above, from simplification to simplification, I arrived at a type of symbolism which, however, fully coincided with my ideas of that moment which, it is worth repeating, were then general ideas more or less diffused in the air and still saturated with the memory of Mallarmé and the Symbolists."[60] Severini explains Mallarmé's desire to reach with each word a unique spiritual point at which the particular form of the expression no longer has any importance. Thus, applied to his own new works, the "pure idea" or "essential state" creates a truly modern idea-image of war.

Severini began to feel an urgent need to exhibit his new work, and on 15 January 1916 *The First Futurist Exhibition of the Plastic Art of War* (fig. 7) was opened at the Galerie Boutet de Monvel. It included pictures of dancers, with titles in the analogical mode, and the now familiar pair of contrasting pictures of spherical expansion. Almost one-half of the paintings and drawings exhibited were new works of war

subjects. Several bore the same title, *Plastic Synthesis of the Idea: "War,"* acknowl-edging Severini's new theoretical direction (cat. 22; fig. 20; F232).[61]

Severini inaugurated the exhibition with a lecture entitled "Les Arts plastiques d'avant-garde et la science moderne." It had three informative subtitles and appeared to be a review of Severini's opinions on several key issues: the relationship of art to science and technology; the continuing role of perception and sensation; and the new role of analogies in the development of symbols. We have no specific information as to what was actually said, but it is generally thought that the lecture was drawn from Severini's article, "Symbolisme plastique et symbolisme littéraire," which was published in *Mercure de France* on 1 February.[62]

In a full statement Severini tries to bundle together sometimes incompatible aspects of Futurist doctrine with stimulating re-evaluations of past and present art. He reminds the reader that with technological advances like the invention of steam and the discovery of magnetism, a new intellectual and social life has begun — a new era in which the notion of the universe itself must be altered. So too there must be a new understanding of the vitality of matter according to which objects and ambiance penetrate each other and knowledge of tangible things is intensified by memory and imagination. The sight of an object or the touch of an object immediately evokes the *idée-image* of that object. Consequently the painter does not reproduce the object itself in painting but the idea-sensation-image which the object provokes in the viewer: not the cause but the effect. Severini makes clear here and in other writings that he refers not to an *ideal* image, but to an idea-image, an image capable of containing the elemental essence of an idea.

Severini explains that literature is more advanced than the plastic arts in express-ing modern psychology. He compares Mallarmé and Monet to Monet's detriment: "Mallarmé saw and thought, Monet only saw. Mallarmé tended toward creation: Monet remained within the limits of a morphological art....In fact, in the realiza-tion of form, Claude Monet and the Impressionists never arrived at the the evolu-tion that they had realized in color."[63] The solidification and consolidation of Impressionism had to occur later, after Neo-Impressionism and Post-Impressionism (presumably emerging in the work of the Futurists). As early as 1912 the Futurists had made the challenge by stating, "It is only possible to react against Impression-ism by surpassing it." They saw a danger in the "liquefaction of objects favoured by the vision of the Impressionists," and wanted to confront "the question of volumes" in painting.[64] This reaction to Impressionism involved a shift of interest from color to form, a shift of attention to the kind of analysis and division of form being practiced by Picasso and Braque. But more was needed: Cubism was not to be the answer. In the eyes of the Futurists, Cubism had failed to deal with motion, as it had failed to deal with modern subject matter.

Severini speaks at length about motion, developing some of Boccioni's ideas to serve his own arguments. Motion is continuity, and to analyze any motion into a

series of successive instants kills the life of the object. "There is no such thing as static art because a painting worthy of the name is always a living organism in which a continual concurrence of forms and colors establishes a movement or subjective life."[65]

In the first epoch of Futurism the artist had dealt with Object and Ambiance; in the second epoch of Futurism he had the grander aim of dealing with Object and Universe. "The division of forms and the interpenetration of planes permit the modern painter to realize the essential elements of Universal Movement: the force of gravity – the force of attraction – the force of repulsion." These forces constitute the *life* of the object, or, conversely, the object *is* the sum of its own life forces. The simultaneous synthesis of these combined forces creates a new realism, or *réalisme idéiste*.[66]

Only at the end of the article does Severini come to the subject of his exhibition, the plastic art of war. Explaining that he believes in a sort of plastic *idéographie*, or synthesis of general ideas, he writes, "I try to express the idea, 'War,' by a plastic example composed of these realities: Cannon, Factory, Flag, Order of mobilization, Airplane, Anchor. According to our conception of *réalisme idéiste* no more or less naturalistic description of the field of battle or the carnage can give us a synthesis of the idea 'war' better than these objects, which are the living symbols of it."[67]

Severini's thoughts are more cogently expressed in the brief preface he had planned for his 1917 exhibition at the "291" Gallery in New York. It has none of the polemic of a proper Futurist manifesto. Instead, it is a document of compromise, of resolution, and of preparation for new ventures. Although it appears never to have been printed as part of a catalogue (no copies survive), it was extensively quoted in the press, suggesting that some sort of written statement was generally available.[68]

Unlike the Panama-Pacific paintings which were recycled from an earlier exhibition in London, Severini's selections for the New York exhibition were intended to display the new directions he had taken in the previous two years. Thirteen of the twenty-five paintings, drawings, and pastels shown in New York were exhibited at the Galerie Boutet de Monvel in Paris early in 1916. All the works in the "291" exhibition were made in 1915 or 1916 with the exception of the three pastels, made one or two years earlier. A new series of elegant dancers traded an earlier Divisionist touch for a more formalized organization of motion and gesture. The most radical departure from his earlier approach is represented by a small group of portraits and still lifes constructed in a flattened Synthetic Cubist style. Their surprising aspect, which sets them apart from the work of the Paris Cubists, is Severini's daring use of fields of brilliant color, which, through their interaction, enliven the entire pictorial surface.

One of the paintings was given the subtitle, *Still Life: Centrifugal Expansion of Colors* (fig. 21; cat. 36; F260), as if Severini were referring back to the decomposition of matter in his earlier paintings of the spherical expansion of light. This time, how-

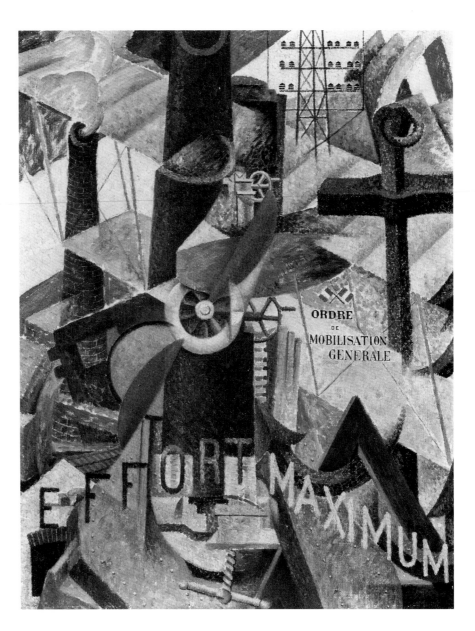

ever, the word is "colors" not "light," and a silent compote of fruit, embedded in
vivid hues, provides a rational justification for the circular forms at the center of
the canvas.

Severini and Picasso had been friends for some years, and undoubtedly had
influenced each other in a number of ways. It was not until 1916 that Severini was
introduced to Matisse. Severini greatly regretted not having met him sooner:
"Perhaps I would have gained a lot of time and would have seen things clearly more
quickly.... The more I knew Matisse the more I valued him as a painter and as a
man."[69] He was very kind to young artists, buying their work when he found them
in financial difficulties. Many people thought that he painted very quickly, but

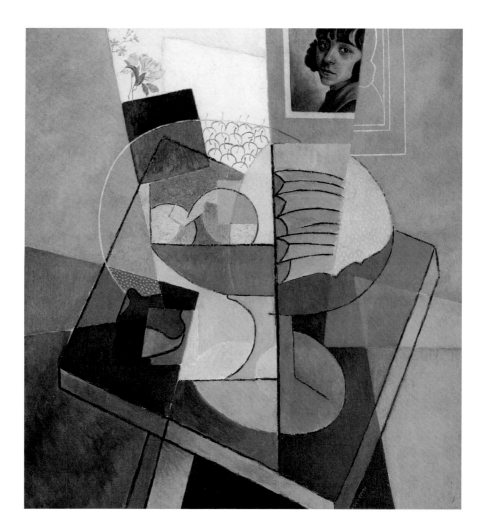

returning to his studio each week, Severini saw the same pictures transformed by the substitution of entire areas of different hues. With great patience and sincerity Matisse would explain to Severini, painter to painter, why he changed an area from red to green.[70]

Severini referred to Matisse as "the first to develop an intuition of the division-ism of color."[71] This was not the *fin-de-siècle* Divisionism which broke colors into small brush marks. (Severini disposed of the artists still practicing that style as "mediocre.") Instead, the term was now broadened to refer to the division of expres-sive forms and of expressive color, irrespective of the outlines or local colors of the objects depicted, but determined by sensibility and the need for construction. "This aesthetic leads naturally to the reconstruction of the object."[72] In the first research of the Cubists and Futurists seven or eight years earlier, Severini had seen this issue as one of opposing tendencies: as for the Cubists: reaction to Impressionism, as for the Futurists: continuation of Impressionism. The first claimed Ingres, the second Delacroix.[73]

Severini was now ready to take another step. "My idea which was shared by many Cubists and approved by Matisse himself was to carry artistic expression to a level that reconciles the desire for extreme vitality (dynamism) of the Futurists with the intention of construction, of classicism, and of the style used by the Cubists. Therefore we found a characteristic formula for this desire, 'Art must be Ingres plus Delacroix.'" A lyrical realism, a romanticism penetrated by classicism.[74]

Severini's formulation is not a confrontational analogy, as "Ingres + Delacroix" might be. He could not resolve his dilemma without accepting both directions, and, as always, he worked more with the brush than with the pen. "In the works I am exhibiting one may discern a balance between reason and sensibility." Therefore it must be "Ingres *and* Delacroix," signifying compromise and a commitment to discover new resolutions to the needs of representation itself.

Notes

1 *La Vita* 1983, 107. Speaking on another occasion, Severini claimed the vivid color of Neo-Impressionism as a source for Léger, in contrast to "the greys and ochers of Corot to be found in the paintings of Picasso and Braque" (*La Vita* 1983, 72).

2 See below, Preface to the Exhibition in New York, 1917.

3 See *Écrits* 1987, "1913, Lettre sur le Futurisme," 32. "We have studied and discussed the most important philosophers, or rather those closest to our sensibility, like Kant, Hegel, Nietzsche. We have run through all the French literature since Boileau, Molière, etc. to the symbolists of the last century. We have also studied the Russians, the English, the Germans, the Norwegians." In his autobiography, *La Vita* 1983, 11–12, Severini says that a young Neapolitan named Mosone Pietrosalvo introduced Boccioni and Severini to Karl Marx, Bakunin, Engels, Labriola; other friends introduced them to the writings of Schopenhauer, Hegel, Proudhon, and Nietzsche, and later to other philosophers and Russian novelists. On page 13 Severini comments on his meeting with Boccioni: "Our reciprocal sympathy was immediate. We evidently agreed on every point, and above all, our enthusiasm for Nietzsche was identical."

4 Notably he became familiar with Impressionism, Fauvism, and a reflowering of Neo-Impressionism as well as with the literary avant-garde.

5 Apollonio 1973, 24–25.

6 Apollonio 1973, 27.

7 Apollonio 1973, 28.

8 Apollonio 1973, 29. This invented term is Apollonio's translation of the original "complementarismo congenito." See Marinetti 1914, 30.

9 Apollonio 1973, 26. The only other artist mentioned by name is the sculptor Medardo Rosso. Segantini was perhaps the most popular painter of the Divisionist group. Previati was even more in the public eye. His works were shown at the Società per le Belle Arti in Milan in February 1910 and received extensive critical comment in the press. He had already published two important works on color theory, *La tecnica della pittura* (1905), largely devoted to the painter's craft, and *I principi scientifici del Divisionismo* (1906), on vision, light, and color. For more on this subject see Maurizio Calvesi, "Previati e Boccioni," in *Gaetano Previati (1852-1920)*, exh. cat., Galleria Civica d'Arte Moderna, Palazzo dei Diamanti (Ferrara, 1969).

10 Apollonio 1973, 29.

11 A thorough study of the scientific works available to the Divisionists is to be found in Quinsac 1972, 171–77. Johan Mile, Professor at the University of Warsaw, published an essay in German in Berlin in 1839, the same year as Chevreul's *The Law of Simultaneous Contrast of Colors*. Mile apparently did not know Chevreul's work, nor was his work known in France. Mile made important observations on the "division" of color and the function of the retina in the perception of colored light. See Quinsac 1972, 174–75, and 274 for Mile's brief essay. The source most used by the Divisionists was Ogden N. Rood, the American physicist and Columbia University professor who published his influential treatise, *Modern Chromatics*, in 1879, which they consulted in a French translation that appeared in 1881. Rood, in turn, is often quoted by Previati.

12 Susan Barnes Robinson, *Giacomo Balla: Divisionism and Futurism, 1871–1912* (Ann Arbor, MI: UMI Research Press, 1981), 7–12.

13 *La Vita* 1983, 70. Severini's later conflation of Neo-Impressionism and Divisionism is confusing, but it must be remembered that the autobiography was written in 1946 many years after the event. Severini states that he made the portrait of Utter while working on the *Pan Pan,* that is to say, in

1911. However, on the back it is signed and dated 1909, which is more reasonable from the standpoint of style and subject.

14 *Archivi* I, 314. Letter from Anzio, 6 February 1914. Sprovieri was director of the Galleria Futurista in Naples and Rome who gave the Futurists several important exhibitions. The gallery is still active, and still run by the Sprovieri family.

15 "The one you have" (probably F185), refers to the painting by this title that was then on view (as number 3) in the Futurist exhibition at Sprovieri's gallery in Rome.

16 The original painting of the *Pan Pan* is lost. With the help of photographs Severini made a replica in 1959–60. The original painting was reproduced in color in Neill Walden and Lothar Shreyer, *Der Sturm* (Baden-Baden: Wodemar Klein 1954), 160–61, before it was destroyed.

17 After 1914 Soffici's name was also added. A note at the end of the essay specifically states that the ideas it contained had already been developed at length by Boccioni in a lecture at the Circolo Internazionale Artistico, Rome, on 29 May 1911. The essay, with modified introductions, is repeatedly used in official Futurist catalogues, and appears as a chapter in the text of the catalogue of the Panama-Pacific Exposition in San Francisco in 1915. See Trask and Laurvik 1915, I, 123–27. The essay is credited to "Umberto Boccioni. (Member of the Futurist Group in Milan.)."

18 Apollonio 1973, 46.

19 Apollonio 1973, 47. There is a markedly Bergsonian flavor to many of Severini's statements here and elsewhere. Bergsonian language is to be found throughout Cubist and Futurist writings. For the fullest and most recent study of Henri Bergson and modern art, see Mark Antliff, *Inventing Bergson: Cultural Politics and the Parisian Avant-Garde*, Princeton University Press, 1993. On pages 53–54, Antliff states that Severini's "Travel Memories" was painted in response to his reading of Bergson's *Introduction to Metaphysics.*

20 Apollonio 1973, 48–49. His emphasis.

21 *Archivi* I, 113–15. Introduction to *The Futurist Painter Severini Exhibits His Latest Works.*

22 *Archivi* I, 114, "We shall no longer give a fixed moment in universal dynamism, but the dynamic moment itself." And see note 6 above.

23 *Archivi* I, 113, "To perceive," says Bergson, "is, after all, nothing more than an opportunity to remember." Boccioni also identified Henri Bergson by name and quoted him directly in *The Plastic Foundations of Futurist Sculpture and Painting*, of 1913. See Apollonio 1973, 89. For further discussion of this connection, see Brian Petrie, "Boccioni and Bergson," *The Burlington Magazine* 114 (March 1974): 140–47.

24 *Archivi* I, 113–14.

25 *Archivi* I, 115.

26 See below notes 31 and 32.

27 *La Vita* 1983, 155. Actually the Marlborough introduction has little to say on the subject.

28 *La pittura dei suoni, rumori, odori,* 1 September 1913, 185.

29 Marinetti to Severini, between September and October 1913, *Archivi* I, 295. See also *La Vita* 1983, 155. Severini states that Carrà's manifesto appeared fifteen days after Marinetti's suggestion, placing their conversation about 15 August.

30 "I am very content not having on my conscience this particular kind of literature," *La Vita* 1983, 155–56.

31 *Art du fantastique dans le sacré: Peinture de la lumière, de la profondeur, du dynamisme. Manifeste Futuriste.* Published in *Gino Severini,* Prix National des Arts, Ministère de l'Instruction Publique, 1960; in *Témoignages* 1963, 24 – 32; and *Écrits* 1987, 47 – 52.

32 An Italian manuscript in the Severini family archives was published in *Archivi* 1, 76 – 80, under the title, *Le analogie plastiche del dinamismo: Manifesto futurista.* Apollonio translated this version into English (1973, 118 – 25). In 1957, at Michel Seuphor's request, Severini translated it into French and it appeared as *L'Art plastique néo-futuriste* in *Dictionnaire de la peinture abstraite* (Paris: Hazan, 1957); and in Lista 1973, 186 – 90. It was also published as *Les Analogies plastiques dans le dynamisme,* in *Témoignages* 1963, 14 – 23, and *Écrits* 1987, 39 – 44.

33 *Archivi* 1, 294 – 95. According to Marinetti it lacked an appropriate title and was not in proper manifesto form.

34 "L'antitradizione futurista: Manifesto sintesi," appeared in *Lacerba,* 15 September 1913, 202 – 03. It includes a list of those who are locked in the past, and a list of those who look to the future, and it awards them "*merda*" or "*rose*" accordingly. Attempting to be equally naughty Severini made his own lists, awarding *merde* and *rose,* not to individuals and types of people, but to painters' subjects, damning mountains and rivers, peasants and cattle, the nude, contemplative melancholy and tragedy, and praising forests of factory chimneys, Grand Boulevards, electric lights, movie houses, and other appropriate Futurist subjects.

35 Marinetti Papers, Letters 26 to 47 all concern the writing of the manifesto. See especially Letter 26, Pienza, 11 October 1913; Letter 28, Pienza, 22 October 1913; and Letter 30, Pienza, 10 November 1913.

36 Marinetti Papers, Letter 32, Anzio, 7 January [1914].

37 Marinetti Papers, Letter 41, Anzio, 22 April 1914.

38 Marinetti 1914. No manifesto by Severini appears in this little volume. The inclusion of Seveini's name in the title indicates only his shared authorship of *Manifesto dei pittori futuristi,* 12 February 1910 and *La pittura futurista: Manifesto technico,* 11 April 1910, pp. 23 – 36.

39 Marinetti Papers, Postcard 31, Anzio, 24 December 1913.

40 Letter to Sprovieri, 6 February 1914, *Archivi* 1, 314. In spite of his disclaimers Severini still hoped to make a splash with his manifesto. He urged Sprovieri to "say as little as possible about analogies or the manifesto will have no effect." Severini states in his autobiography that his plastic analogies were painted in Anzio. A letter to Sprovieri inscribed "Anzio, 9 dicembre 1913," shows him there early in December. See Maurizio Fagiolo dell'Arco, *Esposizione di pittura futurista,* exh. cat., Francesca Barnabò and Paolo Sprovieri, curators, Studio d'Arte Barnabò, Venice, and Galleria Sprovieri, Rome, 1986, 80 – 81. The key works were on display in Rome by the beginning of February 1914. Severini left Anzio some time in the middle of the following May.

41 The sentence quoted here is translated by Apollonio to read, "Individual objects do not exist any more." See Apollonio 1973, 118. In *Archivi* 1, 76 – 80, the line reads, "Gli oggetti non esistono più." The translation in this essay seems better to express Severini's intentions.

42 Apollonio 1973, 121 – 22.

43 Apollonio 1973, 123.

44 The studies L14-55, L14-57, L14-58 are all drawings. Marinetti Papers, Letter 38, 28 March 1914, says that the first seven works listed in the catalogue were [oil] paintings, the others, drawings.

45 Peggy Guggenheim Collection, Venice. Before this painting was relined and mounted on new stretchers, a label from the Doré Galleries, London, was found on the reverse. This makes it appear likely that this version of *Sea = Dancer* is the oil painting listed in the London catalogue. See Rudenstine 1985, 700–706, and cat. 12 below.

46 Apollonio 1973, 124.

47 Alfred Barr, Jr., "Statement by Picasso 1935," in *Picasso: Fifty Years of His Art* (New York: Museum of Modern Art, 1946), 273.

48 Flint 1971, 84–89. For later literary manifestos, see *Destruction of Syntax – Imagination without Strings – Words-in-Freedom 1913,* in Apollonio 1973, 95–106, and *Geometric and Mechanical Splendour and the Numerical Sensibility 1914,* 154–60.

49 Flint 1971, 85.

50 Marinetti Papers, Letter 8, Pienza, 9 August 1912.

51 *We Abjure Our Symbolist Masters, the Last Lovers of the Moon,* in Flint 1971, 66. Also see Marinetti, *Nous renions nos maîtres les Symbolistes, derniers amants de la lune,* in Marinetti 1980, 117–21.

52 Thibaudet 1926. For a fuller discussion of Mallarmé's influence, see Martin 1983, 95–113.

53 15 June 1913, 131; and 1 August 1914, 234. Soffici gives the source from which he made his translation as *Divigations,* Eugène Fasquelle, ed., Biblioteca Charpentier, n.d.

54 Stéphane Mallarmé, *Oeuvres Complètes: Poésie,* 2 vols. (Paris: Flammarion, 1983), 1, 198–99; and Mallarmé, *Igitur, Divigations, Un Coup de dès* (Paris: Gallimard), 1976, "Le Démon de l'analogie," 75.

55 *La Vita* 1983, 159; and see Martin 1983, 98.

56 Thibaudet 1926, "Le Démon de l'analogie," 59–64; "Le Symbole," 65–68.

57 This comment, dated Rome, May 1960, is published in *Écrits* 1987, 44, and *Témoignages* 1963, 22–23.

58 20 November 1914, *Archivi* 1, 349–50. Translation used here from Caroline Tisdall and Angelo Bozzolla, *Futurism* (New York: Oxford University Press, 1978), 177.

59 *La Vita* 1983, 175.

60 *La Vita* 1983, 175–76.

61 For more on this exhibition see Kenneth Silver, *Esprit de Corps: The Art of the Parisian Avant-Garde and the First World War* (Princeton University Press, 1989), 74–78, 85–86.

62 *Mercure de France* 1916. Here quoted from *Écrits* 1987, 61–70.

63 *Mercure de France* 1916, in *Écrits* 1987, 63.

64 "The Exhibitors to the Public," in Apollonio 1973, 47, 50.

65 *Mercure de France* 1916, in *Écrits* 1987, 67. In *La Vita* 1983, 186, Severini says that he never really subscribed to the idea of Boccioni's separation of relative dynamism and absolute dynamism.

66 *Mercure de France* 1916, in *Écrits* 1987, 65–69. Severini again takes up the idea of analogies, graphically describing the *Danseuse = Mer,* but insisting that an analogy is not a generalization based on abstraction, but an intensification of what is realistic and specific.

67 *Mercure de France,* 1 February 1916, in *Écrits* 1987, 69–70; and see *La Vita* 1983, 176.

68 See below, Preface to the Exhibition in New York, 1917. Pacini dates this essay 1917. Since all the paintings for the exhibition were shipped to New York in October 1916, it is highly possible that the Preface was also completed in 1916.

69 *La Vita* 1983, 181.

70 *La Vita* 1983, 191.

71 *Critica d'Arte* 1970, 51.

72 *Critica d'Arte* 1970, 51.

73 *Critica d'Arte* 1970, 50.

74 *La Vita* 1983, 208.

Catalogue of the Exhibition

Notes to the Catalogue

Because of the detailed information available in Daniela Fonti, *Gino Severini: Catalogo ragionato,* 1988, the catalogue entries for this exhibition will not include extensive information on provenance and bibliography. For easy reference the works in this exhibition are arranged in Fonti's order and will be identified with Fonti numbers.

The catalogue entries will stress the early exhibition history of each work. A code has been established to indicate where and when each work was exhibited in the Futurist years between 1912 and 1917. For instance: P12 for the Bernheim-Jeune exhibition in Paris, 1912. Individual works in an exhibition are indicated by the code followed by a hyphen and the number used in the original catalogue. If a work were number 3 in the P12 catalogue the code would read P12-3. For further details, see List of Exhibitions below.

The multiple titles in the catalogue entries also require explanation. The English title assigned to each entry is derived from Severini's inscriptions, contemporary documents, or common use. Severini's early exhibitions took place in several countries, and their catalogues were in different languages. Therefore the catalogue entries also include any other English, Italian, or French titles inscribed on the work or used in an exhibition followed by the code to indicate when and where the title was used. Care has been taken to record accurately the original spelling and punctuation in all titles.

Memories of a Voyage (cat. 1),
1910–11, oil on canvas,
81.2 x 99.8 cm (detail).
Private collection.

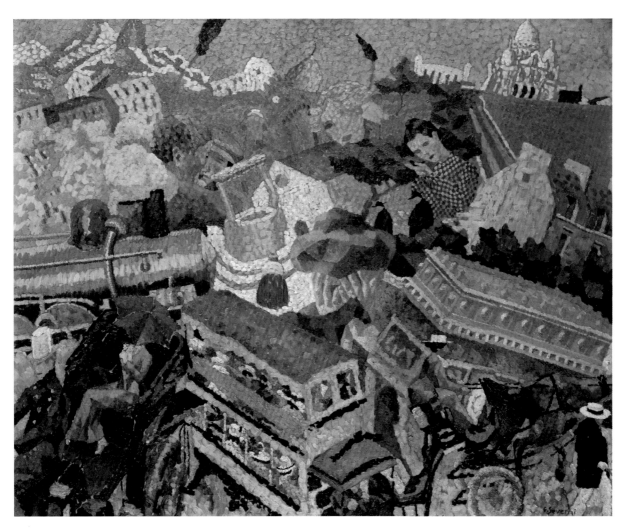

cat. 1

1 *Memories of a Voyage*

1910–11, oil on canvas, 81.2 x 99.8 cm F90

This painting was shown in the first major Futurist exhibition at the Bernheim-Jeune gallery, Paris, in February 1912, and then travelled with the exhibition to several other cities. In the catalogue for BR12, it was noted as "Vendu à Mme de C. M." The catalogue of a Futurist exhibition in Rotterdam a year later (RT13) listed all the works in the original exhibition as "vendus," and this work as "acheté par M. Bernheim-Jeune." The painting was not included among the five works exhibited in Copenhagen in 1912. However, according to Fonti, the work was still noted as the property of Bernheim-Jeune in Severini's 1925 list of his Futurist works.

Severini assigned this work different dates on different occasions. In *L'Arte* in 1931, he dated the painting 1910. In a questionnaire sent to him by Marianne Martin in 1958, he dated it 1909, but in his *Plastic Analogies of Dynamism,* written in 1913 but not published until 1957, he dated it 1911. Scholars have tried to narrow the dating by stylistic comparisons with other early works and by analysis of *Futurist Painting: Technical Manifesto* of 1910. Considering all these factors we suggest the inclusive dates, 1910–11, that is, between publication of the *Technical Manifesto* in April 1910 and the Futurists' visit to Paris in the autumn of 1911.

The authenticity of this recently rediscovered painting is confirmed by comparison with the original color illustration in *The Sketch*, London, 20 March 1912 (fig. 22). Nevertheless some confusion has arisen from the fact that black and white illustrations in seminal books such as those by Pierre Courthion, Jacques Maritain, both of 1930, Martin 1968, and Fonti 1988, were all taken from a faulty photograph, probably provided to early authors by Severini himself. This photograph shows an irregular white form in the sky at the upper right-hand corner and a more regular oval form in the middle of the sky. Fonti ("Souvenirs de Voyage di Gino Severini: Un ricordo dimenticato," *Art e Dossier,* March 1994, 10–13) suggests that the photograph might have been made from a defective copy of *The Sketch.* Instead, the real source was a scrapbook image. Jeanne Severini apparently cut and pasted reproductions of *Memories of a Voyage* from the color pages of *The Sketch.* The front and back sides of a single scrapbook page are illustrated here; note that the edges of the paper match in reverse. The two marks in the sky are clearly visible, and two similar marks (in reverse) appear on the back of the scrapbook page. It seems that these marks were caused by the seepage of the glue used to attach the clipping to the page. This particular image with the marks of the glue was then copied in black and white and circulated.

Travelling Impressions L12; *Ricordi di viaggio; Souvenirs de voyage* P12. Signed lower right: *G. Severini.* Exhibitions: P12-29, L12-28, B12-29, BR12-29. Private collection.

"States of Mind" by Natural-Colour Photography: Paintings by the Italian Futurists Reproduced in the Newest Way.

NATURAL-COLOUR PHOTOGRAPHS SPECIALLY TAKEN FOR "THE SKETCH," AND PUBLISHED BY COURTESY OF THE ARTISTS AND OF THE SACKVILLE GALLERY.

1. "LIGHT EFFECTS UPON THE FACE OF WOMAN": "A MODERN IDOL" BY UMBERTO BOCCIONI. 4. "LIGHT AND SHADOW, CUT UP THE BUSTLE OF THE BOULEVARD INTO GEOMETRICAL SHAPES": "THE BOULEVARD", BY GINO SEVERINI.

2. "SENSATION OF THE BUSTLE AND HUBBUB ... AT THE FAMOUS NIGHT-TAVERN AT MONTMARTRE": "THE PAN-PAN DANCE AT THE MONICO" BY GINO SEVERINI. 5. "THE SCENE IS ROUND THE TABLE OF A RESTAURANT ... THE PRINCIPLE OF THE RÖNTGEN RAYS IS APPLIED TO THE PICTURE": "LAUGHTER" BY UMBERTO BOCCIONI.

3. "THE SENSATION OF THE INSIDE AND OUTSIDE ... EXPERIENCED ON APPROACHING A WINDOW": "SIMULTANEOUS VISIONS" BY UMBERTO BOCCIONI. 6. "SENSATIONS OF THE ARTIST'S JOURNEY FROM HIS NATIVE HOUSE TO PARIS": "TRAVELLING IMPRESSIONS" BY GINO SEVERINI.

We here reproduce, by means of natural-colour photography, some typical examples of the works by Italian Futurists which are on exhibition at the Sackville Gallery, in Sackville Street, Piccadilly, and are arousing a very great deal of interest. As we have said in "The Sketch" before, when reproducing some of the paintings in black and white, the Futurists aim at painting "states of mind," desire "to compel the spectator to live in the picture, which must be the synthesis of what we see and what we remember." "You must," they say, "render the invisible which stirs and lives beyond intervening obstacles, what we have on the right, on the left, and behind us, and not merely the small square of life artificially compressed, as it were, by the wings of a stage."

fig. 22a

The Sketch
20 marzo 1912
London W.C.
172 Strand

3. "THE SENSATION OF THE INSIDE AND OUTSIDE ... EXPERIENCED ON APPROACHING A WINDOW": "SIMULTANEOUS VISIONS" BY UMBERTO BOCCIONI. 6. "SENSATIONS OF THE ARTIST'S JOURNEY FROM HIS NATIVE HOUSE TO PARIS": "TRAVELLING IMPRESSIONS" BY GINO SEVERINI. ... of what we see and what we remember." "You must," they say, "render the invisible ... as we have on the right, on the left, and behind us, and not merely the small square of ... a stage."

fig. 22b

fig. 22c

2 *The Black Cat*

1911, oil on canvas, 54 x 72.5 cm F93

fig. 22
(a) *Memories of a Voyage* (cat. 1)
reproduced in full color in *The Sketch*, London, 20 March 1912.
(b) The image cut out and glued to a scrapbook page showing marks in the sky that are absent in the painting.
(c) The reverse of the scrapbook page showing that the marks were made by seepage of the glue used to attach the picture. Private collection.

One of the eight paintings by Severini exhibited at the first major Futurist exhibition at the Bernheim-Jeune gallery in Paris in 1912. When the exhibition went to a second venue in London, brief remarks in English were added to the titles in the catalogue, probably by Meyer-See, the director of the Sackville Gallery where the exhibition took place. In the case of *The Black Cat*, the title in the exhibition catalogue is followed by the words, "The sense of morbid oppression after reading Edgar Poe's tale." The story tells of a drunkard who blinds a pet cat in one eye. Fonti notes that at the right side of the painting a reflection of the cat lacks half its face, and therefore one eye. She also sees the lone glass on the table as a suggestion of alcoholism.

However, other possible readings of this picture connect it with the Paris nightlife that Severini enjoyed. *The Black Cat* is related in color and style to Severini's *The Obsessive Dancer* (fig. 23; F94) of 1911 which depicts a dancer holding a black cat. Martin (1968, 100, note 2) suggests that Severini may have had in mind Toulouse-Lautrec's images of May Belfort who carried a black cat on stage whenever she performed. When Severini was asked by Martin in 1958 whether the dancer was a specific person, he said she was not. "C'était ce qu'on appelle une 'girl'" — in other words, a type of café inhabitant.

fig. 23
Gino Severini, *The Obsessive Dancer*, 1911, oil on canvas, 73.5 x 54 cm. Private collection. Showing a dancer holding a black cat similar to the one in *The Black Cat* (cat. 2).

cat. 2

The Black Cat was also the name of the famous "cabaret artistique," Le Chat Noir, which opened in 1881 and quickly became a tourist attraction. It ran a shadow theater and produced a weekly newspaper with articles and poems on artists and writers, and many images of frisky black cats. After the café closed in 1897, some of the illustrations from the journal, *Le Chat Noir,* were reorganized and published by Flammarion, thus remaining in the public eye.

The Black Cat L12; *Il gatto nero; Le Chat noir* P12. Signed lower right: *G. Severini.* Inscribed verso: *Le Chat noir. G. Severini.* Exhibitions: P12-30, L12-29, B12-30, BR12-30. National Gallery of Canada, Ottawa.

3 *The Milliner*

1910–11, oil on canvas, 64.4 x 48 cm F95

One of the eight paintings by Severini shown at the first Futurist exhibition in the Bernheim-Jeune gallery in Paris in 1912, and one of two illustrated in the catalogue (the other was *The Obsessive Dancer*). This painting of a young milliner takes up a subject dear to the Impressionists, but endows it with vibrant Futurist light and motion. While it was on display at the Sackville Gallery, London, in 1912, *The Milliner* was reproduced in the *Illustrated London News* (Pontus Hulten, *Futurismo & Futurismi,* exh. cat., Palazzo Grassi, Venice, Milani Fabbri, 1986, 572), under the title "The Gay Milliners." Where forms were fractured and repeated, as in this image, it was not unusual for critics to think that a work represented two or more figures, rather than the inherent motion and energy of one figure. The painting was also reproduced on postcards in London and Berlin, the exhibition's next venue. The exhibition catalogue says "the electric light divides the scene into defined zones. A study of simultaneous penetration." While the presence of mirror images suggests the interior of a shop, the strong shafts of electric light seem more appropriate to a nightspot where a young working girl might spend an evening. Severini said in his autobiography (*La Vita* 1983, 60–63) that this was one of the works he painted in Civray in 1910 while visiting the Declide family. Since he also spent time with them during the following summer, it could have been painted there in 1911. Severini said that the works he painted at Civray were the first in which he defined his "divisionism of form."

The Milliner L12; *La Modiste* P12. Exhibitions: P12-33, L12-32, B12-33, BR12-33. Private collection, New York.

cat. 3

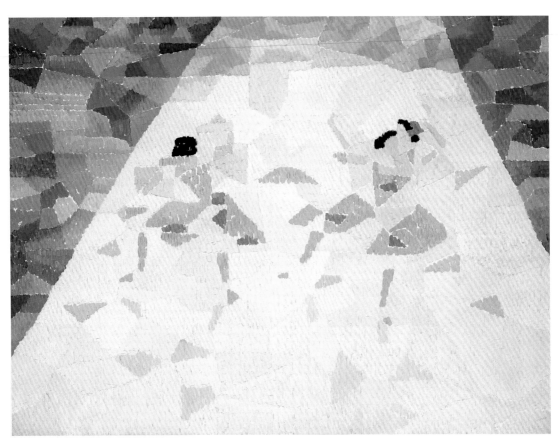

cat. 4

4 *Yellow Dancers*

1911, oil on canvas, 45.7 x 61 cm F96

Yellow Dancers was one of eight paintings by Severini exhibited in the first major
Futurist exhibition at the Bernheim-Jeune gallery in Paris in 1912. When the
exhibition travelled to the Sackville Gallery in London, the painting was purchased
by Meyer-See, the director of the gallery. The catalogue for the London exhibition
says of it, "*Yellow Dancers*. Forms are destroyed by electric light and movement."
Seldom exhibited and rarely reproduced in color, the impact of this work in Paris
and London has been forgotten.

In 1910 and 1911 Severini made several drawings of two women dancing (F96A,
F97B, and F97G) that served as studies for *The Dance of the Pan Pan at the Monico*
(fig. 10; F97) and *Yellow Dancers*. These pairs of dancers may relate to two models
described by Severini in a letter to Marinetti as protagonists for the *Pan Pan:*
Nenette who was shapely and wholesome, and the passive Liette who was small
and nervous (Marinetti Papers, Letter 5, 18 January 1911). In *Yellow Dancers* Severini
has isolated a pair of dancers from the agitated crowd of patrons at the Monico
and placed them like emblems in a large triangle. At one moment the converging
diagonals suggest a simplified perspectival space for their frenetic movements. At
another, the figures appear to be immersed in an enormous shaft of electric light
coming toward the viewer and creating a dense but luminous atmosphere in a
contained area.

Yellow Dancers L12; *Danseuses jaunes* P12. Signed verso, on support upper right.
Exhibitions: P12-32, L12-31, B12-32, BR12-32. Fogg Art Museum, Harvard University
Art Museums, Gift of Mr. and Mrs. Joseph H. Hazen, 1961.

5 *Self-Portrait with Straw Boater*

1912, black chalk on ivory laid paper, 54.7 x 44.8 cm F103A

This masterly drawing is of the same dimensions and composition as the self-
portrait in oil called *Il mio ritmo* (F103). The painting shows the artist's new interest
in a Cubist fragmentation of naturalistic color and form. The drawing goes much
further in describing the facial features in a vivid alternation of small planes, and in
creating a nervous animation and excitement that suggests the artist's own internal
vitality or rhythm. In spirit, it too deserves the title *My Own Rhythm*, but for

cat. 5

purposes of identification its accepted title, *Self-Portrait with Straw Boater,* is used here. (For its relationship to other portraits of the period, see Taylor 1967.)

Autoritratto col "canotier." Related to the oil painting (F103), which was exhibited in R13, RT13, F13, N14. The Art Institute of Chicago, Margaret Day Blake Collection, 1965. Fort Worth only.

6 *Dynamic Hieroglyphic of the Bal Tabarin*

1912, oil on canvas with sequins, 161.6 x 156.2 cm F107

In early February 1913 Severini wrote to Marinetti about the pictures he was sending to Rome for exhibition (Marinetti Papers, Letter 14), "No 1 is the Bal Tabarin. With two figures of dancers and a few decorative elements I wanted to express plastically and rhythmically the absolute feeling of the environment." Immediately following this statement, and added in another hand, are the words, "Geroglifico dinamico del 'Tabarin,'" perhaps the first suggestion of the more provocative title used in Rome and Rotterdam. In calling the painting a dynamic hieroglyphic, an active but undecipherable sign, Severini proposed transforming sensory experience into an intentionally inscrutable verbal-visual language. "In the painting of the Tabarin, always obsessed by the painting of sounds, I was stirred to write: Micheton, Intermede, mome, etc., words heard in the surroundings which I considered to be of great emotional importance" (*Archivi* 1, 292). The introduction of reflecting sequins played against the contrasting hues and fractured forms of the moving figures ensures a constantly active picture surface and challenges the very function of painting itself by confusing illusion and reality. While light breaks down the perception of solid forms, the sparkling sequins take part in the luminous atmosphere, but are at the same time real things, foreign to the painted surface, and capable of reflecting and refracting light into the viewer's own space. For the social atmosphere of the Bal Tabarin, see *La Vita* 1983, 59–60.

The Bal Tabarin; Geroglifico dinamico del "Tabarin" R13; *Le Bal Tabarin.* Inscribed verso: *G. Severini, 1912, Le Bal Tabarin.* Exhibitions: R13-1, RT13-30 (illus.). Der Sturm, *Erster Deutscher Herbstsalon,* Berlin, 1913 (illustrated but not included in the exhibition). The Museum of Modern Art, New York, Acquired through the Lillie P. Bliss Bequest, 1949.

cat. 6

cat. 7

7 *Festival at Montmartre*

1913, oil on canvas, 88.9 x 116.2 cm F 111

The carousel in *Festival at Montmartre* is described in the catalogue for the exhibition at the Marlborough Gallery in London as "lighted by electric lamps and gyrating in the darkness of the Boulevard." There could be no more perfect answer to the Futurists' own challenge "to put the spectator in the centre of the picture." Here the excitement of the over-bright shafts of modern electric light and the insistent music of the calliope capture the passing sensations of a festival moment — intensified by the choice of a point of view slightly above the swirling surfaces of the carousel. The introduction to the catalogue for the exhibition reminds the reader of the Futurists' promise that they would "no longer [offer]...a fixed *moment* in universal dynamism...[but] *dynamic sensation* itself" (Apollonio 1973, 27). This thrusting circular motion was later to become the essential subject of Severini's studies of the spherical expansion of light.

The Fête at Montmartre L13; *La Festa a Montmartre* N14; *Fête à Montmartre: Carousel.* Signed lower right: *G. Severini, 1913.* Exhibitions: L13-6, B13-6, N14-6. Richard S. Zeisler Collection, New York.

8 *Still Life with Box of Matches*

1912, charcoal, white chalk, red and blue pastel, and collage on paper, 49.7 x 62.2 cm F 142

When the artist's wife Jeanne Severini was over ninety she still insisted that Severini, not Picasso, had invented collage. She argued that the addition of sequins to many paintings of 1912 should insure his primacy, but saw his *Still Life with Box of Matches* as the final proof. Actually it is possible to place it quite early in the sequence of events, although not before Cubist collage experiments. *Still Life* was included in Severini's exhibition in the Marlborough Gallery in London in April 1913. It was illustrated in *The Sketch*, 16 April 1913 (fig. 24). Therefore it is reasonable to conclude that it was completed some time in 1912, or very early in 1913.

Severini credits Apollinaire for having drawn his attention to some Italian primitive painters who had put real elements in their pictures (for example, a Saint Peter with a real key; others with precious stones and pearls). He notes that their presence augments the life of the pictures. This inspired him to introduce collage elements in his own works and thus heighten their expressive intensity (*La Vita* 1983, 131–32).

fig. 24
Still Life with Box of Matches
(cat. 8) reproduced in *The Sketch*,
London, 16 April 1913. Showing
the condition of the work in 1913.

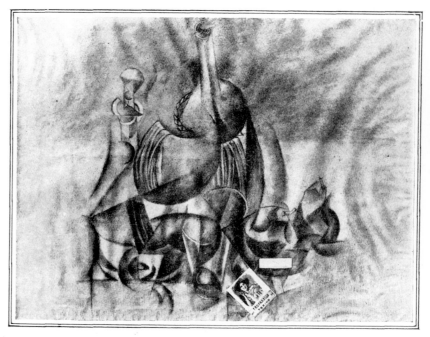

SHOWING A MATCH-BOX PICTURE STUCK ON: "STILL LIFE," BY SEVERINI—PUZZLE,
DISENTANGLE THE OBJECTS.

Signor Gino Severini, the Futurist, whose "Café Monico," which caused such a sensation in London last spring, has since been acquired by a public gallery in Germany, has a number of "plastic perceptions" on show at the Marlborough Gallery. In certain cases, he relies not only on paint, but on such alien objects as sequins stuck upon the canvas. He holds, amongst other opinions, that the time has gone by when the painter painted as the bird sings—that is to say, naturally, without thought.

This work is singular in its isolated attachment of two parts of a matchbox, and in its delicate use of color (now almost invisible) in an otherwise rich charcoal drawing. It has been suggested that the attachment of the collage elements may have taken place later than the drawing. This is not the case. A close examination of the edges of the matchbox cardboard shows that the pasting and drawing were accomplished at the same time. There is also evidence that the paper has been flattened more than once. The illustration in *The Sketch* shows a disturbing pattern of wrinkles only a matter of months after its completion. Wrinkles falling in a different pattern are visible in a later reproduction in Fonti (1988, 148). Now appropriately conserved, *Still Life* is still a witty and vivid drawing and a worthy contender in Severini's dialogue with Cubism.

Still-Life L13; *Natura morta* N14; *Collage à la boîte d'allumettes.* Signed and dated lower right: *G. Severini, 1912.* Exhibitions: L13-25, N14-30. The Art Institute of Chicago, Restricted gift of Curt Valentin and Mrs. Henry C. Woods, Bequest of Joseph Winterbotham, 1974. Fort Worth only.

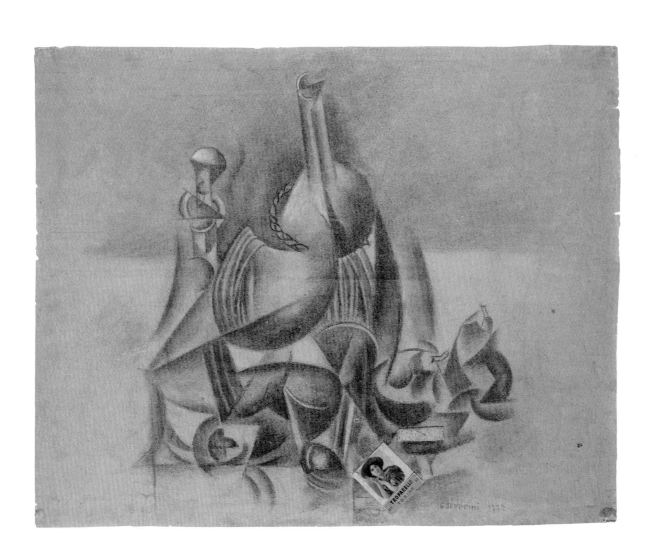

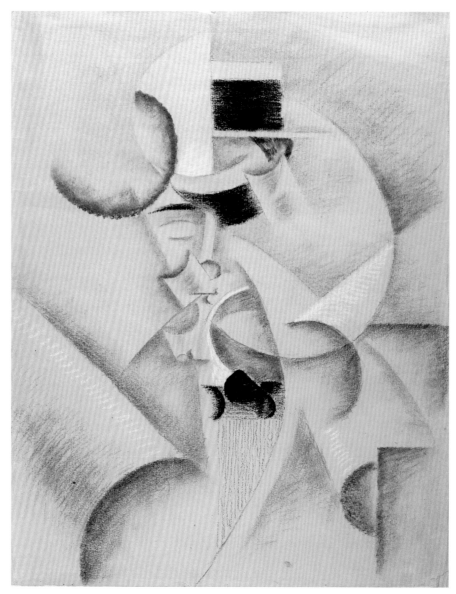

cat. 9

9 *Self-Portrait*

1913, charcoal and blue chalk on paper, 65.7 x 52.1 cm F145

In this elegant drawing Severini portrays himself in his summer straw hat and a stylish blue-and-white striped shirt (the only touch of color). The drawing is of the same motif as an oil painting (F146, 54 x 46 cm) entitled *Autoportrait au canotier*, now in the Kunsthaus in Zurich, but it does not appear to have been a preparatory study. It is larger than the painting, and the structure of the head and shoulders is more resolved. According to Fonti, an *Autorittrato* in charcoal, dated 1913, is on a list of his Futurist works compiled by Severini before 1925. The painting was not included in early exhibitions, but the drawing was probably the *Self-Portrait* shown in Berlin in 1913. In a letter to Walden (Paris, 5 May 1913, *Archivi* 1, 266), Severini explained that he was then making some new works to replace those sold from an earlier venue in London (L13-22) in order not to reduce the total number of works in the exhibition. On 27 May 1913 (*Archivi* 1, 269), Severini wrote again from Paris to say that he was sending "today" four new drawings for the Berlin exhibition, numbers 17, 22, 24, 25. He refers to them as his most recent works, notes that they have been fixed, and that they are signed and numbered on the back. The new number 22 is listed as *Selbstporträt* in the Berlin catalogue. See *Selections from the Hope and Abraham Melamed Collection*, exh. cat., Milwaukee Art Museum, 1983–84, 41, 43, no. 44; and see Taylor 1967, 59, and 61, note 26.

Autoritratto. Exhibition: B13-22. The Hope and Abraham Melamed Collection, Milwaukee.

10 *The Argentine Tango*

1913, china ink on paper, size unknown (original lost) F164

After the publication of *The Argentine Tango* toward the end of 1913, Marinetti sent words of praise to Severini, "We are very enthusiastic about your latest drawing for *Lacerba*" (*Archivi* 1, 293). This was in fact Severini's first drawing for the Futurist publication. Its lively diagonal thrusts and textural surfaces do much to express the colorful rhythms of the pair of dancers. The composition closely follows Severini's pastel, *Le Tango argentin, étude no. 1* (F163).

Il tango argentino. Reproduced in *Lacerba*, 15 November 1913, 257. Private collection.

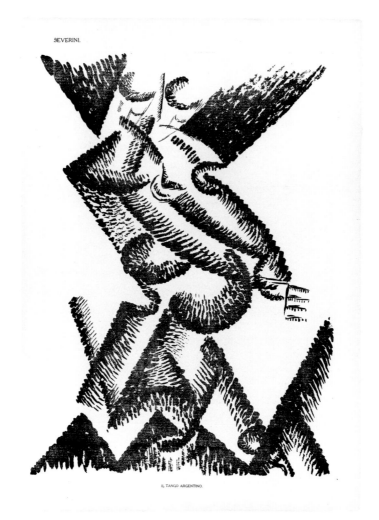

SEVERINI.

IL TANGO ARGENTINO.

cat. 10

11 *The Argentine Tango*

1913, charcoal on paper, 57.2 x 43.3 cm F166B

Toward the end of 1913 Severini had become interested in the Argentine Tango, the most talked about of popular nightclub dances. The catalogue of Severini's exhibition in Rome in 1914 listed four works entitled *Tango argentino*, three of which have been securely identified. This forceful charcoal drawing can be identified as the fourth on the basis of information in a letter from Severini to Soffici (*Archivi* 1, 304 – 05). Severini said that he was sending Soffici two pastels he had just finished, *Le Tango argentin, étude no. 1* and *Le Tango argentin, étude no. 2* (F163, F166). These two works represent two different formulations of the motif indicated by the inscriptions: "study number 1" and "study number 2." Severini also said in the letter that he was working on an oil painting for the exhibition in Rome. Indeed, an oil painting (F167) following the motif of study number 2 was shown in Rome. A fourth work was listed in the Rome catalogue as a "disegno," a word Severini often used for his large charcoal drawings. This one is an elegant interpretation of motif number 2, and it is inscribed on the reverse "disegno no. 2." We can therefore assume that the charcoal drawing in this exhibition was in fact the work exhibited in Rome in 1914.

The tango, although enormously popular in the prewar years, was regarded by many as scandalous, or at least naughty, and even the Vatican mounted a campaign

fig. 25

The Sketch, London, which informed the world of art and leisure, starred the latest dance team, "knee to knee," on the front page of the 15 October 1913 issue.

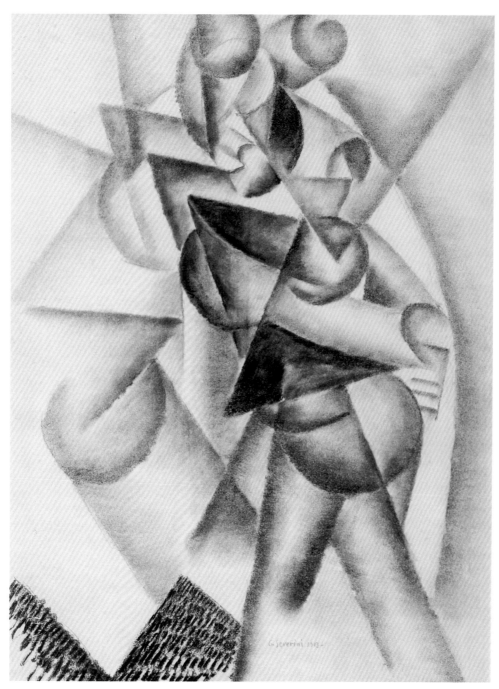

cat. 11

against it. Nevertheless descriptions of the dance, diagrams of foot patterns, and popular illustrations of performers could be found in periodicals in Europe and the United States (fig. 25).

Tango argentino (*Disegno*) R14. Signed lower center: *G. Severini, 1913*. Inscribed verso, upper half: *Il Tango Argentino/disegno no. 2/Gino Severini*. Exhibition: R14-8. Private collection.

12 *Sea = Dancer*

1913 – 14, oil on canvas with sequins, 92.7 x 73.6 cm F188

In his manifesto, *The Plastic Analogies of Dynamism* (Apollonio 1973, 118 – 25), Severini describes a new painting, *Sea = Dancer,* "covered in sparkling sequins," which he identifies proudly as the first in a new phase of Futurism: the painting and sculpture of plastic analogies (see above, pp. 39 – 41). *Sea = Dancer* must have been completed before 7 January 1914 when Severini wrote to inform Marinetti that his manifesto had been rewritten and now included a precise definition of analogies (Marinetti Papers, Letter 32). Severini saw the use of sequins as a major step forward in modern representation, comparing it to Picasso's use of collage elements in his work. Although it is not possible to identify with certainty where and when *Sea = Dancer* was first exhibited, the motif of the painting was fully developed in a preparatory drawing which appeared in *The Sketch* on 29 April 1914 to illustrate an article about Severini's exhibition then on view in London (fig. 15).

The painting *Sea = Dancer* remained one of Severini's prize possessions. Severini sold it directly to Mr. and Mrs. Harry Lewis Winston in 1951. In 1960 the artist wrote to Mrs. Winston informing her that a beautiful book of his works was being prepared and that he absolutely had to have a good color transparency of *Sea = Dancer* for reproduction. In this correspondence Severini dates the painting 1913.

Sea = Dancer L14; *Mare = Ballerina; Danseuse au bord de la mer*. Signed lower right: *G. Severini*. Inscribed verso: "*Gino Severini/Danseuse au bord de la Mer/à Monsieur et Madame Harry Winston avec toute ma sympathie/Paris 10 Mai, 1951. G.S.*" Exhibitions: L14-48?, R14-3?, SF15-1166?. Private collection. Fort Worth only.

13 *Sea = Dancer*

1914, china ink on paper, size unknown (original lost) F190

This drawing was an important step in the development of the composition of Severini's sea = dancer motif. The treatment of the ink in small agitated marks

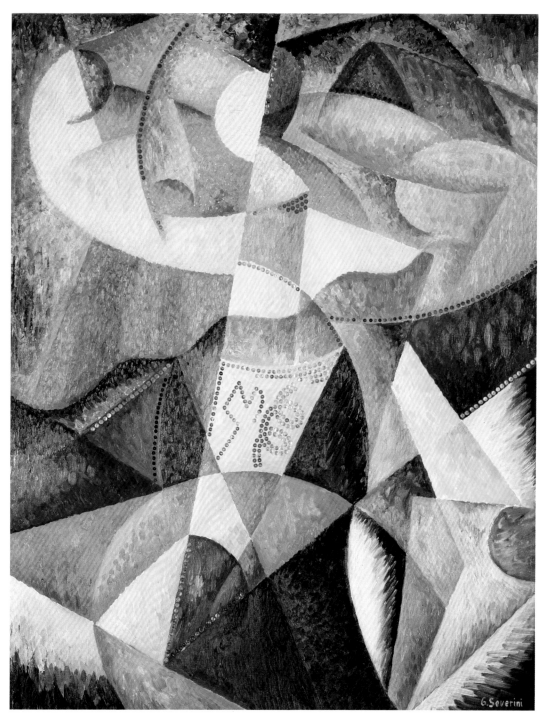

cat. 12

SEVERINI

Mare = ballerina

cat. 13

gives the drawing rich luminosity even in reproduction. The publication of Severini's serious studies in black and white in *Lacerba* was significant for the spread of Futurist ideas.

Mare = ballerina. Reproduced in *Lacerba*, 15 April 1914, 121. Private collection.

14 *Spherical Expansion of Light: Centripetal and Centrifugal*

1913–14, oil on canvas, 61.3 x 50.2 cm F199

Severini painted a group of pictures in vivid prismatic color which capture sensations aroused by objects in the real world but omit references to the objects themselves. From analogies of objects, Severini moved to analogies of color, or more precisely colored light, and to his perception that light expands (Apollonio 1973, 124). This luminous expansion could move both inward and outward, and Severini was careful to label his works accordingly. Both thrusts are felt in active opposition in *Spherical Expansion of Light: Centripetal and Centrifugal*. In these studies a Divisionist touch adds to the suggestion of elemental energy or universal dynamism. Although not shown in contemporary exhibitions, this painting was part of a series of experimental works of approximately the same size in which the artist explored the functions of light and motion. The inscription on the back of this work identifies it as "Picture No. 1A," and therefore possibly the first in the series.

Espansione sferica della luce; Expansion sphérique de la lumière: centripède et centrifuge. Signed lower right: *G. Severini.* Inscribed verso: *Gino Severini/"Expansion sphérique de la lumière"/(Centripède et Centrifuge)/Simultanéisme/Tableau No. 1A.* Munson-Williams-Proctor Institute Museum of Art, Utica, Museum Purchase.

15 *Spherical Expansion of Light: Centripetal*

1913–14, oil on canvas, 60.9 x 49.5 cm F200

Severini made several paintings of the "Spherical Expansion of Light: Centripetal and Centrifugal" to demonstrate internal oppositions in color and composition. In this instance, however, centripetal and centrifugal forces are separated into contrasting studies: *Spherical Expansion of Light: Centripetal* (F200), and *Spherical Expansion of Light: Centrifugal* (fig. 17a; F198). Severini abandons the imitation of objects in the real world in order to create "color analogies" of contrasting hues and thus to suggest *"luminous intensity, heat, musicality, optical and constructional dynamism"*

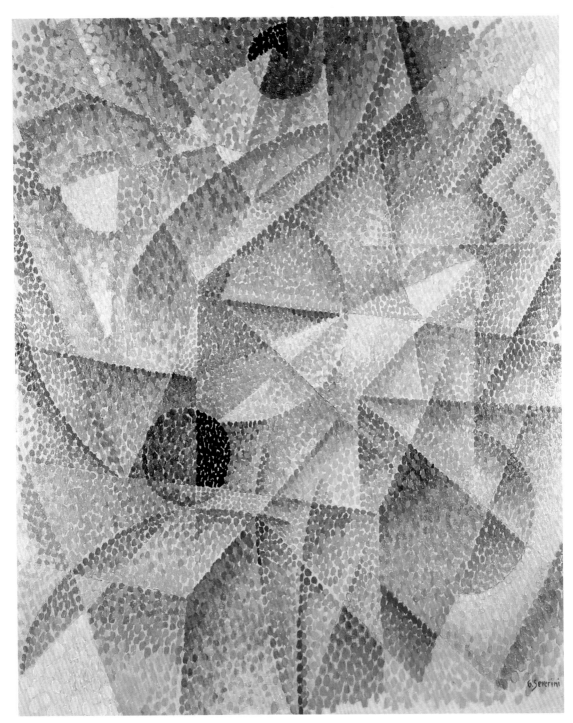

cat. 14

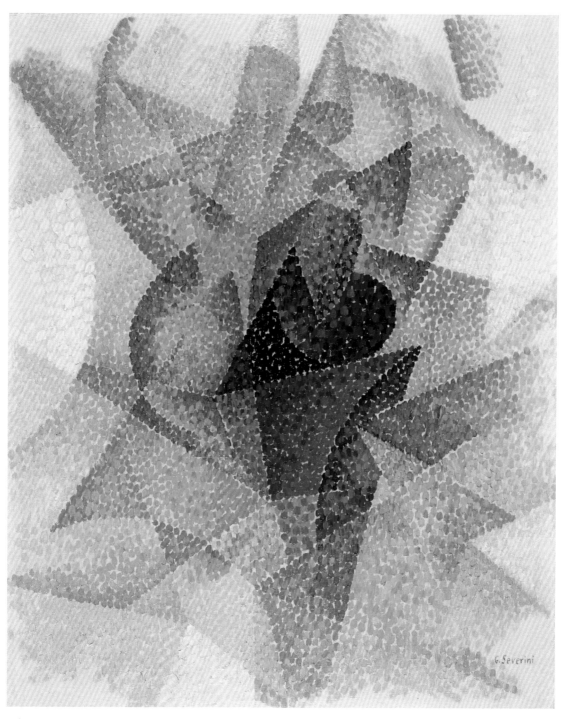

cat. 15

(Apollonio 1973, 123). In both these works the separation of hues in agitated brush strokes against a neutral unpainted ground creates strong suggestions of motion. The painting of centrifugal expansion is inscribed on the back, "Picture No. 2," and this example of centripetal expansion is similarly inscribed as "Picture No. 3." Severini was apparently very satisfied with this unique pair of opposed works since he showed them together in several important early exhibitions. The two works actually shared the same basic catalogue number (49 and 49A) when they were shown in London. When Severini sent Sprovieri a priced list of works to be exhibited in Rome, he remarked on the two small paintings as having "great beauty and transparency of color" (letter from Anzio, 6 February 1914, *Archivi* 1, 314).

Spherical Expansion of Light: Centripetal L14, SF15; *Espansione sferica della luce (Centripeta)* R14; *Expansion sphérique de la lumière, centripède.* Signed lower right: *G. Severini.* Inscribed verso: *Gino Severini/"Expansion sphérique/de la lumière"/ "Centripède"/Simultanéisme Tableau No. 3.* Exhibitions: L14-49, R14-4, SF15-1167. Private collection, U.S.A.

16 *Bear Dance = Sailboat*

1915, pastel on paper, 49.5 x 43 cm F212

This is an example of Severini's so-called apparent analogies, in which the conjunction of totally unrelated subjects intensifies the expressive power of a work of art. Lukach (1974, 77) describes the picture as a male dancer dressed in blue and red, and encircled in white sails. Shown in Paris and New York under the title, *Bear Dance = Sailboat*, this pastel was purchased by John Quinn and later listed in the catalogue of his collection as *Abstraction*, thus confusing its identity and its original connection to Severini's theory of analogy. Lukach's description omits an important aspect of this lively picture — its subject. The Bear Dance was one of the most popular "animal dances" then being performed in Paris night spots. Like the Turkey Trot, it involved awkward animal gestures (fig. 26), and it was roundly condemned as inappropriate for well brought up young ladies and gentlemen. Severini, who loved to dance, undoubtedly enjoyed depicting the racy new dances. In the Bear Dance the hands are held in a drooping position like paws, creating a curved line from arms to finger tips. This line can be seen at the upper left of *Bear Dance = Sailboat*.

Bear Dance – Sail Boats NY17; *Danse de l'ours = Barque à voile* P16, NY17. Signed lower center: *Severini.* Exhibitions: P16-30, NY17-P3, NY17-14. The Jorge and Marion Helft Collection, Buenos Aires.

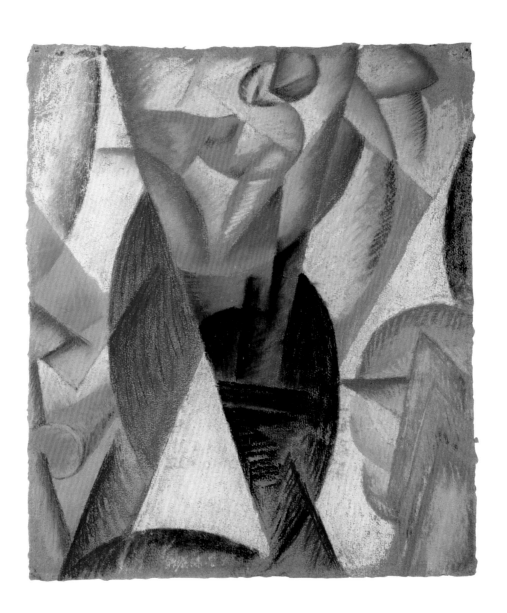

fig. 26
"The Bear Dance and the Turkey Steps as the Latest Dancing Fad," *The New York Times*, 15 January 1911.

17 *Serpentine Dance*

1914, china ink on paper, size unknown (original lost) F 216

On 2 May 1914, Severini wrote to Papini saying that he had sent him a writing-picture called *Mare = Ballerina* for publication in *Lacerba* (*Futurismo a Firenze: 1910–1920*, exh. cat., Sansone Editore, Florence, 1984, 96–97). He says in *La Vita* (1983, 156, note), "I think I entitled it *Composizione di parole e forme (Danseuse = mer)*." The editors of *Lacerba* published it as *Danza serpentina*, the name of a dance performed by Loie Fuller and a title with entirely different connotations. Severini wrote Papini again on 23 July about his drawing "which should have been called" *Danzatrice = mare* since it better described the research he was then doing. He wanted to unite literary and pictorial elements in what he intended to call "Letteratura pittorica," or "Letteratura-pittura," in an attempt to express not only the forms of the words but also their essential significance.

Carrà, who had been attempting the same kind of research, wrote to Severini from Milan on 11 July 1914 (*Archivi* 1, 341). "I saw your drawing in the last number of *Lacerba* which shows a certain point of view that has interested me very much, because I, too, have recently made a work which I call 'festa patriottica – poema pittorico,' and which has many points of contact with yours." Carrà's drawing was published in *Lacerba*, 1 August 1914.

Danza serpentina; Composizione di parole e forme (Danseuse = mer). Reproduced in *Lacerba*, 1 July 1914, 202. Private collection.

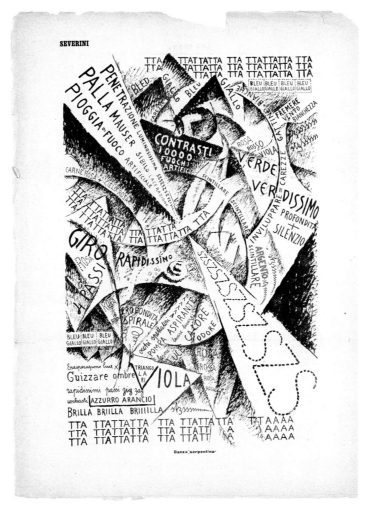

cat. 17

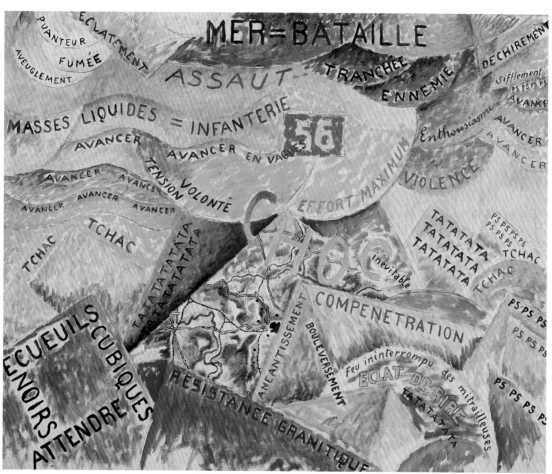

cat. 18

18 *Sea = Battle*

1914–15, oil on canvas, 48.5 x 59.6 cm F 218

With the title of this work, Severini returns to his system of plastic analogies in which disparate experiences are brought together in the same composition. His inscription on the back of the painting, however, indicates that the event is an infantry assault. The viewer is flying above the command post looking down at a centrally placed war map which seems to control the events occurring around it. Wavelike forms in the upper part of the painting suggest both the unstable surfaces of the sea and the darkened trenches. Severini's use of shockingly bright color tends to heighten the inconsistencies of war, the tension of the attack, and even to express the machine gunners' nervous outbreak of laughter.

Mer = Bataille (Mots en liberté et formes) P 16. Inscribed verso, on canvas support: *Gino Severini/"Mer = Bataille"/(assaut d'infantrie)/Mots en liberté/et formes.* Exhibition: P 16-10. Art Gallery of Ontario, Toronto, Gift of Sam and Ayala Zacks, 1970.

19 *Italian Lancers at a Gallop*

1914–15, ink on paper, 24.8 x 32.7 cm F 224

A similar drawing, now lost, was published in *La Grande Illustrazione*, Pescara (February–March 1915, 30), where it was used to illustrate a poem by Paul Fort, called "Les Cosaques." See Marinetti Papers, Letter 50 (fig. 30), for Severini's instructions as to how the drawing is to be placed on the page.

fig. 27
"Les Dragons italiens, armés de la lance, escortent des prisonniers autrichiens," *Album de la Guerre,* 15 October 1915, pl. 80. Bi-monthly publication of war photographs, 30 illustrations each issue, M. Rol, 4 rue Richer, Paris.

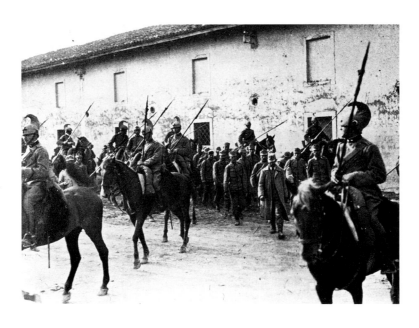

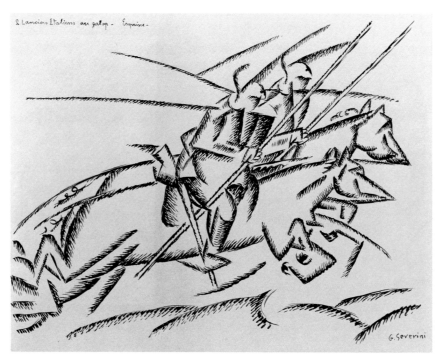

cat. 19

The motif was then repeated in a formidable oil painting (F225), and in the drawing under consideration here. The suggestions of exotic Russian dress or medieval armor, sometimes seen in these works, are contradicted by the title *Italian Lancers at a Gallop*. It seems that Severini was inspired both by Paul Fort's poem, and by seeing a group of modern Italian fighters in their distinctive uniforms. The group is similar to the advancing lancers depicted at the same time by Boccioni in his *Charge of the Lancers*, 1914 (Pinacoteca Brera, Milan), and more forcefully by a photograph of a unit of Italian dragoons escorting Austrian prisoners, reproduced in the bi-monthly war publication, *Album de la Guerre* (fig. 27).

Italian Lancers in Galop NY17; *2 Lanciers italiens au galop (croquis)* NY17. Signed lower right: *G. Severini*. Inscribed upper left: *2 Lanciers Italiens au galop (Esquisse)*. Inscribed verso: *10*. Exhibition: NY17-D10, NY17-24. The Metropolitan Museum of Art, New York, Alfred Stieglitz Collection, 1949.

20 *Amazons*

1914–15, charcoal on paper, 49.2 x 64.5 cm F226A

In contrast to Severini's bristling war pictures, this large, spare drawing of two Amazons riding sidesaddle in the Bois de Boulogne conjures up a nostalgic view of prewar urban pleasures. The use of the title *Amazons* recalls Manet's paintings of the same subject. The simplified forms of both horses and riders anticipate the classicizing style that Severini was to adopt by the end of 1916.

Amazons NY17; *Amazones (croquis)* NY17. Signed lower right: *G Severini* (cursive). Inscribed verso: *9/Amazones (croquis)/G. Severini*. Exhibition: NY17-D9, NY17-23. The Museum of Modern Art, New York, Anonymous gift.

21 *Train Crossing a Street*

1915, charcoal, conté crayon, and chalk, over graphite, on cream wove paper, 55 x 46.3 cm F227

On a typed list of works for Stieglitz's New York exhibition (fig. 32), this drawing is listed as *Regiment Crossing a Street*. "Regiment" is then crossed out in pencil and the word "Train" inserted. This does not appear to be a war subject. The smoke of the distant factory chimney and the activity of the people going in and out of the shops

cat. 20

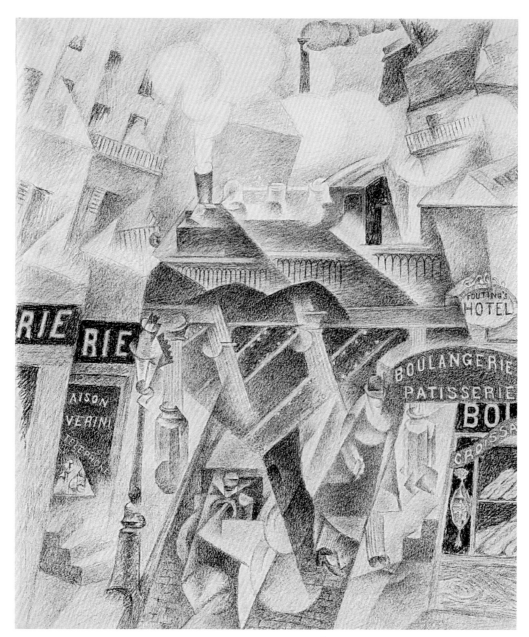

cat. 21

suggest normal urban life. Even the train seems to be slowly crossing a street in the bustling city, its progress slowed by the horizontal format of the composition, and by the dominance of the architectural fragments which claim the foreground space. As in his much earlier *Memories of a Voyage* (cat. 1), Severini has combined images from more than one place: here memories of a hotel in London and the familiar views of shops in Paris.

Train Crossing a Street NY17; *Train traversant une rue* NY17. Signed lower right: *Gino Severini* (cursive). Inscribed verso: *6 / Train traversant une rue / Gino Severini.* Exhibition: NY17-D6, NY17-20. The Art Institute of Chicago, Alfred Stieglitz Collection, 1949.

22 *Plastic Synthesis of the Idea: "War"*

1915, oil on canvas, 92 x 73 cm F232

In the Paris exhibition in 1916, *Gino Severini: First Futurist Exhibition of the Plastic Art of War,* there were three paintings that bore the same title: *Plastic Synthesis of the Idea: "War."* The picture shown here is the largest of the group and number one on the exhibition list. The other two were identified by Severini as studies, "étude 1" (F220 and number 2 on the exhibition list), and "étude 2" (F233 and number 3 on the list).

fig. 28
Photograph, 1915, showing a battalion of Italian soldiers with one of their cannons. Marinetti Papers, Yale University.

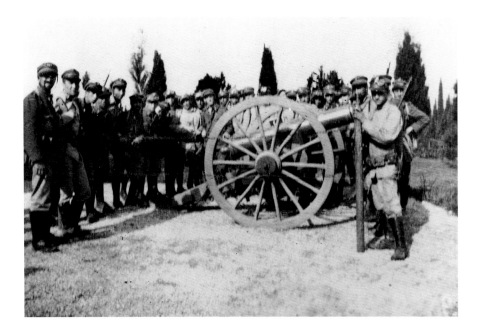

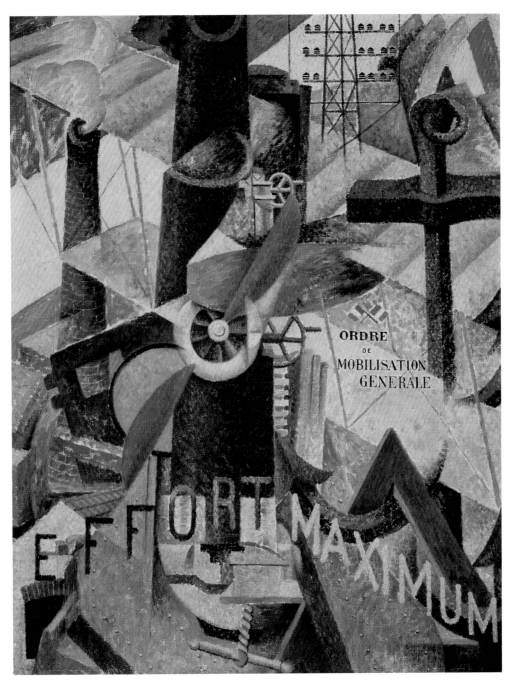

cat. 22

These paintings reflect Severini's new interest in what he called *réalisme idéiste* in which an ensemble of plastic realities such as cannon, factory, flag, can give a more convincing concept of war than a naturalistic depiction of the field of battle (fig. 28). The piecing together of various elements into a compositional whole is reminiscent of the series of small views in *Memories of a Voyage* (cat. 1). However, the elements in *The Idea: "War"* are not assembled excerpts from the real world, but "living symbols" of a new theoretical position where power and order will replace dynamism.

Synthèse plastique de l'idée: "Guerre" P16. Signed lower right: *G. Severini*. Exhibition: P16-1. Private collection, New York.

23 *The Train in the City*

1915, charcoal on paper, 49.8 x 64.8 cm F236

The 1917 exhibition of Severini's works in the Stieglitz gallery in New York included several large charcoal drawings of closely related views of the city that amply demonstrate his mastery of the medium. Here huge puffs of white smoke float apart to allow the spectator to see the sharp leftward thrust of the train speeding on open tracks. These simplified forms are played against the insistent pattern of the tiles on the foreground roofs. When this drawing was sent to New York, it was listed in Stieglitz's records as "Soldiers in the City." The word "soldiers" was then crossed out and replaced by the word "train" (fig. 32, and see cat. 21).

Severini remembers seeing military trains from the windows of the little house he lived in at Igny, and again, from the window of Jeanne's grandmother's apartment on the rue de la Tombe-Issoire that looked out on the station of Denfert-Rochereau. It was from these many views of trains that he began to develop his new theory of symbols (*La Vita* 1983, 175–76).

Train in the City NY17; *Le Train dans la ville* NY17. Signed lower right: *G. Severini*. Inscribed verso: *4/Le train dans la ville/Gino Severini*. Exhibition: NY17-D4, NY17-18. The Metropolitan Museum of Art, New York, Alfred Stieglitz Collection, 1949.

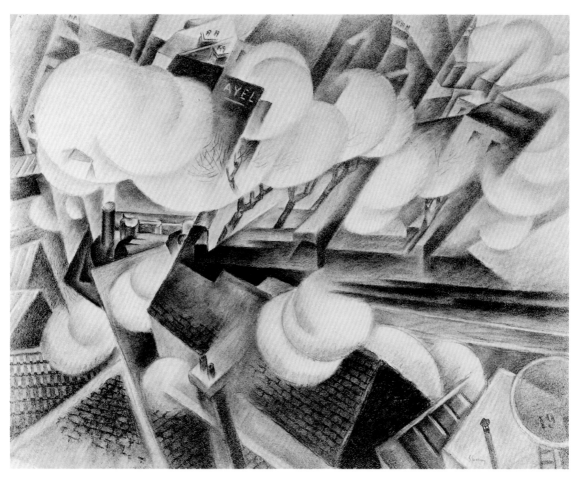

cat. 23

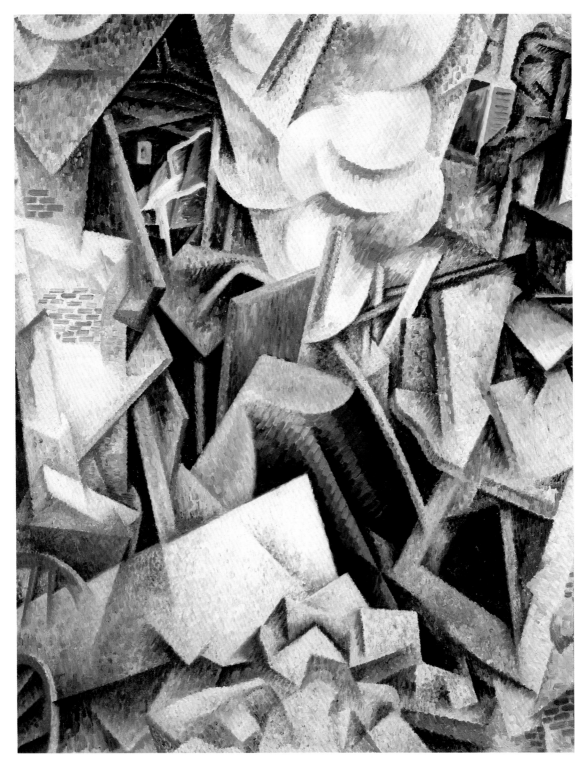

cat. 24

24 *Crash*

1915, oil on canvas, 91.9 x 73 cm F237

This monumental painting records the dynamic destruction of a city under siege.
It is the culmination of a series of city scenes exhibited in Paris in 1916 which focus
on trains speeding through an urban landscape. Instead this picture shows the
wreckage of buildings as seen from above, its tumbling forms and subtle colors
presenting a marked contrast to Severini's heraldic studies of "the idea of war" that
were included in the same exhibition. The postscript of a letter from Severini to
Sprovieri, 25 March 1920 (*Archivi* I, 385), mentions a picture made during the war
measuring 92 x 73 cm, entitled "Bombardamento," and described as being grey in
tone, but thickly painted with effective contrasts. The writers of *Archivi* gave the
location of the work as unknown, not realizing that they listed and illustrated it
elsewhere as *Il Crollo* (*Archivi* II, 340, no. 78). "Bombardment" would certainly be
an appropriate title for *Crash* but we know of no other instance of its use.

Il Crollo; Écroulement P16. Signed lower right: *Severini*. Exhibition: P16-8.
Mr. and Mrs. George S. Coumantaros.

25 *Flying over Rheims*

1915, charcoal on paper, 56.8 x 47.3 cm F238

Although Futurist writings urged the destruction of the past, the realities of the first
World War changed many youthful attitudes. In this image past and future have
been brought together. The bombarded cathedral of Rheims is shown as if seen in
a series of views from an airplane banking and turning above the damaged building.
As a young man Severini had wanted to learn to fly, and this propeller-like compo-
sition attests to his continuing fascination with the conquest of the air. It has also
been suggested that Severini's interest in the subject may have been aroused less by
the event of the bombing in September 1914 than by the war poem, "La Cathédrale
de Reims," written by his father-in-law Paul Fort.

Flying over Rheims NY17; *En volant sur Reims (étude)* P16. Inscribed verso: "*En
volant sur Reims*"/*Étude*/*G. Severini*/*2*. Exhibitions: P16-27, NY17-D2, NY17-16.
The Metropolitan Museum of Art, New York, Alfred Stieglitz Collection, 1949.

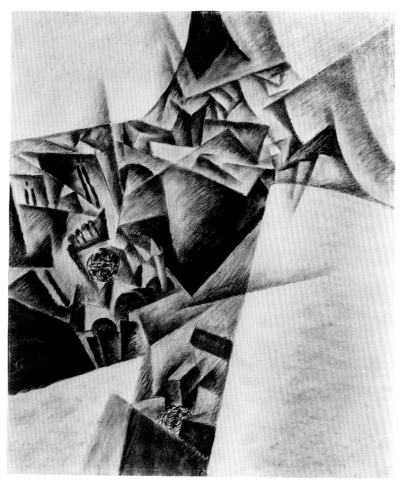

cat. 25

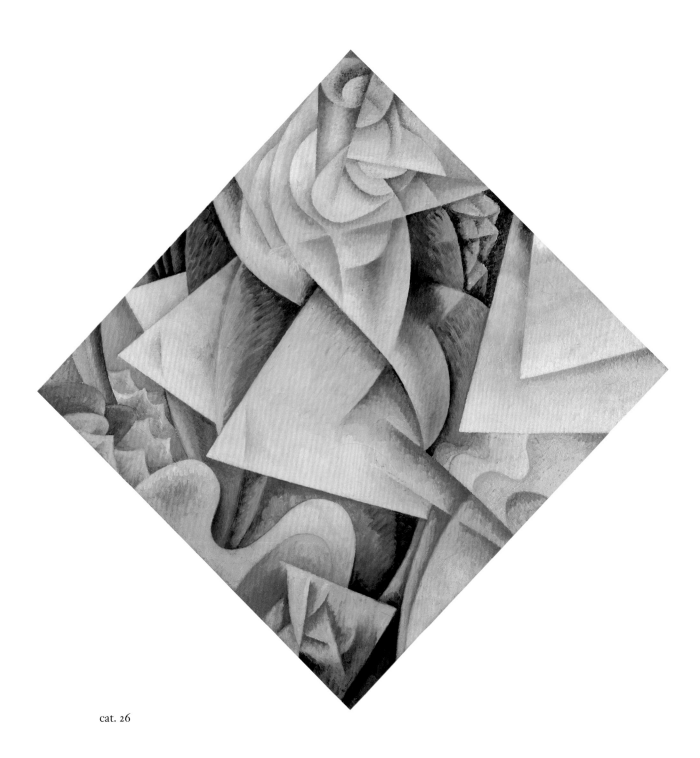

cat. 26

26 *Dancer = Helix = Sea*

1915, oil on canvas, 75.2 x 78.1 cm (diamond shape) F239

The theme of analogous sensory experience that had preoccupied Severini in 1913 and 1914 is again taken up in this painting. Here he returned to images of a dancer and of the sea, adding the idea of the spiral and confirming its centrality in the diamond shape of the canvas itself. Surely a pun is intended by Severini's title since in Italian and French "helix" and "propeller" are translated by the same words. Severini remained concerned that this painting be hung correctly. He wrote to Marianne Martin as late as 1958 with small sketches of its diamond shape requesting that she remind the Metropolitan Museum of this requirement. A photograph of Severini of about 1916 shows the painting, properly hung, on his studio wall (frontispiece).

Dancer – Helice– Ocean NY17; *Danseuse = Hélice = Mer* P16, NY17. Signed lower center: *Gino Severini*. Inscribed verso: *Gino Severini/"Danseuse-Hélice-Mer"/Paris/ 1915/7*. Exhibitions: P16-13, NY17-T7, NY17-7. The Metropolitan Museum of Art, New York, Alfred Stieglitz Collection, 1949.

27 *Still Life: Bottle + Vase + Journal + Table*

1915, charcoal and collage on paper, 56.2 x 47.3 cm F240

This imposing charcoal drawing, with its addition of two large newspaper clippings is an ostensibly simple still life with rounded objects and a newspaper on a table top. The clippings, however, were not accidentally chosen but were selected because they refer directly to the war. At the left, the front page of *La Presse* (3 September 1914) takes up the crucial issue of Italy's neutrality. The long cutting down the right side of the paper includes two illustrations of war in the trenches, the one at the right dominated by a single standing soldier. When the collage was shown in Severini's Paris exhibition, *The Plastic Art of War*, it bore the title *Soldier = Vase*, thus highlighting the intended analogy.

Still-Life NY17; *Nature Morte: Bouteille + vase + journal + table; Soldat = Vase* P16; *Nature morte* NY17. Inscribed on verso: *3/nature morte/(Bouteille + vase + journal + table)/Gino Severini*. Exhibitions: P16-28, NY17-D3, NY17-17. The Metropolitan Museum of Art, New York, Alfred Stieglitz Collection, 1949. New Haven only.

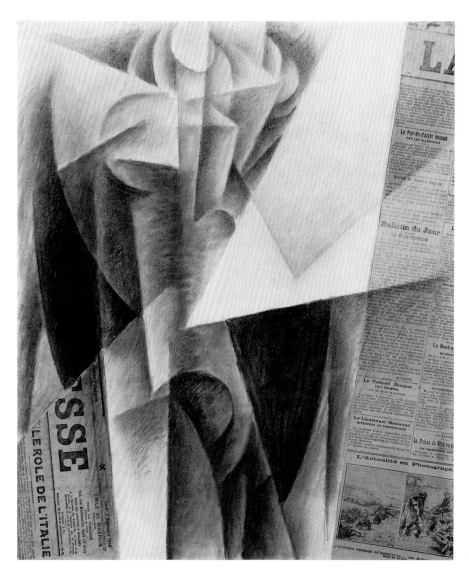

cat. 27

28 *Armored Train in Action*

1915, oil on canvas, 115.8 x 88.5 cm F 242

This painting of mechanical and natural forms seen in air view from above is the brilliant culmination of Severini's studies of war. The abstraction of the speeding forms and the vivid, almost sweet, colors of the landscape seem to create a fantasy world. However, the actual source for this picture was real indeed: a photograph of an armored train of Belgian soldiers depicted in the popular French photographic periodical called *Album de la Guerre* (fig. 29). This painting was originally listed in Stieglitz's records as *Iron-clad Troops in Action,* then corrected to read *Iron-clad Train in Action* (see fig. 32).

fig. 29
"Le Train blindé de l'armée belge,"
Album de la Guerre, 1 October
1915, pl. 72. Bi-monthly publi-
cation of war photographs, 30
illustrations each issue, M. Rol,
4 rue Richer, Paris.

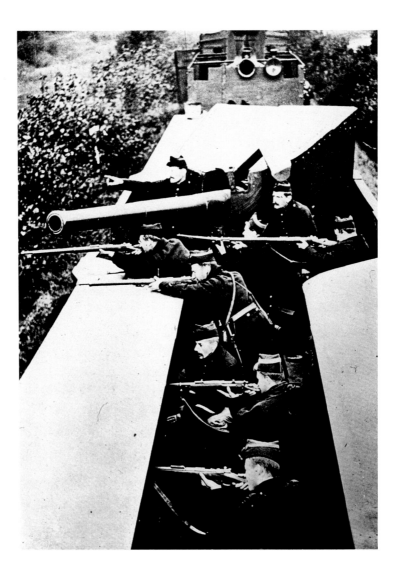

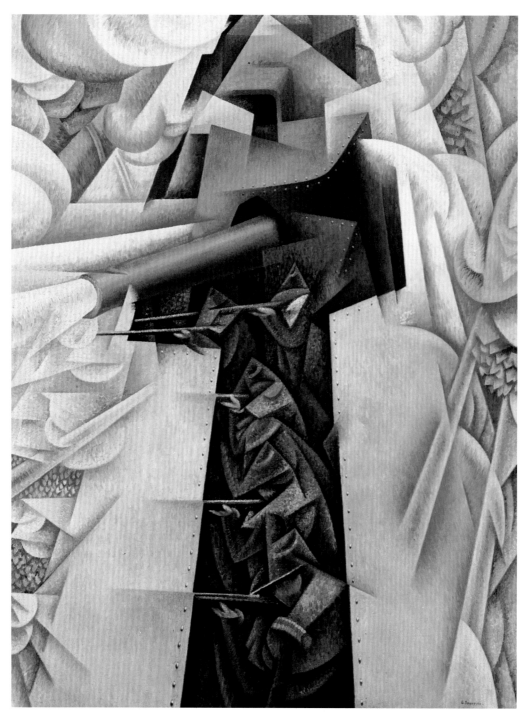

cat. 28

Iron-clad Train in Action NY17; *Train blindé en action* P16, NY17. Signed lower right: *G. Severini*. Inscribed verso (and later relined): *Gino Severini/1/"Train blindé en action"/Paris–1915*. Exhibitions: P16-4, NY17-T1, NY17-1. The Museum of Modern Art, New York, Gift of Richard S. Zeisler, 1986.

29 *The Society Violinist*

1915, charcoal on paper, 56.5 x 47.6 cm F251

In the second half of 1915, Severini returned to Futurist subjects of previous years, and particularly to depictions of dancers and their environment, some showing violinists or guitar players in the background. In this unique charcoal study of the figure of the musician alone, the solid reconstitution of the instrument and the playing hand is in marked contrast to Severini's earlier, more fragmented studies of individual sitters.

Society Violinist NY17; *Le Violoniste de société* P16, NY17. Inscribed verso: *1 "Le Violoniste de société"/Gino Severini*. Exhibitions: P16-24, NY17-D1, NY17-15. The Metropolitan Museum of Art, New York, Alfred Stieglitz Collection, 1949.

30 *Guitarist and Spanish Dancer*

1915, charcoal on paper with stumping and traces of red chalk, 63.8 x 47.5 cm F252

Inscribed "Quinn 5," this was one of the several works which John Quinn purchased from Severini's exhibition at the "291" Gallery in New York in 1917, and kept until his death in 1926. It was then purchased by Robert Allerton and donated to the Art Institute of Chicago. In this lively drawing the transparencies of form, the rippling skirt, and the lively rendering of the female dancer's hair (a collagelike insertion of texture) look back to Severini's earlier charcoal studies of dancers, but are combined here with a new sense of volume and compositional stability.

Guitarist and Spanish Dancer NY17; *Guitariste et danseuse espagnols* NY17. Signed lower right: *G Severini* (cursive). Inscribed verso: *Quinn 5*. Exhibition: NY17-D5, NY17-19. The Art Institute of Chicago, Gift of Robert Allerton, 1926.

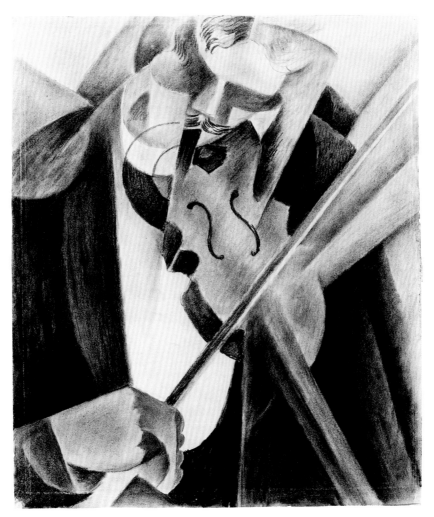

cat. 29

31 *Dancer*

1915 – 16, oil on canvas with sequins, 92 x 73 cm F255

Three paintings called "Dancer" were exhibited in the Boutet de Monvel gallery in Paris in January 1916 (F248, F254, F255). The same three paintings went on to the "291" Gallery in New York in 1917 where they were listed as "toiles" numbers 4, 5 and 6. Thanks to Severini's habit of inscribing his works when sending them to exhibitions, we can identify this *Dancer* as number 6. (Fortunately Joan Lukach, 1974, 79, recorded this information before the painting was relined.) All three of the paintings were subsequently sold to John Quinn. An annotated copy of these transactions is preserved in the Stieglitz Archive at Yale (fig. 33). It shows that *Dancer* number 5 was sold on 19 March 1917, and that *Dancer* number 4 and *Dancer* number 6 were sold together at a "special price" on 10 April.

While all three paintings are sizable works in oil, only *Dancer* number 6 is decorated with sequins. Rather than express bursting energy and repeated motion as do Severini's earlier studies of dancers, this figure is elegantly controlled in its compositional matrix, surrounded by areas of vivid color and decorated with the patterns of her marcelled hair, the rich fabric of her shawl, and the delicate but very real sparkling sequins on her swirling skirt.

Dancer NY17; *Danseuse* P16, NY17. Signed lower right: *G. Severini*. Inscribed verso: *6/Severini/Danseuse*. Exhibitions: P16-14, 15, or 16, NY17-T6, NY17-6. Private collection.

32 *Dancer*

1915 – 16, charcoal and crayon on paper, 66.4 x 48 cm F256

In addition to three oil paintings called "Dancer" in Severini's exhibition in New York in 1917, there were also two drawings with the same minimal title. They both relate strongly in pattern and composition to one of the oil paintings (cat. 31). Thanks to the inscription on the verso, this drawing can be identified as number 7 in the French list where drawings have their own numbers, or number 21 in the consecutive English list. Although the drawing lacks the animation of vivid color seen in the painting, it captures its lyrical rhythms, accenting them with the specific details of the wood graining of the floor boards and the pattern of sequins drawn on the dancer's clothing.

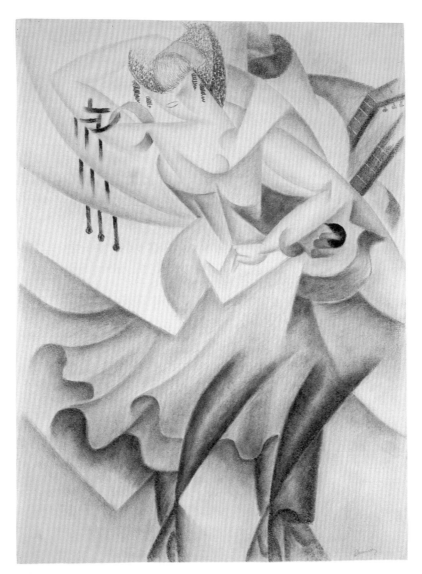

cat. 30

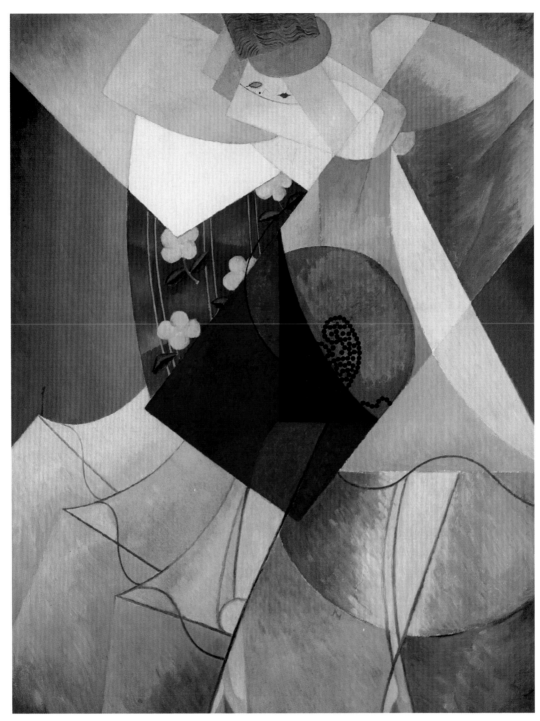

cat. 31

cat. 32

cat. 33

Dancer NY17; *Danseuse* NY17. Signed lower right: *G. Severini* (cursive). Inscribed verso: 7/*Danseuse*/*Gino Severini*. Exhibition: NY17-D7, NY17-21. The Museum of Modern Art, New York, Anonymous gift.

33 *Dancer*

1915 – 16, graphite and charcoal on wove paper, 48.5 x 33.5 cm F257

This wonderful spare drawing of a dancer with her castanets is directly related to the oil painting, *Dancer* (cat. 31), and to another drawing of the same title (cat. 32). Dancers had been one of Severini's major Futurist subjects in 1912 and 1913. Before entirely abandoning the motif, he made a new series of dancers which bridge his earlier agitated style and the static domestic subjects of 1917 on. In describing the pictures he was sending to New York, Severini said, "As you will see, these pictures belong to different periods and result from different research." (See below, Stieglitz Archive, letter from Gino Severini to Walter Pach.)

Dancer NY17; *Danseuse* NY17. Signed lower right: *G. Severini* (cursive). Inscribed verso: *8 Danseuse*/ *G. Severini*. Exhibition: NY17-D8, NY17-22. Philadelphia Museum of Art, gift of George Biddle.

34 *Woman and Child*

1916, oil on fabric, 130.7 x 97.7 cm F258

The largest of the paintings sent from Paris for the Stieglitz exhibition in New York in 1917, this calm and imposing study of Severini's wife and child represents new interests both in subject and form. He wrote in his autobiography that he had abandoned objects in motion and had been drawn almost automatically toward more solid form and to the idea of construction and composition (*La Vita* 1983, 208). A photograph of Severini standing in his studio shows the painting in an unfinished state directly behind him (frontispiece). Here it is possible to see that Severini was building up large areas of flattened color. The finished work has then been accented with lines and realistic details. One of these is a small area of caning in the depiction of the chair. Perhaps in recognition of the Cubists' struggle with reality and illusion, it is carefully painted to simulate real caning. Although undoubtedly in a dialogue with Picasso, the painting as a whole reflects the influence of other artists, such as Gris and Ozenfant, and a new fascination with the organization of forms and, on a large scale, the "reconstruction of the universe" (*Mercure de France*, 1 January 1917).

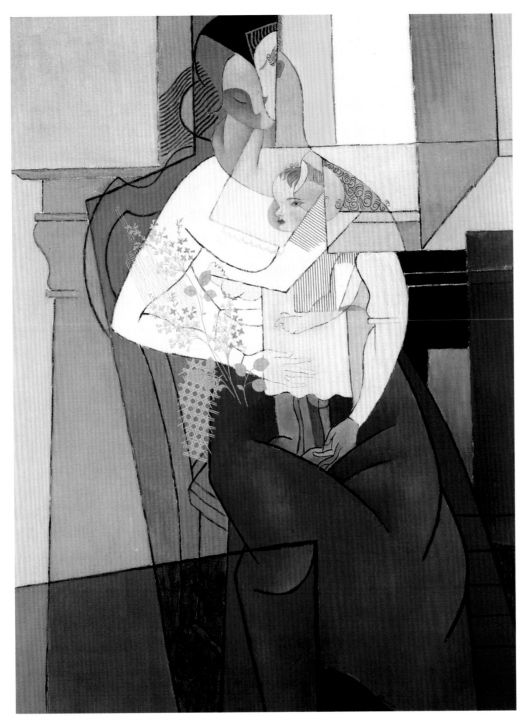

cat. 34

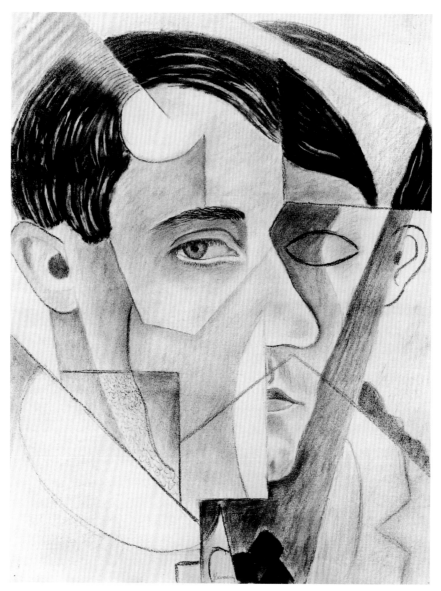

cat. 35

It was in the autumn of 1916, exactly at the time of this painting, that Gris brought the noted dealer Léonce Rosenberg to Severini's studio for the first time (*La Vita* 1983, 209).

Woman and Child NY17; *Femme et enfant* NY17. Signed lower right: *G. Severini.* Exhibition: NY17-T8, NY17-8. The Alfred Stieglitz Collection, Fisk University, Nashville.

35 *Self-Portrait*

1916, charcoal with ink wash on paper, 52.7 x 40 cm F259

This drawing can be seen in an unfinished state in the background of a photograph of Severini taken some time in 1916 (frontispiece). Martin (1968, pl. xv) erroneously dates the photograph "ca. 1917." The photograph also shows *Dancer = Helix = Sea* of 1915 (cat. 26) and *Woman and Child* of 1916 (cat. 34), also unfinished. Since both paintings were completed and shipped to New York in October 1916, the photograph cannot be dated later than that year.

Severini's image seems to confront the spectator with one realistic eye and one diagrammatic eye, as if his features were in the process of transformation into a new Cubist structure. It appears to have been based directly on a realistic charcoal drawing (F259A) of 1916, but it also relates to several earlier pastels of the artist looking over his right shoulder (F29, F48, F81). A vivid range of values, light to dark, gives this drawing an unusual sense of volume. Severini's mastery of charcoal is fully displayed in the carefully modeled forms, crisp liberated lines, and satiny dark tones.

Autoritratto. Signed lower center: *G Severini* (cursive). Dr. and Mrs. Martin L. Gecht, Chicago.

36 *Still Life: Centrifugal Expansion of Colors*

1916, oil on canvas, 66.7 x 61 cm F260

By 1916 Severini had shifted away from violent Futurist subjects and many of his new works were devoted to domestic scenes, family members, and still lifes. In this painting a compote of fruit on an extended table top offers a system of alternations between solids and transparent planes rendered in vivid spectral colors. The effects of one color area on another tend to retain a Futurist vitality at odds with the calm

disposition of simple forms. The witty inclusion of a sepia photograph of Severini's wife Jeanne (in fact carefully rendered in paint) visually demonstrates his current concerns with illusion and representation. Severini also plays on the title of this painting, shifting from *Spherical Expansion of Light,* the formula he used for his cosmic abstractions of 1913 and 1914, to *Spherical Expansion of Colors,* thus recalling his Futurist preoccupation with the explosive energy of light and replacing it with a new commitment to the artist's control of color and form.

Still-Life: Centrifugal Expansion of Colors NY17; *Nature morte (Expansion centrifuge de couleurs)* NY17. Signed lower right: *Severini.* Inscribed verso: *10/G. Severini/(nature morte).* Exhibition: NY17-T10, NY17-10. The Art Institute of Chicago, Alfred Stieglitz Collection, 1949.

37 *Woman Seated in a Park*

1916, oil on canvas, 73.8 x 60.3 cm F261

In October 1916, Severini wrote to Walter Pach enclosing the list of works to be exhibited at the "291" Gallery in New York in early 1917. Severini pointed out that the works came from different periods (actually about half from 1916 and the rest from the two preceding years), and he noted that one of his most recent canvases was *Woman Seated in a Park.* He clearly saw this painting as transitional — an effort to reconcile the spirit of Futurism to the spirit of Cubism. The painting is mentioned by name in Severini's planned, but never published "Preface to the Exhibition in New York, 1917" as one of his most recent works. Here Severini discusses the influence of Matisse in his massing bright colors, mentioning particularly the displacement of the "green of the landscape" on the seated figure.

Woman Seated in a Park NY17; *Femme assise dans un square* NY17. Signed lower right: *G. Severini.* Inscribed verso: *11/Gino Severini/"Femme assise dans un square."* Exhibition: NY17-T11, NY17-11. The Alfred Stieglitz Collection, Fisk University, Nashville.

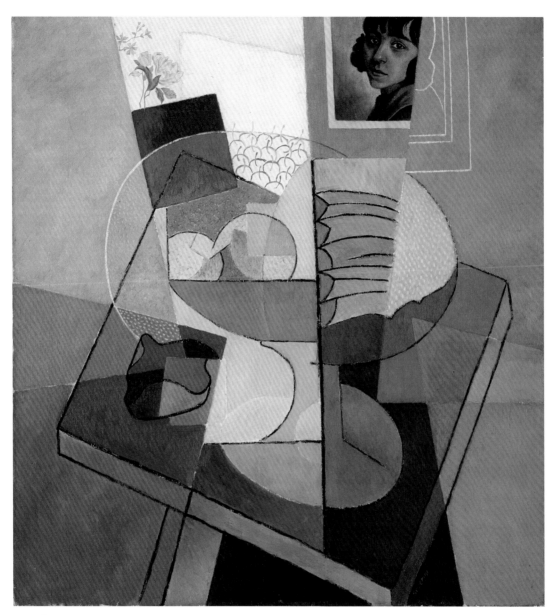

cat. 36

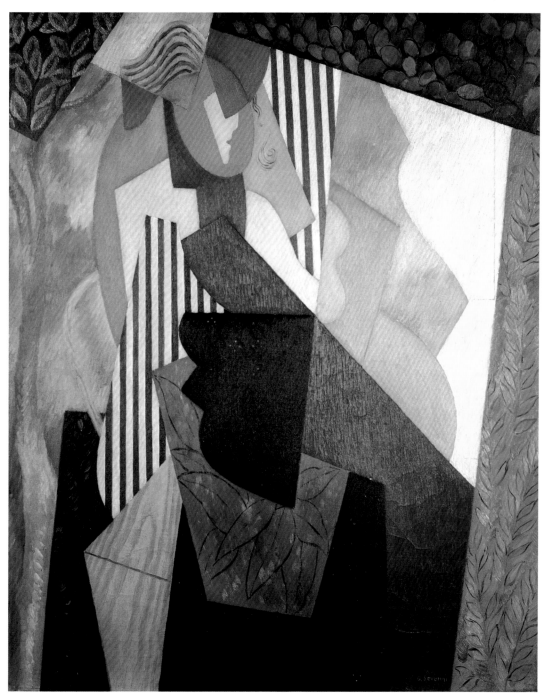

cat. 37

Selected Documents

nei "Poèmes" –

È il caso del poema che ti mando "Les cosaques" che uscirà il 15 Gennaio –

Secondo il desiderio di Casella ho fatto un piccolo disegno che dovrà essere riprodotto e stampato sopra il poema di Poema di Paul Fort, cioè : [disegno / poema] Questo disegno è un rapido schizzo per un quadro –

Bisognerebbe riprodurlo possibilmente della

Preface to the Exhibition in New York, 1917

Préface à l'Exposition de New York (1917), by Gino Severini, was found by Piero Pacini in the Severini family archive. He published it in *Critica d'Arte* (1970, 50–53) and republished it without changes in *Esposizioni* 1977. Joan Lukach discovered a central portion of the essay in English translation in "News and Comment in the World of Art," *The Sun*, New York, 11 March 1917 (Lukach 1971, 204–05). The English translation that follows has been made from Pacini's text, with the passages which appeared in *The Sun* set off in italic.

Seven or eight years ago the first Cubist and Futurist research expressed two opposing tendencies which can be defined as follows: as for the Cubists, "Reaction to Impressionism"; as for the Futurists, "Continuation of Impressionism." In sum, the first claimed Ingres, the second Delacroix.

Both tendencies were right and they are equally right today in complementing each other reciprocally toward a unique aim.

In fact the truth is somewhere between the two aesthetics. The pure form of Ingres leads fatally toward a Platonism deprived of life; the lyricism, the romanticism of Delacroix no longer belongs to our cerebral and geometric epoch. The first represents the element, *will, reason;* the second the element, *sensibility, emotion.*

As in all great epochs the work of art today must be made up of these two elements.

In the works that I exhibit, works belonging to different periods, one may discern the search for a balance between reason and sensibility. I have wanted also, while obeying the tendency toward composition which I have inherited from the old Italians, to attain a new classicism through the construction of the "picture."

Cézanne who wanted "to recreate the art of Poussin with a new vision and new sentiments," had doubtless understood the same necessity.

And so I have in an orderly and logical way made use of the elements acquired during several years of research, and I have applied them to a "subject."

fig. 30
Letter 50 (detail), Marinetti Papers, Yale University.

127

At times sensibility carries me further along than intelligence, and then reason inter-venes only in the technique of the picture.

For example, the picture "Dancer–Propeller–Sea" expresses three sensations united by their analogies. Here the cause of the sensation disappears completely; the effect alone is expressed. Thus one can on the same canvas express a single emotive reality composed of three analogous and genuine realities. This exalting of pure sensation was the continuation of impressionism to its extreme limits.

I leave to others the task of judging it and clarifying it; my task is to draw conclusions with my brush rather than with my pen…, the present considerations being more in the nature of general rather than individual principles.

If Ingres gives us a sense of discipline and will, Delacroix gives us that of move-ment and light.

The synthesis of these essential and different elements was accomplished neither in Cézanne, our venerated master, nor in Renoir — a stone wall — nor in any of the Impressionists and Neo-Impressionists whose faults, however, are a great education for us.

Research into movement and light through the separation of colors by these groups of artists, has given us the base on which to separate color from form, in order to reconstruct objects according to a new perception and, gradually, to place them according to a new sense of space.

For certainly, at the base of the research of Seurat, Cros, Signac, was the aim, possibly unconscious, to strip the object of all that is accidental and relative, and to give it its specific and absolute value.

Unfortunately none of them attained this aim and their research was developed exactly on their weak side, that is to say it is used to promote that which in the color of an object is accidental and relative.

I refer to those mediocre painters who are called Divisionists and who work in Italy and France.

Matisse was the first logically to develop this intuition of divisionism of color.

Instead of painting with little touches by opposing to each color-touch another analogous or complementary color-touch, he massed a quantity of red, for example, and then a quantity of green or of blue etc. opposing one quantity to another quantity.

In pushing this aesthetic further one can consider displacing a "local color" outside of its form, and paint, for example, the figure of a person with the green of the landscape which surrounds it (picture no. 11, *Woman Seated in a Park*).

It is this ultra-impressionist logic which led me to make a table on a stomach, a bottle on a cheek, etc., in one of my first futurist pictures: *The Dance of the Pan Pan at the Monico* (1911). The divisionism of form obeys the same logic as the divi-sionism of colors of which it is an immediate consequence.

This aesthetic, over which presides the desire for selection and synthesis which animates all artists, leads naturally toward a reconstruction of the object. This reconstruction will not be arbitrary, or imaginative, but will be suggested by the complete knowledge that we have of the object itself. The forms and lines which compose it have their directions, their synthesis, and their aversions, which determine their vitality. These are the directions, this vitality, which the painters must perceive and express.

The "means" will be provided by his "sense of space," for basically, painting, like geometric science, is nothing more than a rapport between one surface and another, between two or more sizes, and all the effort of a painter must consist in effectively establishing these rapports or contrasts which give the "continuity" of the object. It is here that the will intervenes, to find an architecture which is not accidental or fragmentary, but absolute, that is to say which expresses a synthesis of the expansive and intuitive life of the object, of space and of time.

I would like to have the spectator forget these considerations of general order when looking at my works, or better, that he be aware of them after having seen the works; for they exist only outside all theoretical justification.

Dessins 10/2/16 -3. 4

1 Le violoniste de société frs 150
2 En volant sur Reims " 150
3 Nature morte " 150
4 Le train dans la ville " 150
5 Guitariste et danseuses espagnols " 150
6 Train traversant une rue " 150
7 Danseuse " 150
8 " " 100
9 Amazones (croquis) " 100
10 Lanciers italiens au galop (croquis) " 100
11 La modiste (gravure sur bois. Épreuve d'essai. unique) " 50

fig. 31
Three-page list in French of
works for exhibition at Alfred
Stieglitz's "291" Gallery, enclosed
in letter from Severini to Walter
Pach, 2 October 1916. Stieglitz
Archive, Yale University.

Toiles 10/2/16 -4. 5

1 Train blindé en action ✓ frs 1000
2 " de la croix rouge traversant un village ✓ " 1000
3 " de banlieu arrivant à Paris ✓ " 1000
4 Danseuse ✓ " 800
5 " ✓ " 600
6 " ✓ " 600
7 Danseuse = Hélice = mer " 600
8 femme et enfant " 1500
9 nature morte ✓ " 250
10 nature morte (expansion centrifuge de couleurs) " 300
11 femme assise dans un square " 500

 8150
 600
 1400
 10150

Pastels 10/2/16 -5. 6

1 Métro - Grande Roue - Tour Eiffel (1911) frs 200
2 Portrait de madame Paul Fort (1912) " 200
3 Danse de l'ours = Barques à voile) (1914) " 200
 600

Stieglitz Archive: Correspondence, 1916–1917, Concerning Severini's Exhibition in New York

The Severini exhibition held in Alfred Stieglitz's Photo-Secession Gallery in New York in 1917 was the first solo exhibition of any Futurist artist in the United States. It marked the close of Severini's active Futurist period and the beginning of new stylistic and theoretical directions in his work. Documents relative to this important exhibition are preserved in the Stieglitz Archive at Yale University.

Severini wrote in French to his friend Walter Pach, who acted as an intermediary for Stieglitz in organizing the exhibition. The letter, here translated from the original French, refers to an "enclosed list" of works to be exhibited (fig. 31). A second list of titles, in English, was apparently used as a gallery worksheet (fig. 32). An annotated bill of sale from Stieglitz's office (fig. 33) shows that John Quinn bought ten important works from the exhibition, making it a financial success (see above, pp. 25–26).

..

6 rue Sophie Germain *Paris 2 October 1916*

My dear Mr. Pach,

I have recieved your first and second letters, and I thank you infinitely for the very great service which you have rendered to me by concerning yourself with this exhibition. At present the pictures, for which I send you an enclosed list, are at the shippers and soon will be on their way to New York. I have met Mr. George de Zayas who is a very earnest and likeable young man; he went with me to the American Consulate to fill out the forms and he gave me all the necessary instructions.

Thanks to you and to the friendship of Mr. de Zayas, my pictures will travel with a sizeable shipment of pictures and furniture; thus allowing me the advantage of very reduced expenses after the arrival of the works in New York.

The costs of transporting them to Mr. de Zayas at the Stieglitz Gallery cannot possibly be very high, and Mr. Stieglitz, who undoubtedly has men at his disposal, could perhaps take care of this. (Perhaps as you said in your first letter, you have already made the necessary arrangements with Mr. Stieglitz.)

I would also like to ask you if Mr. Stieglitz intends to prepare a catalogue. If he wants to do so, I can send you a preface by Guillaume Apollinaire. Perhaps this would be better for the public and the cost would not be very great....I understand, naturally, that these expenses would be covered by the gallery; if it is not possible one could do without a catalogue, and a simple list of the works hung in a corner of the room would do the trick.

As for the frames, it is necessary to omit them, alas!, because even the simple moulding that you suggest on 11 canvases would amount to an expense that I could not possibly absorb at this time. Furthermore, the only way I have shown my works since the war is without frames, and I am not the only one who does this....

————————————

I was very happy to receive, indirectly and vaguely, it is true, news of Stella about whom I have the most pleasant memories. I would like very much to receive more ample news of him.

I thank him in advance with a handclasp for being willing to contribute to my exhibition, and it is understood that no expense should be incurred either by him or by you yourself; so if you have any expenses, I beg you to let me know.

I could not, it is true, repay you for the loss of time all this has caused you and which has taken you from your work, therefore I want to express my sincere and deep appreciation, and I beg you to count on me any time my presence in Paris could be helpful to you. Let us hope that these works will have some success, especially material, for the war has completely upset the affairs of painters, particularly the avant-garde....

As you will see, these pictures belong to different periods and result from different research, so as to give the exhibition a varied appearance in keeping with the spirit of the Gallery. One of the most recent canvases is the "Woman Seated in a Park." An effort to reconcile the spirit of Futurist research (continuation of Impressionism) with the spirit of Cubist research (reaction to Impressionism) is evident in this painting. And at this moment all painters are involved in this effort, each with his qualities and failings.

————————————

You have perhaps read in the newspapers that the Futurist painter, Boccioni, is dead from a fall from a horse. He was more than a friend to me and I was terribly shocked by his tragic end.

I am sending you separately an article on art which has just been published.

Please thank Mr. de Zayas for me, and tell him that I am very appreciative of his extreme kindness on my behalf.

My hearty greetings to Mr. Stieglitz, and to you, dear Mr. Pach, an affectionate clasp of the hand from

<div align="right">

your devoted friend Gino Severini

</div>

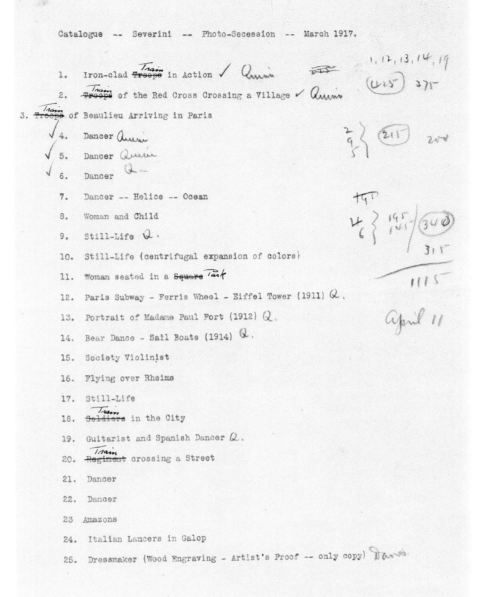

fig. 32

"Catalogue – Severini – Photo Secession – March 1917." Annotated carbon copy of a typed list in English of works for exhibition at Alfred Stieglitz's "291" Gallery. Stieglitz Archive, Yale University.

fig. 33

Carbon copy of typed list, dated 19 March 1917 and annotated by hand, showing John Quinn's purchases of works by Severini. Stieglitz Archive, Yale University.

Marinetti Papers: Letter and Postcards from Gino Severini to F. T. Marinetti, 1910–1915

TRANSLATED BY LAURA HARWOOD WITTMAN

LETTER 1

Civray 17 May MCMX [1910]

Dearest Marinetti,

I received the manifesto and I approve of it completely. The passage: "The gesture that we want, etc.... It will be simply the dynamic sensation itself"[1] *summarizes the ideal that today's painter must strive toward in all his efforts. I am very happy that Balla signed the manifesto; Boccioni and I consider him one of our best friends; the example of his moral strength has often encouraged us through the innumerable difficulties that have arisen in our path.*

Did you send the manifesto to our other friends in Paris? The painter Cominetti writes me that a <u>Milan group</u> *has put a certain Rizzi in charge of searching out the approval of avant-garde artists for an [illeg.]sivist exhibition to take place in Milan. It seems that Rizzi spoke to people altogether incapable of appreciating and understanding our movement, at which they laugh and are amused. Boccioni and I have known Rizzi for a long time, and I would be very surprised if Boccioni had solicited Rizzi's intervention.*

We must admit only the strong into the movement, those whose tendencies are solidly defined at least at their starting points, and whose sincerity in art is indisputable.

Could you send me a few copies of the manifesto? Has it been published in the Paris newspapers? Can one talk about it and discuss it freely?

Please inform me on these essential points so that I may act accordingly.

I thank you infinitely for the second package of Poesia *etc.... I am reading the* Roi Bombance *which is extraordinary.... Your writing is Wagnerian; I am enthusiastic about Mafarka.... I would consider it a great gift if you could get me "La Conquête des Étoiles" and "Destruction."*[2] *Keep me informed about the outcome of your recent battles.*

Greetings to Boccioni and a handshake from your

Aff [illeg.] *Gino Severini*

rue des arts
(Vienne) <u>*Civray*</u>

1 Severini quotes the original French: "Le geste que nous voulons, etc....Ce sera simplement la *sensation dynamique* elle-même." See *Manifeste des peintres futuristes*, in Lista 1973, 163. Also see Apollonio 1973, 27.
2 Severini is referring to the following works by Marinetti: *La Conquête des étoiles, poème épique* (Paris: Éditions de la Plume, 1902); *Destructions, poèmes lyriques* (Paris: Librairie Léon Vanier, Éditeur A. Messein, Succ., 1904); *Le Roi Bombance, tragédie satirique en 4 actes, en prose* (Paris: Société du Mercure de France, 1905); *Mafarka le futuriste* (Paris: Bibliothèque Internationale d'Édition E. Sansot, 1909).

[across top of letter] I just realized that my handwriting is horrible; please excuse me. I am in a period of intense work, and therefore very nervous and short of time. Again very affectionate greetings.

LETTER 2

Paris 17 October MCMX [1910]

Dearest Marinetti,

I urgently need to know whether the Society of Air Pilots of Milan is a serious organization, and what conditions it offers, and what guarantees, for a person desiring a pilot's license. I would be very obliged if you could have a copy of its regulations sent directly to me (as soon as possible).

When are you coming to Paris?

Please let me know, because I need to talk to you, and I would not want to be absent when you came.

In ten days or so I may be at Mourmelon, but for the time being you can send the information I am asking for to the

Hôtel des Deux Emisphères

79 rue des Martyrs. Paris XVIII

Bielovucic has received your works and sends his greetings.[1]

Thank you for having welcomed him warmly and also for defending him; Bregi and he have good memories of your courtesy.

Mademoiselle Sephora[2] wishes you good day; she is taking her exam at the Conservatory tomorrow and Monsieur Lugné is on the jury. He bids me to send you his greetings, and says that you are a cochon *because you found a way to avoid him when he came to Milan even though he had a longstanding invitation from you!…*

I am writing from the offices of the Oeuvre[3] *and Monsieur Lugné is dictating this message for which I decline all responsibility!…*

Please send greetings to all my friends and to Boccioni in particular, whose visit to Paris I await impatiently.

I clasp your hand.

your Gino Severini[4]

1 Jean Bielovucic was a Peruvian airman who flew over the Alps on 25 January 1913. Accounts of this exciting event describe the plane as "ascending spirally to a great height" (*Flight* 5, no. 5, 1 February 1913, London, 110–11). The spiral take-off fascinated the Futurists who incorporated spiral forms in their work. Bielovucic met Severini toward the end of 1910 and took him on his first flight. Severini was enthusiastic and briefly hoped to become a "celestial chauffeur"; see *La Vita* 1983, 61. And see Martin 1981, 306.

2 Sephora Mossé was an actress at the Théâtre de L'Oeuvre. See Martin 1981, 306–07.

3 The Théâtre de L'Oeuvre, on the rue Turgot, Paris, was an experimental theater close to the studio that Severini rented in 1907–08. Directed by Aurélian François Lugné-Poë, it was a gathering place for the literary avant-garde, producing a periodical entitled *L'Oeuvre*. Severini made an etching of the courtyard of the theater (F49) for the frontispiece of *L'Oeuvre*, no. 13, November 1909. See also *La Vita* 1983, 48–49.

4 The inscription, at top right, on the last page of the letter is in a different hand. Nearly illegible, it appears to be a reminder to send publications to certain individuals.

POSTCARD 3

Paris 21 October MCMX [1910]

Greetings to Boccioni

Dearest Marinetti,

The complete victory of Mafarka is intimately tied to the triumph of our Futurist movement, I therefore rejoice doubly…once for the book I love and once for the idea.

Greetings from Bielovucic and Bregi. Please send me the information I asked for,
I shall be most grateful.

your Gino Severini

Hôtel des Deux Emisphères *Paris 15 Nov. MCMX* [1910]
79 rue des Martyrs

Dearest Marinetti,

I am delighted that you will be coming very soon for all the reasons you know; I think your presence is indispensable to our reaching an agreement on many points concerning the action of Futurism here. In the meantime I will have made a decision about aviation, and I will tell you about it in person. When is Boccioni coming?

Please tell me of your arrival as soon as you are in Paris by giving me an appointment at any time; otherwise it would be difficult to meet because I work all day and I go the Oeuvre irregularly.

Affectionate greetings to all and to Boccioni.

A handshake from your Gino Severini

Paris 18 January MCMXI [1911]

Dearest Marinetti,

I am sending you the 5 drypoints which I mentioned to you. I hope it will not be too difficult to sell them at 20 frs. each, but only in a milieu of connoisseurs or intelligent amateurs.

I began the first sketches for the Monico; the two protagonists…of the Pam-pam [sic] *are Nenette and Liette; the first, shapely and wholesome, the other (passive part) small, nervous; both are very interesting and ready to pose whenever I want them to.*[1]

Therefore, if you could do me the great favor of advancing me the one hundred francs on the prints I am sending, I would begin the large canvas immediately. I am sure that you understand my enthusiasm and impatience to express a big idea amply, and that you will thus be able to excuse me for asking another favor of you, after the very great one you did for me a little while ago.

Zacconi performed in Ghosts,[2] *last night…great success. Isadora Duncan could not stop clapping and Lugné-Poë too, but more discreetly, in the shadows of his box…. The success was earned, but in my opinion, Zacconi takes too much advantage of the effect an epileptic can have on the public; in all moments of passion or pain he is always epileptic….*

1 *The Dance of the Pan Pan at the Monico* (F97) was included in the Bernheim-Jeune exhibition in 1912 and was later lost. Severini made a precise replica of the painting which he signed and dated "1909–1911/1959–1960." It is now in the Centre Georges Pompidou, Paris.
2 Henrik Johan Ibsen (1828–1906) wrote *Ghosts* in 1881. In 1911, it was still playing in independent theaters in Paris.

I will be attending Isadora Duncan's opening at the Châtelet; I think that at the Oeuvre I noticed some doubts and fears about the outcome…we'll see.

At the Oeuvre and at Antoine's, I saw the beautiful blonde who was with us on Saturday night; she is really lovely and I have almost decided to fall in love with her.

She will be coming to the studio to have her portrait done soon.

Send greetings to Boccioni; I will write to him at length one of these days; please show him my drypoints.

I would be very pleased to receive the musicians' manifesto…which I have not seen yet; to all my Futurist friends, warm and congratulatory greetings.

I clasp your hand affectionately and thank you.

your Gino Severini

5 Impasse de Guelma
(Montmartre)

LETTER 6

Paris 10 June [1912]

Dearest Friends, [1]

Your very amusing letter has put me back in good humor. But you must confess that by now it is too easy to make light of the usual and stale (Passatista) argument about my nose (that even itself borders on becoming snotty).

I will try to respond to your jibes as well as possible; unfortunately I will be overcome by numbers (4 against 1 is an uneven battle) and I'm going to jack-off to your health, captain!

You reproach me for my secondary role in the Picasso, consort, and brat affair; [2] *I admit that I could have acted differently, and indeed would have acted differently had not the indispensable tool been in poor shape and out for repair. Sergeant Boccioni knows, since we survived many blows, one against the other, that in the affairs of love, less time passes… than between what I say and what I do. I am surprised he did not come to my defense.*

I told you that Mayer Sée [sic] [3] *heard about the sale in Berlin* [4] *before I did, and that I did not announce anything new to him when I mentioned it to him; yet you seem to doubt it. You are wrong, for nothing could make me invent* bâteaux [5] *for you and I would not even have mentioned it, had you not added to this first problem by your continual laxness in responding to me, and, perhaps, my bad mood has exaggerated it all in my own eyes.*

You live in an atmosphere created for yourselves, and you do not know what it means to be completely alone with serious problems and worries. Why doesn't Boccioni remember the old times spent in Milan in conditions similar to mine?

After I wrote to you for the first time from Brussels, one morning, I began to spit a little blood; this went on for three days in succession; and in alarming quantities; I went to the hospital to have myself examined, but it seems I am not entitled to do so because I pay more than 500 francs rent; I am therefore awaiting the arrival of the money I asked you

1 Severini's "Friends" are Boccioni, Carrà, Russolo, and Marinetti.
2 The letter refers to a love triangle: Picasso, his consort, Fernande, and a handsome young Italian painter, Ubaldo Oppi, whom Severini introduced into his group of friends which already included Marcoussis and Eva Gouel (Marcelle Humbert). A complicated series of events aroused suspicion that Severini had been implicated in a seduction. For details of this *dramma passionale*, see *La Vita* 1983, 113–14, and letter in *Archivi* 1, 144–45, Boccioni to Severini, Brussels, May–June 1912.
3 R. R. Meyer-See (consistently misspelled by Severini as "Mayer Sée") was the founder and director of the Sackville Gallery, Ltd., London, and Madame Meyer-See, a co-director of Sackville Objets d'Art, Ltd. Early in 1913, they left the Sackville and purchased the lease of the Marlborough Gallery, 34 Duke Street, St. James's, London, S.W.
4 When the first Futurist exhibition left London and went to Berlin, a number of the works shown were purchased by a Dr. Wolfgang Borchardt, apparently on speculation. See Letter 14,

for, so that I can see a doctor. I think that Boccioni and I had the same thing some years ago, in Rome, and perhaps it is only an irritation of the throat; therefore I have stopped smoking, but I confess that I have been quite frightened and will not feel reassured until I see a doctor.

As soon as I finish my current works, and when I am in possession of the first part of my fortune, I will leave for Italy and I think I will pass through Milan.

Would it be possible to know when the exhibit in Rome will take place? What arrangements should I make for sending the paintings?

I wrote what was necessary for the Rouen exhibition, even before I got your last letter.

A young sculptor named Martini[6] from Treviso, who knows you and has been with you at some Futurist evenings, came to visit me here. He clearly expressed the desire to join the group as sculptor and it seems that he has ideas for a manifesto. Personally, I don't think he sounds particularly interesting and I have my doubts about his ideas; I told him to keep working, and that when you are all here we will talk about it.

On Sunday I attended a performance of Marius vincu [sic] by Mortier[7] at the Théâtre de la Nature at Marne la Coquette; you can imagine what sort of junk it was!…This evening I am going to Valentine de S.P.'s.[8]

I need to have you send me right away some manifestos of Futurist music, in French; also add letterhead sheets for the office correspondence!…

I am returning the letter from Utrecht that you sent me, and tell me whether you received one too, and whether I should send a drawing.

Don't act the same as you usually do and try to answer me. This week I will respond at length to Russolo's last letter.

I embrace you all fraternally.

> your Gino Severini

..

LETTER 7[1]

> *Pienza 5 Aug.* [1912]

Dearest Marinetti,

Just a few hurried lines between one brushstroke and another. Paul Fort sent me a subscription bulletin for his book which just came out, Vivre en Dieu.[2] There are copies at twenty francs, at ten, and at 3. I am sure you have all received the same thing; what are you doing? which copy are you getting? is it enough to get the one for 3 francs?

Do me the favor of answering right away so that I can return the signed bulletin that I have already had for two days.

I cannot find any explanation for the delay of the money from Berlin and I beg you to tell me something in that regard. I urgently need colors to continue my large painting [Pan Pan, F97], which I have been working on assiduously for a week; for now, I am happy with it.

note 3. Herwarth Walden, director of Der Sturm gallery and organizer of the Berlin exhibition, acted as intermediary for the sale and took a percentage of the sale price. See letters Boccioni to Severini, *Archivi* 1, 244–46.

5 Literally "boats"; a colloquialism for misleading stories.

6 Arturo Martini, a young artist briefly associated with Futurism, exhibited in *Esposizione libera futurista internazionale* in Rome in 1914. See Martin 1968, 182, note 3.

7 This appears to have been an historical play by Pierre Mortier about the Roman general Gaius Marius.

8 Valentine de Saint-Point (1875 Lyons–1953 Cairo), painter, dancer, and prolific poet. She published two Futurist manifestos, *The Manifesto of Futurist Women*, 25 March 1912, and *The Futurist Manifesto of Lust*, 11 January 1913. She abandoned the movement early in 1914.

1 Movimento Futurista letterhead.

2 Published in Paris by E. Figu- ière, 1912. Paul Fort was a central figure in the literary avant-garde where he was known as the "Prince of Poets," an honorific title invented by Verlaine. Severini married Fort's daughter.

3 *La Bataille de Tripoli vécue et chantée par F. T. Marinetti* (Milan: Poesia, 1911).

I have to write to Boccioni at length, but I am waiting to have a day off; in the evening when I stop working I am very tired. The town I am in is a town of savages, I am always alone, or in the company of the olive trees, the principal element of this town.

Tell Carrà and Russolo to answer me; greetings and very affectionate embraces to all from your

<p style="text-align:center">Gino Severini</p>

(Pienza)
Provincia di Siena

P. S. *You will send me, I hope, your latest* Battaglia di Tripoli[3] *which you performed before I departed.*

LETTER 8[1]

<p style="text-align:center">*Pienza 9-8-12* [1912]</p>

Dearest

 Money letter monoplane
landing thirst paint
calm work health = paintings
glory Battle Ma
rinetti = space + 1000 *motors*
vastness space
 Walden = whore
 Russolo silence - clock =
swine

<p style="text-align:center">Affection friendship Severini</p>

1 See fig. 18.

LETTER 9

<p style="text-align:center">*Paris 25 Nov. 12* [1912]</p>

Dearest Marinetti,

I am enclosing a registered letter: offer exhibition New York. Take cognizance of it and answer right away directly to New York.

What answer must I give to those who spoke to me and Boccioni, also for N. York!

Do I have to make arrangements to exhibit at the Indépendants?

Please answer, don't act the same as usual....

As soon as you receive the latest installment of my money, please send it, I need it desperately.

Tell Boccioni that I was not able to get anything out of Ortiz [de Zarate], *but I think I will succeed in doing so with much bone breaking. . . .*

Very affectionate greetings to all; I await the arrival of books, manifestos etc. . . .

your Gino Severini

LETTER 10

Paris 9 Decem 12 [1912]

Dearest Marinetti,

I am sending you an issue of the Annales *with an article on the Cubists and some reproductions of Futurist paintings. Metzinger and others are furious, and I think they have sent a protest to the newspaper. They wanted me to join them, I refused. I said that only you take charge of certain things and that in any case I did not like to give importance to such things. . . .*

Metzinger wants to press charges with the Justice of the Peace against the Director of the newspaper because he published his paintings without asking for permission.

He is really a typical petty quibbler, but it is just as true these days that the Cubists are at the height of their glory, that they have conquered Paris no less, indeed, even more, than we, and that they are selling at breakneck speed. . . . All this is apparent (they make it well enough understood by their manner) in the conquerors' airs they give themselves, now that they have abandoned the melancholy aspect they displayed for a long time after our exhibition.

In the same issue there is a relatively innocuous article, a little stupid perhaps, by Gleizes. I will talk to him about it at the Closerie,[1] *on Tuesday.*

Madame Finaly receives every Thursday in December; she awaits you and demands your presence repeatedly. Saturday evening I dined with her, along with Madame Mendès, Madame Benezech, friends of Annie de Pène, Rachilde and Valeta, Monsieur Thierry, and a few others (an agreeable poet, author of the "Plaisir" and another young poet that we met for the first time with Boccioni a month ago at Finaly's house. The latter is phenomenally ignorant and is just asking to be slapped, talk to Boccioni and you will understand why he remembers the man). What could I do, by myself? I keep him in his place, but a real correction needs to be administered.

Madame Mendès held a conference on Saturday after lunch but I did not go, and Valentine held one last Sunday in one of the most miserable milieux I have ever seen. Did you write to New York in response to the letter I sent you?

I urgently request that you send the books that I mentioned in the note to Boccioni. These constitute a useful base of operations for all of us. I especially recommend these two addresses:

1 Closerie des Lilas, a Parisian restaurant on the rue Notre-Dame-des-Champs near Montparnasse, was in a neighborhood full of artists' studios. It was a meeting place for the literary circle associated with *Vers et Prose.* See also Letters 12, 16, and 19.
2 See Letter 1, note 2. *Le Monoplan du pape: Roman politique en vers libre* (Paris: E. Sansot, 1912).
3 *I Poeti futuristi. Con un proclama di F. T. Marinetti e uno studio sul verso libero di P. Buzzi* (Milan: Poesia, 1912).
4 Severini had written on 10 June 1912 (Letter 6), asking "right away…[for] some manifestos of Futurist music, in French; also add letterhead sheets for the office correspondence!" Francesco Balilla Pratella, the official Futurist musician, wrote two manifestos. Severini had apparently received one or both of them and had not found them exciting. See also Letter 16.

Comtesse de Ste. Croix

7 rue Marbeuf — Paris

(send: Monoplan — Destruction — Futurisme, manifestos (signed, etc.) ²

—————————————

Madame Flageolet

2 rue de Provence — Paris

(Monoplan — Mafarka in French — Manifestos)

—————————————

Please do me the favor of telling me when these have been sent, so that I can pick the right time to visit the Comtesse de Ste. Croix, who is an intellectual Royalist, intimate with the Princes of Orleans etc. . . .

I am anxiously awaiting money, which I need desperately to work and to make the studio decent enough to receive well-to-do people! Please don't be late and send it as soon as you have it. Boccioni says they will pay the second installment on the 10th; but tomorrow is the 10th and the first one has yet to come! . . .

Tell Boccioni I will write to him at length tomorrow or the day after. I have received his letters.

Good work and very affectionate greetings to all.

<div align="center">

your Gino Severini

</div>

[first page, upper left, probably Severini's hand, first sentence crossed out] *Send the "Poeti Futuristi"* ³ *to Nicolaë Serban 9 rue Mazarine, Paris VI. He is a young man who is very interested in the cause of Futurism and can be very useful. Answer right away.*

[first page, upper right, below date] *I got the paper thank you: Your Pradella* [sic] *is heavy and indigestible.* ⁴

· ·

POSTCARD 11

<u>*Please answer right away.*</u>

<div align="center">

Paris 22 January 13 [1913]

</div>

Dearest Marinetti,

I see that you forgot. . . . [*Please send it to me immediately as we agreed since I can't imagine how I will be able to wait for the sale of my retrospective paintings to come through. . . . Tomorrow Madame Benezech, her husband, and some friends will come to the studio, it seems; but I have to be able to wait a few days, it is not possible to complete a sale from one day to the next. I am counting on you, I don't know who I can ask for such a favor, I have used all my old contacts, and I cannot ask the new ones. You understand. . . . Send* I Poeti Futuristi *to Paul Fort, and* Le Monoplan *to Mademoiselle Marthe Roux — 21 rue Pierre Nicole — I thank you in advance.*]¹ *I will soon write a long letter to Boccioni; have you seen the 2nd number of* Lacerba? *We will see the article on the Futurists.*

1 The message begins and ends in Italian; but the text enclosed in square brackets is in French.

Everyone was crushed not to have seen you on Sunday at Benezech's. You cannot hope for anything from that shit Finaly. Very affectionate greetings from your

Gino Severini

..

LETTER 12 [1]

Paris, 28 January 13 [1913]

Dearest friends,

I got your telegram, the money order, the letter; thank you for everything. Your sage advice (which I appreciate a lot!) reaches me a little late, when circumstances have already forced me to make a decision similar to the one you advise. [2] *I lacked the means of committing suddenly what you call "a foolish act," and now it is too late. Doctor Matja, the Greek whom Boccioni and I met at Finaly's, examined me last week, told me that there is still a danger of tuberculosis in the right lung, that it was better to leave Paris, to lead a peasant's life for a year, and, especially, to abstain from women, tobacco, etc. —*

This is one of the reasons I gave up my project; the other, you can guess, is the absolute absence of means. In the end it is better like this; you are right, what little force I still have I owe to art, Boccioni you are not wrong, art has taken over above all else, and, although this renunciation has cost me a great effort, now I am calm, I am working with ardor, and I hope to be out of danger.

As for the rest I will do my best to leave Paris as soon as possible, the expensive cure prescribed by the doctor is impossible to follow here, and I need calm, I am tired of the Closerie, of the conferences, of the salons, I am fed up with lighting the fire, sweeping the studio, I can't wait to be out in the country; from time to time I will come to visit you for a few days, but I will live like a rustic for at least a year. When I return to Paris many things will have changed and everything will go well.

In order that I might have the funds to leave (I see no possibility at all of a sale), I thought I could organize a small exhibition of drawings in Sée's new gallery in London [Marlborough Gallery]; I have reached an agreement with him. I spoke to Marinetti about having it the Hôtel Ritz in Paris, but the owner of the hotel is absent; I would have a gallery Avenue des Champs Elisée [sic], but I think it better to organize exhibitions here as a group only, and with a different attitude. I hope that you have no objections, indeed, tell me whether it would be useful to put the technical manifesto at the beginning of the catalogue. It will be an almost private thing and without éclat, but with an aristocratic and serious form; I hope to be able to put together thirty or so drawings and some watercolors.

You didn't tell me whether I should send something else to Rome, nor when I have to send it. I have a painting ready, here, that satisfies me better than any of those down there.

Soffici writes that you are friends; I would have been happy to hear about that from you and I think you could have told me.

1 Movimento Futurista letterhead.
2 Marinetti and the other Futurists tried to persuade Severini not to get married at this time.
3 Ugo Giannattasio and Ubaldo Oppi, Italian painters living in Paris, were younger adherents to the Futurist cause. When Giannattasio enlisted during the war he allowed Severini to use his studio. *La Vita* 1983, 117, 166, 175.

I would have a thousand things to tell you, but I don't have the calm I need: on Sunday I spat blood again; every evening I have a fever, if I don't pay the bailiff 250 lire by 15 February I will be thrown out and all my paintings and possessions sold at auction. Think of my state of mind and imagine how amused I am by the bullshit in your postcards.

In any case, in spite of my condition I find your pessimism about the future very exaggerated. Here Futurism and Futurist painting gain ground each day; Oppi, Giannattasio and other young German painters are doing interesting Futurist stuff;[3] foreign painters and writers are always asking me for explanations, manifestos; the Cubists will inevitably become Futurists too....

All we have to do is work with faith; this is what I do in spite of everything, but in a few days I will again be penniless, and God knows what I'll do.

Very affectionate greetings to all; and write....

<div align="right">

your G Severini

</div>

[upper left] *I have just received Valentine's manifesto, thanks.*

POSTCARD 13

<div align="right">

Paris 1 February [1913]

</div>

Dearest Marinetti,

I just got a personal invitation to exhibit in Florence at the Società delle B. arti [Società delle Belle Arti] *from 30 March to 30 June. Were the others invited too? What are they doing? I do not think it useful to participate in this exhibition with only one work, but before I answer let me know your opinion.*

Greetings to all. Write.

<div align="center">

your Gino Severini

</div>

I am working a lot.

LETTER 14

First Part　　　　　　　　　　　　　　　　*Paris 9 February 13* [1913]

Dearest Marinetti,

I received your letter, I wrote right away and certainly the paintings are already on their way; the distance between Montepulciano and Rome is short and we do not have to worry about delays. I am surprised and happy at the extraordinary way you have arranged this Futurist event and I wish I were able attend.

The titles of the paintings are written on the back of each canvas with the signature;[1] however I would like them to appear in the catalogue simply like this: (painting no. 1) — no. 2 — etc. — up to 6.

1 This letter concerns Severini's exhibition in the Galleria Giosi, located in the foyer of the Teatro Costanzi, Rome, which opened 11 February 1913. See *Archivi* 1, 480–81. The actual titles used in the exhibition catalogue are written into the text of this letter in pencil in another hand: *Geroglifico dinamico del "Tabarin"* (F107); *Ritmo astratto di la Sra M.S.* (F104); *Il mio*

No 1 is the Bal Tabarin. With two figures of dancers and a few decorative elements I wanted to express plastically and rhythmically the absolute feeling of the environment.

No 2 — portrait of Mrs. Mayer Sée. The lines and the planes, constituting an abstract and completely subjective rhythm, are the realization of an intuitive and objective effort.

No 3 is my portrait, no. 4 a landscape, 5 and 6 two dancers.

All these things are done, so to speak, "d'après nature" since I did not want to apply a subjective and thus unavoidably relative concept to things. This is the basis of my way of seeing, but each work is a different step toward ever-purer realities. In painting no. 1, I have used real spangles and sequins to satisfy this need for absolute realism, vice versa I remain in this way in an analytical field, therefore relative and removed from emotion (it is not necessary to explain this to others). I cannot imagine what kind of catalogue you are planning and I think these few notes will suffice. In any case I must write to Boccioni quickly with my latest pictorial conclusions, if I cannot actually come to Milan, which would be better. Won't you put in any photos? Will Boccioni's sculpture be there? Will the exhibit with the Secessionists take place? I am working a lot and preparing important works for Rotterdam; completely different from the ones that will be in Rome.

Second Part

Most cordially, Madame Benezech has done her best to get me a sale; it looked as if she had convinced a friend to buy a drawing for about one hundred francs, but in the last twenty days or so it has not been mentioned; it vanished. If by the 15th I have not paid the bailiff what I owe plus expenses, I will be thrown out of the studio and my things will be sequestered and sold at the Hôtel de Ville, but in court and without banns. It would be a complete disaster for many reasons; I need calm to work, and I need the studio, at least until April. It's the German's fault if I'm in this mess. I beg you, dear Marinetti, to do me this favor and get me out of the Impasse.² I am certain that I will reimburse you the sum very soon (I need, with expenses, at least 250 francs). I am almost certain that I will sell some drawings in London, the German³ will decide to pay one day or another soon, I saw Palamenchi who came from Munich; he said that there was a Futurist exhibition there; it was a enormous success; the postcards of my Pan-Pan were in everyone's hands. I received two clippings from Hungarian newspapers in BudaPest [sic]. They are about the Pan-Pan. So that pig is burning our bridges in all the places we have not yet been. A real screwing, my dear. I don't need to tell you I have confidence in the capacity of current work to attract interest once again in the very milieux where he has organized exhibits. I am working with great passion and my work is enthusiastically received by young Futurists here to whom I give encouragement and advice.

Among the many sequestered paintings there are two interesting Futurist works; but I am counting on you to save the day; I had somewhat higher hopes, I confess, for the contacts for whom I have sacrificed money, time, health; however there is nothing left to hope for.

ritmo (F103); *Equivalente plastico d'un paesaggio* (F108); *Prima danzatrice* (F105); *Seconda danzatrice* (F106). See cat. 6, *The Bal Tabarin.*

2 A play on words. *Impasse* in French corresponds to the English "impasse," a situation with no way out. Severini lived on the Impasse Guelma in Paris, and was having trouble paying his rent. He therefore begged Marinetti to give him an advance.

3 "The German" is Borchardt, elsewhere referred to as *cochon* and *porco;* he had still not settled his accounts for the purchase of Futurist paintings from the show in Berlin in 1912, and was arranging other venues without consulting the Futurists. See Letter 6, note 4.

I will be grateful if you can answer right away; I very badly need some tranquillity. I thank you and clasp your hand affectionately.

<div align="center">

your Gino Severini

</div>

greetings to all my dearest friends

LETTER 15 [1]

Most dear friends brothers,

Enthusiastic for the beautiful battle that you are waging and sorry not to be with you personally, I send you the congratulations of all our friends and mine too, and I embrace you with great affection.

<div align="center">

your Gino Severini

Paris 12 March 1913

</div>

1 Movimento Futurista letterhead. See fig. 1.

LETTER 16

<div align="center">

Paris 31 March 1913

</div>

Dearest Marinetti,

I saw Walden who spoke Futurist extension Berlin. <u>Your presence Berlin new conference most necessary</u>. Enthusiastic latest work destination London. Had most cordial affectionate welcome Closerie. Seems that German scoundrel decided to pay — financial crisis, Berlin, over.

Apollinaire came to see my works; am noticing great progress in qualifying me as orphic, ultimate pictorial expression!… Forms and colors in their relationship to light. (Delaunay). But Delaunay's painting at the Indépendants is irrelevant, vulgar, superficial. He had to agree. He wants to do a book on Futurist painting, for this, he wants to talk to you. He asks if it would be possible to come to Italy.

Am enthusiastic your terrific battles Rome. Why haven't you asked for my photographs Soffici book? What am I, a son of a whore?

Beautiful, correct, Russolo manifesto. In preface my catalogue London I allude to influence of noises and sounds on plastic perception. Coincidence.

As soon as I have them, you will receive catalogue and details. Sée is a pig and he is screwing me but I need him. In works and in attitude preface exclusively <u>We Futurists</u>. As for the rest I am fighting with ardor here to substitute word <u>Orphism</u> with word <u>Futurism</u>.

Cubists and other avant-garde painters see danger in being understood as Futurists. They feel attracted toward research of Movement, complexity of subject.

To escape the danger they invented Orphism.

All the interesting intellectual world came to my studio, noted enormous distance between us and Cubists who remain stationary on the formal level.

1 For writings by Marinetti, see Letter 1, note 2, and Letter 10, note 2.

2 See above Letter 10, note 4. Severini now has a more positive opinion of Francesco Balilla Pratella than he did the previous December. He may have been reacting favorably to performances given by Pratella on 21 February and 9 March.

Dufy will become a Futurist.

Carrà speaks lightly of Picasso who is evolving color form. But always fundamental error of considering objects isolated. Matter, integral value = enormous error.

A young writer from Holland desires to give lecture Futurist painting Rotterdam time exhibition. Wants to know whether you intend to; in this case will give it up.

Soffici will send to Rotterdam? When? I need complete manifestos French and, if possible, English. Received Russolo manifesto which I will distribute.

I hope to be able to go to London. If possible I will go in 8 days. Hope good results. Have passed tragic moments, sustained fierce work, faith.

Addresses to send Manifestos — Monoplan — Futurisme[1]

Monsieur Eugène Humbert
 Détenu Quartier Politique
 Prison de la Santé Paris

———————————————

Monsieur Romain Rolland (very important)
 162 Boulevard Montparnasse Paris

———————————————

Monsieur M. Pathias
 61 rue Cardinal Lemoine Paris

———————————————

How are all the friends doing? Balletta [diminutive of Balla], *is he happy? Send manifestos right away — in any case in 8 days I must leave studio.*

Will write from London if I go.

I embrace you all affectionately

 your Gino Severini

The young Pratella is becoming more polished, entering the Movement — inspires confidence.[2]

When are you coming to Paris? I was hoping to see you at the Indépendants. Ciao

 your G Severini

I will send photos soon my latest works.

- -

POSTCARD 17

 Paris 5 April [1913]

Dearest Marinetti,

I received your letter, Boccioni's, Russolo's. Tomorrow morning I leave for London and I will have the thing you mention put in the catalogue, but you notified me a bit late. I will write in great detail from London about how I dealt with A . . . [Apollinaire] *and others,*

and where we stand on Orphism. You can be certain that even before I received your letters I had fought forcefully for Us.

In Paris there is agitation, indecision; I will stay in London only a short time since my presence is useful here; But I will leave things so that an absence of 10 or 15 days will not do us any damage.

I will certainly write on Monday; tell Russolo I will do as he asks.

I embrace you all fraternally.

> *your Gino Severini*

LETTER 18 [1]

<div align="right">London 7 April [1913]</div>

Dearest Marinetti,

Today is the inauguration of my Exhibition,[2] this morning for the press, and this evening by invitation, of a more mundane nature.... Have begun violent discussions with journalists. The press is starting out well, as you can see from the newspapers I am sending. I will keep you informed. I am sending you the catalogue, in the blank page we will put the list of names that you are sending. You could have made up your mind earlier, and it would have been done by now.

Sée has arranged everything rather well and seriously and so I am quite certain of moral success. As for the rest who knows....

Last week I invited Apollinaire to lunch, and we discussed the Orphists, among whom he classifies me and Boccioni. But I saw yesterday that in his latest book,[3] which you must certainly have seen, he puts us with the Instinctive Cubists. I will write to him more about this from here, since we have established a certain intimacy that I will use to our advantage.

The idea of doing a book on Futurist painters comes from him; as soon as I am in Paris, in ten days or so, I will talk to him about it again.

I was not able to speak to Kahnweiler since he is away; the widow Sagot is rather a friend of ours, but has no opinion concerning the new factions. She is new to commerce....

Send me, here, the latest Lacerba, *and if you can more than one so that I may use it by sending it to Paris.*

The journalist from Holland will prepare the lecture. I need to know when it should be. Sée is coming to tell me that some journalists are asking for me, I embrace you fraternally, all of you.

> *your Gino Severini*

Write immediately if you have <u>something to tell me</u>.

Two important journalists "Daily Chronicle" and "Academy" have demonstrated great sympathy for Futurism, which they have been following since its beginnings.

1 Printed address for Marlborough Gallery.
2 This letter gives us a piece of information not included in the catalogue — that the exhibition was opened on 7 April.
3 *Les Peintres Cubistes,* 1913. See Apollinaire 1944.

34 Duke Street
St. James's
London S.W. *London 19 April 1913*

Dearest Marinetti,

Tell me whether you plan to come to Paris soon.

Yesterday I sent you the latest number of Montjoie!, *which perhaps you are aware of.
In the article about the Salon Societée [sic] Nationale Apollinaire ridicules us. Boccioni's
article stung him to the quick. All the better. But at the Closerie no one knows this article
because* Lacerba *is only in the hands of a few Italians, and Apollinaire will certainly not
talk about it. But as soon as I am in Paris I will arrange things with him and the others.
You can trust me, and in any case we will communicate often, because I think some polemics
are about to erupt which we will have to sustain aggressively.*

*Here in London things are going marvelously well for the time being; every day there
are serious articles and reproductions of paintings. I am sending you* The Sketch *and
the* Graphic, *but there are many more; all important.[2] I have to sustain our moral cause
energetically since our friend Sée says openly he doesn't give a damn.*

*I would add, incidentally, that any future proposal for exhibition can already be consid-
ered out of the question, because for all sorts of reasons it is not working. In a few days the
English Review will publish an article of mine where I establish the difference between the
inclination of* Cubism *and the inclination of* Futurism. *I have written the article along
these lines:* Cubism: *reaction to Impressionism, objectivism, analysis, stasis.* Futurism:
*continuation of Impressionism; simultaneity plastic states of mind; synthesis; dynamism
in the sense of duration and displacement.*

*I have analyzed the different factions of Cubism which Apollinaire himself speaks
of in his book,* Le Cubisme, *concerning Picasso whom he classifies among the scientific
Cubists, and he himself states, "A man like Picasso studies an object as a surgeon dissects a
cadaver."[3] I did not pass up the occasion to use this. In terms of the Orphist Cubists, to show
our Futurist influence on Cubism and how much the word Orphism stands for the word
Futurism, I have used the documents cited by Boccioni in* Lacerba. *All this is done very
seriously and clearly in any case as you will see. A very influential critic from the* Daily
Chronicle *whose name is Lewis Hind has joined our band as have many young artists
and journalists who surround me with support.*

*But I am amazed that I have not sold a single drawing yet. People have kept coming,
even though the weather is horrible, and chic people with cars, etc.; there have been
requests for prices, but no sales. I don't need to tell you this puts me in desperate conditions.
I put in all the effort that I was able to muster to organize this exhibition. As you can see in
the Catalogue I am exhibiting 6 paintings, and the rest are drawings and watercolors (the
idiotic titles are Sée's work)* I need to know right away when the exhibition in Rotterdam

1 Movimento Futurista letterhead.
2 For Severini's lively reception in London, see Caruso 1991.
3 Apollinaire 1944, 13. Severini is actually referring to *Les Peintres Cubistes*, 1913. The original French reads, "Un Picasso étudie un objet comme un chirurgien dissèque un cadavre."
4 Herwarth Walden, German musician, writer, and publisher, founded the magazine *Der Sturm*, a German Expressionist periodical which published major achieve-ments of the European avant-garde, including the Italian Futur-ists in 1912 and 1913. His gallery, also called Der Sturm, gave the Futurists a number of exhibitions in those years. Walden had an entrepreneurial role in arranging exhibition venues and representing the Futurists as their dealer. Severini was often irritated with Walden. See Letter 20, note 1.
5 See Letter 6, note 4.
6 Olimpia, or Olympia, was a massive exhibition building opened in 1886 on the Hammer-smith Road, London.

will be, because I will have the paintings sent to Rotterdam and the drawings will go back to Paris. From Paris I will send 2 or 3 to Walden who will take care of selling them.[4]

I don't know whether I told you I am Sée's guest, I am guzzling his food and sleeping in his house (the organization of his house is immense, grand); but this state of affairs cannot go on and I have to cross the Channel as soon as possible; in any case in 8 days the exhibition will close and anyway I have done all that I can.

Has the German paid?[5] *Walden assured me that it was a question of days. In case of a negative answer I will not be able to avoid calling on your friendship again. I was not able to buy a round-trip ticket, and I will have to return to the center of the action as soon as possible. It is also necessary to procure all the newspapers and journals that concern the movement for the archives of Futurism; Sée has the clippings but he is keeping them. I need at least 150 lire, that along with the 430 you already advanced me on the German account comes to 580.*

Please tell Boccioni to send me the address of those friends of his that I must pilot around Montmartre right away; because I don't have the studio in Paris anymore; as soon as I am in Paris I will write to them and ask them how we can meet. Tell Russolo I went to the Olimpia [sic],[6] *but the Exhibition was closed; but a friend is getting me the address of the organizer and I will go directly to him. Please give Boccioni my message right away, I will write to him at length later.*

I would be very grateful if you could send me the means to get out of here as soon as possible, because I cannot prolong my stay here, for all the reasons you know.

I embrace you all fraternally.

Gino Severini.

[above letterhead] *Watching the blonde Madame Sée grow old is a pleasure; she is becoming ugly and sick of men.*

LETTER 20

Paris 9 July 1913

Dearest Marinetti,

I communicated our decision of Sunday to Giannattasio. He took it with the same apathy with which he takes everything and which is typical of his flaccid character; maybe he hopes that the one to be elected to the Milan exhibition will be none other than him. I saw his latest works again: groping attempts without order, without direction, with a few pictorial qualities (not always) borrowed from the most disparate elements: (Futurist, Orphic!, German literature).

But he is full of ardor to defend Futurism.

It seems that Walden has put Delaunay in charge of seeking young people of worth, and that an Orphic *group will be assembled in one of the rooms of the Salon d'Automne*

1 Erster Deutscher Herbstsalon, Berlin, 1913. Director Herwarth Walden. 366 works from several countries and in various styles. Delmarle's work was not included in the exhibition. Giannattasio was represented with 2 works, as was Severini: *Portrait of F. T. Marinetti* (144) and *Plastic Rhythms of the 14 July* (158).
2 *Broccolo* literally means "broccoli," but is also slang for "moron."
3 Félix (Mac) Delmarle (often spelled Del Marle), was the only

in Berlin.[1] Delaunay, Léger, Ortiz de Zarate will take part in it. We should find out whether this is true from Walden.

———————————

Get the council together and decide whether it is useful to assemble a Futurist group in the same Salon. In case of affirmative, we must demand a Futurist room from Walden.

I warn you that next to our works there will be those of Giannattasio (the great green broccoli[2] that you have seen and another) and those of a young Futurist (Mac Delmarle) of my fabrication but not yet finished.[3]

———————————

My opinion is that we should not take part in this sort of joust which we don't need. My exhibition in Berlin will end on 15 July, and it seems that Walden wants to move it to another German city.

———————————

Moreover, comparisons will be established between the different avant-garde factions and the only two Futurists present, Giannattasio and Mac Delmarle. (Will the memory of my exhibition and the Futurist influence that existed in Berlin last year be sufficient to maintain our position?) Or is it better that all 6 of us from the directing group be present? (Works that have never been exhibited are needed.)

———————————

Answer right away so that I can send my decision to Berlin. I could contribute at least one important painting and one small one.

———————————

I went to rue de La Boetie — nothing new — there were a number of people there. I asked to be informed about the transport of the plaster cast to Sagot! Write to me if you come to Paris.

An important and favorable article on my exhibit has been published in The Blue Review *in London.[4]*

I saw the very interesting issue of Lacerba. *Your "Contrabbando di guerra" is wonderful, strong, and pure.[5] I am enthusiastic and full of affection for you.... Enclosed is a note with addresses and things to send to me. Very affectionate embraces to dear Boccioni Carrà Russolo. Answer right away.*

fraternally yours Gino Severini

P. S. I am preparing an article on Boccioni, it will be published next Tuesday. I do not think it useful to become permanently associated with the journal Action d'art, *it is not worth it, and it is only useful to use it like this from time to time. I am saving myself for* Vers et Prose. *I will speak to Paul Fort about it at the first opportunity.[6]*

again yours Gino Severini

French Futurist painter. He arrived in Paris in 1912, shared his studio with Severini, and was declared a Futurist in 1913. His *Futurist Manifesto against Montmartre,* attacking its nostalgia and urging its destruction, was published in *Paris-Journal,* 13 July 1913, and in *Comoedia,* on 15 July. Until he enlisted in World War I, Delmarle made spirited paintings and took an active part in the Futurist group. See Lista 1973, 119 – 21.
4 R.O. Drey, "G.S." *The Blue Review,* 9 July 1913.
5 F. T. Marinetti, "Contrabbando di Guerra," *Lacerba,* 1 July 1913, 142.
6 *Vers et Prose* was published by Paul Fort.

Paris 17 July 1913

Dearest Marinetti,

I got the telegram. I had already asked the Gallery to warn me before they packed and transported the sculpture to Sagot's.[1] Today I went to rue de La Boetie. They were packing the pieces destined for Milan very carefully. I went to Sagot's and made an appointment for tomorrow after lunch. Sagot does not want to take the responsibility for this difficult move across Paris; therefore we will do it together, just as we had arranged with Boccioni. The statue will be put in the center of the shop on the table full of journals and art books. Tomorrow I will send you a postcard telling you whether all went well, as I hope.

———————————

The painter Mac Delmarle whom I introduced to you as sympathetic to Futurism has written a manifesto in response to the <u>campaign</u> *certain artists are running against the demolition of old Montmartre.[2] I saw some excerpts from it in his studio: he is taking a completely Futurist stance and has sentences such as this: "Make room for the Futurist pickax…" etc. and at the end of the manifesto, under his signature, he has put, "Direction of the Futurist Movement" 61 Corso Venezia Milan. I told him he must absolutely remove these last sentences. I made him understand that it is not worth writing a manifesto against those long-haired daubers from Montmartre in their velvet trousers, but he thinks he will get some publicity and did not give up having it published at his expense and sending it to the newspapers.*

You should know that he literally copied our technical manifesto in a magazine in Lille, and added a few sentences copied entirely from Bergson, and had the enormous cheek to add his signature at the bottom.

For these reasons and because of his God-almighty-like attitude I felt the need to remind him his past and present nullity, burying him in shit with a few choice words. Therefore I had to give up the use of the studio he was going to let me use during his absence, and we are, naturally, on bad terms.

Today André Salmon said that he had heard about a new manifesto by Marinetti; I understood what he was referring to (he explained that it was a manifesto [actually by Delmarle] that had something to do with Montmartre…you can rest assured that the style of it has nothing to do with our manifestos) and I told him that it came from a fake and a plagiarist who wants publicity. I will do the same with Apollinaire, Ornyvelde [illeg.], Warnood [sic], etc.[3] But tell me if you think I should act more energetically.

By the way I don't think that any of the newspapers are going to pay attention to it; if he left the sentence "<u>Direction of the Futurist etc…</u>*" perhaps some idiotic editor will actually believe that it came from Milan and from our group.*

We really have to defend ourselves against the idiots who feign admiration and sympathy simply to take advantage of the celebrity of the "Futurist" name. We tolerated that idiot Ciacelli because he is among savages, far from the civilized world; but he needs a good lesson too.

1 On the rue Lafitte, Clovis Sagot had a small gallery where he showed works by Braque and Picasso. Boccioni had just had an exhibition of his sculpture and drawing at the Galerie La Boetie which closed on 16 July. Most of the works were to be sent to Milan, but Severini helped with the transfer of a sculpture from the exhibition to Sagot's. See *La Vita* 1983, 139.

2 See Letter 20, note 3. Severini is annoyed that Delmarle has associated himself with the Futurist movement without actually having sought Marinetti's permission to do so. Marinetti, always interested in enthusiastic supporters, overlooked this audacity and republished the manifesto in *Lacerba*, 15 August 1913.

3 See preceding note and Letter 20, note 3. *The Manifeste des peintres futuristes* (Technical Manifesto of Futurist Painting) was published in *Comoedia* 4, no. 961 (18 May 1910): 3, together with a series of caricatures drawn by André Warnod. See Martin 1968, 47, and pl. III, and Lista 1973, 166.

In any case about this Del Marle beast who plays at the interpenetration of triangles and squares without understanding anything about it, and has been at it for only three months, we must absolutely prevent him from being taken for one of us by public opinion. (I realized little by little that he wanted to use me and us, but the break between us is only 2 or 3 days old.)

I have not yet received the newspaper with my article on Boccioni; I will send it as soon as I have it. Why aren't you sending me the things I asked for in my last letter? I urgently need more manifestos — and I hope that you will not take long in sending them.

I am awaiting a response about Berlin. My opinion is not to send anything — but write to me about this — answer my previous letter and this one as soon as possible, by return mail.

I embrace you all fraternally

 yours Gino Severini

LETTER 22

 Paris 18 July 1913

Dearest Marinetti,

I went to the apartment with Sagot's employee: the statue had already been transported to the shop[1] (they were early because it was easier for them) I went to check and all is well. But at the Galleria La Boetie I saw the last statue, the only one that was not already packed, and the base was split in two pieces. I asked the packer (whose address I took) and the owner and manager of the gallery if this was an accident that had happened to the employees of the gallery. They assured me that it had arrived from Milan in that state, and that in fact almost all the works had sustained some minor damage. Write to me when they arrive if there are claims to be made.

 ————————————

I got the manifestos, paper, etc.

 ————————————

I sent you some newspapers concerning the Del Marle manifesto. I think all this will be only of relative usefulness to him; write to me right away about what attitude to take. I told Salmon that he has nothing to do with us and is nothing more than a vile plagiarist.

 ————————————

I saw Herbin's new paintings at Mrs. Sagot's. Good painterly qualities. Luminous color, but he still has everything to learn where form is concerned. He is struggling in a Cubism that has no way out; I think he will be moving closer to us. Mrs. Sagot and her employee seem enthusiastic about us; sadly there is no money in the till.

I am waiting for you to answer my letters.

Ciao, I embrace you all affectionately

 yours Gino Severini

1 See above Letter 21, note 1.

P. S. Yesterday I had lunch with Max Jacob. He spoke of you with great enthusiasm. He sends greetings, to Boccioni also. I think that tomorrow my letter to Salmon where I call Mac Delmarle a plagiarist and nonexistent will come out in Gil Blas. *I will send you a copy right away. Write right away.*

 your Gino Severini

LETTER 23

 Paris 6 August 1913

Dearest Marinetti,

I was just about to write to you and I received your letter, which puts me in a very difficult situation.

I will explain the whole situation:

The documents relative to the marriage have already returned from Italy twenty days in advance.

The impossibility that Boccioni come before October or at the end of September and other diplomatic reasons have made us ask Apollinaire to be a witness, and he has accepted and is ready.

A friend and admirer of mine, knowing that the only reason for the delay of my marriage was the lack of necessary funds, is lending me, with sacrifice, the little sum of three hundred francs so that I can equip myself and take care of other expenses....

Thus I have no excuses left to put it off, except the fact that you are not able to come.

———————————

My little capital is running out — what a pleasure that is![1] *To wait means to find myself again, in a month, with no money and no hope of getting any.*

(I think that on their side, it is the same; for this reason they also want to get things done in a hurry.) Madame Paul Fort has confessed to me that next month will be disastrous because of the expenses for the next issue of the journal [Vers et Prose] *etc....*

For these reasons we had all agreed to move it up by a few days, and we had chosen the date of 21 August; immediately after the ceremony we would go celebrate at the house of some friends of mine, near Poitiers.

On the other hand, this way of living between the hotel and Paul Fort's house, my life the way it is organized now, believe me, is unbearable, especially from the point of view of art. I need an enormous amount of energy just to find a way to work.

I cannot, for all sorts of reasons, give up having you in this circumstance. It is useless for me to list the diplomatic reasons, you understand and know them all.

This evening a note on the wedding will be published in the Intran;[2] *they will publish the names of the four witnesses.*

1 "Se ne va che è un piacere," sarcastic expression in Italian.
2 *L'Intransigeant.* For Gino Severini the witnesses were Apollinaire and Marinetti: for Jeanne Fort they were the noted American poet, Stuart Merrill, and Alfred Vallette, director of *Mercure de France.* They were great friends of Paul Fort, and Jeanne knew them from her childhood. The wedding was given much attention by the press in London, Paris, and throughout Italy. Paul Fort called it "The marriage of France and Italy." See *La Vita* 1983, 140–43.

If it suits you to have it a few days earlier, it could be done on the 19th.

You will only lose two days; it does not matter where you are coming from, you can get to Paris the evening of the 18th e.g. and leave on the 19th after dinner. See if you can arrange to do it this way.

Believe me, dear Marinetti, that aside from the need to get out of this indefinite state, the financial aspect of the situation, on my part and theirs, requires a rapid solution. . . .

Please answer me right away by return mail. Tell me whether you think you can count on the automobile you mentioned.

Tomorrow our friend Apollinaire is coming to lunch. He has prepared an article on Boccioni for Montjoie!. *Have you read the issue of* Gil Blas *with the article by A. Salmon. . . . It has the venom of failure.*

Madame Paul Fort and Jeanne join me in asking you to come, and send greetings. Most affectionate greetings to all my friends and an embrace from your

> *Gino Severini*
> *12 rue Sophie Germain*

LETTER 24

> *Paris 12 August 1913*

Dearest Marinetti,

Thank you infinitely for arranging to come. We are agreed that you will be here on the 27th (the marriage will be on the 28th in the morning because the 27th is not possible according to municipal rules).

Please tell me when you arrive because I would like to talk to you about things relative to art (and it would be difficult to be alone the next day).

Merill [sic], Apollinaire and Vallette have nothing against the 28th and so all is well.

Tell me whether there is any hope on the horizon regarding that filthy German swine's bill of exchange.

Painting and literature are navigating in difficult seas. . . .

Could you do me the favor of arranging to send or bring 3 or 4 labels with my name, for the paintings for Berlin.

Tell me whether it is possible to have the automobile you mentioned.

I wish you smooth sailing and embrace you affectionately

> *your Gino Severini*

Paul Fort's family sends greetings

12 rue Sophie Germain

POSTCARD 25 [1]

Paris, August [1913]

to the Great Futurist Poet
F. T. Marinetti
61 Corso Venezia
Italy Milano

Dearest Marinetti
I am extremely happy.... It is a wonderful event.
Very important. Good, good, Letter follows.
I embrace you all affectionately

Gino Severini

1 Picture postcard, dated by cancellation. *Spanish Dancers at the Monico* (F110), Marlborough Gallery.

LETTER 26

Pienza 11 October 1913

Dearest Marinetti,

Your manifesto on the Teatro di Varietà [1] *is beautiful. Speaking of theater, I am sending you a lovely story in the* Sourire.

I am also sending you some articles that you may already know, given to me by Paul Fort.

The manifesto I spoke to you about in Paris is almost ready, tell me where I should send it; if I ought to send it to some of the Paris newspapers. In other words I am awaiting your instructions regarding this. [2]

———————————————

Boccioni wrote me that we will soon get possession of that little sum of money from Berlin.

On that I owe you 430 lire
of which you gave me 150 at the Grand Hôtel, 30 you sent to me
and 250 you also sent to me from Rome.

You would do me an immense favor if you reimbursed yourself the least possible amount; since I really need to go to Rome as soon as possible with that money.

Against all my predictions I am living an intolerable life here that leaves me no peace at of any sort.

Jeanne cordially detests my family and they cannot stand her. You understand: absolutely different in habits, temperaments, and conceptions of life. Continuous wars, tears, battles that exasperate me.

(I hope (in fact, without doubt) the next exhibitions will go better, and that, in several installments, I will be able to reimburse you.)

I thank you in advance; once I am in Rome, with a few contacts I will manage. What can I do, for my health I absolutely must spend this winter in Rome. (I am already doing better.)

1 *Il Teatro di Varietà*, Milan, Direzione del Movimento Futurista, 29 September 1913 (leaflet). Published in *Lacerba,* 1 October 1913.
2 Throughout the following year Severini makes many references to the manifesto he was writing. The progress of this manifesto is reviewed above in the essay, The Disappearance and Reappearance of the Futurist Object. See also Letters 26–47.

The manifesto is in French. If you want it in Italian please tell me; but I will still work on it for a few days. Answer me about this.

Jeanne sends her greetings and I embrace you fraternally.

your Gino Severini

P. S. *Here there is a terrible electoral fight; the Mayor Conte Piccolomini has had me registered as a voter....Is it necessary to abstain from voting?*

LETTER 27

<u>*Please answer right away*</u> *Pienza 16 October 1913*

Dearest Marinetti,

Since I did not get an answer to my last letter I am afraid that you are away. I would be very upset if the manifesto that I spoke to you about, which is ready, were to come out late; since there could be no better moment than this to feed it to the Paris newspapers.

In fact it seems that the famous Lacerba *trial that* Gil Blas *gave a tragic account of has started a real scandal, to which the other newspapers are paying some more or less benevolent attention.*

Paul Fort sent me a telegram asking what had happened in Milan; then he had Madame Fort write to me that it was necessary to make a public denial.

I explained that the trial was done amongst ourselves as a joke, and that they should just let things go as they are.

Because of this and maybe because of Carrà's manifesto, the press is full of Futurism.

Let's give them another one; they will say that we have manifesto diarrhea....

I think this manifesto will interest you; I am certain that it will raise hell — because I have touched on certain subjects...of curious interest!

Answer as soon as possible, I am awaiting your answer about this, because I would not want to let this new publicity about us pass without taking advantage of it as you taught me to do!...

Tell me where things stand with the German Borchardt since I am in the darkest stew. Send me one or two volumes of the Futurist anthology right away, and various series of all the manifestos.

The Contessa Piccolomini is here again with guests, and I have started a new Futurist campaign with them that is having some success.

I will visit her in Rome because I think her circle is useful and interesting.

Write right away. Affectionate greetings to all.

I embrace you

your Gino Severini

Pienza 22 October 1913

Dearest Marinetti

 Here is the manifesto in which I elect you Messiah. I hope that you will make me Pope. The adjective: Religieux *is used in the ethical, philosophical sense.*

 Since many pictorial truths are by this point common to all of us, it would be better to use

 Manifeste synthèse futuriste.

 On page 4 where I say: "Every sensation can be rendered by means of forms and colors," I am quoting my own preface [1] *from London and Berlin and Carrà's manifesto. If this were to displease Carrà, to whom I had written that I had also prepared a manifesto on Sounds and Noises, eliminate it, since I am above all concerned that there be perfect accord among us.*

 As you will see clarity requires a printing with different kinds of typefaces.

 I don't think I have plagiarized Apollinaire by using his classic merde, since he is one of the family by now ….

 Tell me when I must send a copy to (Action d'art — *Paris*) Lacerba — *etc ….*

 Greetings from Jeanne; affectionate embraces to all and especially to you from your

 Gino Severini

Write and tell me whether it is OK *or requires modifications — I hope that it is not too short! …*

1 *The Futurist Painter Severini Exhibits His Latest Works*, Marlborough Gallery, London, 7 April 1913, reads: "I believe that every sensation may be rendered in a plastic manner. Noise and sounds enter into the element, 'ambiance,' and may be translated through forms." Carrà's manifesto, *The Painting of Sounds, Noises, and Smells*, was published in *Lacerba*, 1 September 1913 (fig. 12). Carrà and Severini agree on many points but the exact words quoted in the letter do not appear in either publication.

Pienza 3 Nov. 1913

Dearest Marinetti,

 I have read in the Giornale d'Italia *the long and interesting interview where you synthesized our social and artistic attitudes so well.*

 Excellent, for the success of "Elettricità." [1]

 Great, Madame Ferrero with her open letter. [2]

 Please hold off the publication of the manifesto since it will be necessary to eliminate certain things and modify others. I will write to you about this in a few days.

 I know that you are going to Paris on the 7th and to London on the 12th. Greetings to everyone in Paris. Did you read the article on Lacerba *in* Gil Blas?

 Today I sent my last painting for the Lacerba *exhibition. With this work I begin a new series of investigations. I hope that you will like them.*

 About London, I have to tell you about a young painter whose name is Nevinson. [3] *I met him during my exhibition, and he introduced me to other young artists, who with him all became convinced Futurists.*

1 A performance in 1913 by the Compagnia Tumiati of Marinetti's *Elettricità sessuale*, a drama of 1909. Originally published with the title *Poupées électriques* and performed several times under that title.
2 *Giornale d'Italia*, October – November 1913.
3 C. R. W. Nevinson, avant-garde British painter, converted to Futurism after the London exhibitions of 1912 and 1913. With Wyndham Lewis he was co-founder of the publication *Blast*, and he was briefly associated with the Vorticists. He fell out with Lewis after Marinetti and Nevinson together published *Vital English Art: Futurist Manifesto*

He wrote to me a couple of weeks ago asking me to send some of my work to a dealer friend of his, since some sales were possible. I sent two drawings that the group of young painters, it seems, was enthusiastic about. However, no sales!...

<u>*Nevinson will thus introduce himself to you on my behalf; he writes to me enthusiastically about Futurism and will put himself at your service for any purpose that you may deem useful.*</u>

I am enclosing a photograph that he sent to me of one of his first Futurist works. Naturally you will show it to our friends.

Nevinson is a real Englishman; he still has a lot to understand about [top of this page of the letter has been cut off].

If you see Roger Fry, as is almost certain, thank him so much on my part for the very nice letter he sent for the wedding — and greetings. I think he has been completely conquered by Futurism. Give him the finishing touches.

———————————

If a certain Sydney Schiff introduces himself giving my name, I warn you that he is a shit; he wasted my time.

———————————

I thank you infinitely for doing me the favor I asked for regarding the Berlin money.

But I have not heard anything…and the situation is becoming impossible. I live in a true inferno; I must [back side of page with missing top] *the way to sell some; do you think the German will pay? I await this money anxiously so I can get out of here; I hope I can get some peace, I can't stand these useless battles anymore.*

Write to me. Very affectionate greetings to all. Jeanne sends her greetings.

> *fraternally yours Gino Severini*

(June 1914). Nevinson was a warm and generous friend to Severini. See *La Vita* 1983, 133, 149.

..

LETTER 30

> *Pienza 10 Nov. 1913*

Dearest Marinetti,

I got your letter yesterday. I had asked you to suspend publication precisely because in rereading the manifesto I had seen that it was necessary to remove the Merda et Rose *and also* Titres des tableaux.

And also new ideas require that I expand the section: Pittura Religiosa, *to which I will give a new title.*

Therefore I will expand it and work calmly since I have more than a month of time.

Please tell me whether, by making it more of an article-synthesis, I can use it for Der Sturm, Action d'art, Lacerba. *They are asking me for articles, especially* Action d'art *in Paris and also* Der Sturm.

<u>*Do you have any news from Walden concerning the 29 works that would be on exhibit, according to him, in Hamburg?*</u>

1 Two works by Severini were exhibited in the Post-Impressionist and Futurist Exhibition of 1913: no. 58 *Polka*, and no. 59 *Waltz*. These works have, in fact, disappeared.

I am sending you the address of the gallery in London where I sent the two drawings; please go and have a look and tell me what it's like. (Maybe those have been lost too)…[1]

Doré Gallery
35 New Bond Street
London

Will you go to Florence for the Lacerba *exhibition?*
Has the German finally decided to shell out the money? I am really hard up and await good news about a payment…but when? This is killing me!!!
I embrace you fraternally.

your Gino Severini

[written in red pencil, in large letters, sideways] *Answer as soon as possible please*

POSTCARD 31[1]

Anzio 24-12-13 [1913]

Dearest Marinetti

Please tell me by return mail whether you will be in Rome on the 28th or when. I have to go there to transport some works and will make my stay coincide with yours; I absolutely need to talk to you about the manifesto. My latest works are the outgrowth of it and conversely, they foretell its contents.

Have some manifestos in Italian sent to me; and paper and envelopes.
Affectionately yours

Gino Severini

1 Picture postcard, *The Motorbus* (F129), Marlborough Gallery.

LETTER 32

Anzio 7 January 1913 [1914][1]

Dearest Marinetti,

Here is the manifesto, which I tried to intensify and synthesize. It seems clear and well-organized to me. I am sending you two versions of page 12 because I cannot decide whether I should end with the words plastic analogy*. I think it might be better to remove the part between "analogie plastiche" and the end. You can see for yourself.*

I barely pressed the issue of the social influence of Futurism, but this is such a vast and important topic that I plan to develop it in a lecture. I think that the quotation from Kant about individual autonomy *(another wonderful issue to be discussed) does not give an excessively philosophical, erudite character to my exaltation of intuitive forces.*

I quoted the parts of your manifesto that I believe are most significant for us as painters; I think I have given an exact definition of analogies and their expressive power.

1 The contents of the letter show that it was written in January 1914. Severini must have made a mistake in dating it.
2 The young painter and art critic, Giuseppe Sprovieri, opened the Galleria Futurista Permanente in Rome in December 1913, and from that date he held Futurist exhibitions in Rome at Via del Tritone, 125, and in Naples at the Galleria Futurista, Via dei Mille, 16.

It is no longer possible to separate these two elements which complete each other. In my opinion <u>thought</u> includes <u>action</u>, <u>sensibility</u>, and <u>intelligence</u> — I speak of matter and thought — three dynamic and simultaneous forms of mental activity.

———————————

We will talk about these things in person on the 14th since you are coming to Rome.

Please send me whatever you can because I have virtually exhausted my resources.... I had to pay 40 lire rent, 15 for the nurse, and 10 for medicines, injections, etc.; therefore I have but twenty or so lire left out of the 100 from Florence.

French literature cannot do anything because of the incredible number of issues of V.e.P. [Vers et Prose] that are appearing and because of the Terme de Janvier....

At the end of January Jean de Bonnefort, whom you met at the Mercure, *will come to Rome.*

He has invited me to come and visit, and I hope I will be able to arrange something, he has so many contacts.

So please help me until the beginning of February; I am aware of the enormous expenses you have, and I understand the difficulty my situation puts you in, but who else could I go to for help here?

I have sent the sketch for the poster to Sprovieri.[2] I hope to bring the finished one on the 14th.

———————————

Please tell me whether you are coming to Rome on the 14th or on the 15th; because I can only come for a day and I will come on the 14th in the morning or on the 15th depending on your answer. I cannot stay longer because of my health and for financial reasons.

My health is continuing to get better; it just needs a little peace.

I beg you to answer and send me what you can right away otherwise I will not be able to go on, nor will I be able to come to Rome. I thank you, and I embrace you affectionately.

 your Gino Severini

My best greetings to Boccioni (and the book?) to Carrà and Russolo. Have you seen my drawing in the latest Sturm? *again, ciao, write right away.*

[upper left] I have found a new plastic and aggressive form that I cannot claim as my own offspring!...Please eliminate it, but I laughed so much putting it into the manifesto....

..

POSTCARD 33[1]

 Anzio 24-1-14 [1914]

Dearest Marinetti

 I got your letter this evening and just this morning I had written and sent another version of the manifesto. I will be happy to see you in Rome on the 28th, and I will

1 Picture postcard, *Spanish Dancers at the Monico* (F110), Marlborough Gallery. See fig. 3.

definitely be there. I will arrive at noon and be at the [Café] Aragno at 2, don't stand me up.[2] *Very affectionate greetings to all my friends. An embrace from your*

Gino Severini

Warn me if you are no longer going on the 28th.

2 Text reads "non posare lapin" (don't play rabbit), a mixed French and Italian use of the French idiom, "poser un lapin à quelqu'un," i.e., to fail to turn up for a rendez-vous.

LETTER 34

Anzio 19-2-14 [1914]

Dearest Marinetti,

I am sending you the manifesto, translated into Italian, and made even more clear. I think that it is good now; I have made a few changes to the technical side of it.

Try to publish it as soon as possible or it will become Pulcinella's secret.

I would be very pleased if it were to come out in Paris while you are there with our friends; you could stir up discussions and explain it and defend it in the circles we frequent, as I do when I am in Paris, my favorite battlefield.

Please keep the difference between the typefaces, and even accentuate it if this does not create typographical difficulties.

Write soon. Ciao, and greetings to all.

Tell Carrà to write to me about Florence.

Will you take care of sending it to Lacerba? *Write me about this as soon as possible.*

I went to Rome for the inauguration of the exhibition, which took a truly unusual form — Boccioni and Carrà will surely have told you about it.

It will be very useful for you to visit, to bring things back to an appropriate level....

How did things go in Russia?

They say that the cold makes one's hair grow, following your advice I will go too as soon as I have finished my heat cure, but it may be too late by then, since it is falling out at an alarming rate....

Patience and courage. Ciao, write soon about the manifesto. I embrace you affectionately.

your Gino Severini

LETTER 35

Anzio 23-2-14 [1914]

Dearest Marinetti,

Did you get back from the Russias? I got Lacerba *today and am reading Papini's article "Il cerchio si chiude."*[1]

As you can see my manifesto answers the problem posed by Papini. The moment is ripe to feed it to the media.

1 Giovanni Papini, Italian writer, editor of *Leonardo,* contributor to *La Voce,* and founder of *Lacerba,* 1913–15, which was to become a Futurist organ. His essay "Il cerchio si chiude" (*Lacerba,* 15 February 1914), was the beginning of

Please do not delay, in any case you will understand on your own the value of acting quickly — as quickly as possible.

Write me about this.

I embrace you

> *your Gino Severini*

an argument with Boccioni who answered with "Il cerchio non si chiude" (*Lacerba*, 1 March 1914) and continued with Papini's answer, "Cerchi aperti" (*Lacerba*, 15 March 1914).

POSTCARD 36[1]

Dearest Marinetti,

Before you leave Milan again, write me, please, about the manifesto; which you could in the meantime send to Lacerba.

Write as soon as possible about this.

> *affectionately*
> *your Gino Severini*

1 Cancellation date is Rome, 13 March 1914. Picture postcard, *A Dancer at Pigal's* [*sic*] (F109), Marlborough Gallery.

LETTER 37

> *Anzio 23-3-14* [1914]

Dearest Marinetti

I understand your fears, but do not be afraid, I have never thought of engaging in polemics with my friends. I wrote privately to Papini and it would have been better if Boccioni had done the same, since if Papini were wrong to debate such an issue publicly, Boccioni was even more at fault in attacking it <u>publicly</u> *and without resolving the plastic* <u>problem raised by Papini</u>.[1]

Fortunately it is all over and it will not have consequences given the serious and very solid ties of common understanding and affection that bind us all together.

I am awaiting your telegram that will tell me the exact day of our appointment in Rome.

I felt the need to clarify even further a few points of the manifesto, but there are no major changes.

See you soon.

> *Affectionately yours Gino Severini*

Please have some paper sent to me

1 See above Letter 35, note 1.

LETTER 38[1]

> *Anzio 28-3-14* [1914]

Dearest Marinetti,

Here are the titles for the London catalogue; some of them have been modified, and only one work has been added; a charcoal drawing that I will send or bring in person to Sprovieri (depending on the telegram I am expecting from you).

1 See fig. 4.
2 The catalogue numbers run from 46 to 58. In the catalogue titles, dashes are used instead of

Rome Catalogue	_London Catalogue_ [2]
1. Tramway in rapid motion	_1. Light + speed + noise in simultaneous interpenetration_
2. Argentine tango	_2. Forms and color sound of the Argentine Tango_
3. Sea = Dancer	_3. Sea = Dancer_
4. Spherical expansion of light (centripetal)	_4. Spherical expansion of light (centripetal)_
5. Spherical expansion of light (centrifugal)	_5. Spherical expansion of light (centrifugal)_ } _studies_
6. Portrait of Marinetti	_6. Dynamic Decomposition of the Portrait of Marinetti_
7. The 14th of July	_7. The 14th of July_
8. Argentine Tango (drawing)	_8. Forms and color sound of the Argentine Tango (drawing)_
9. Light + speed + noise (drawing)	_9. Light + speed + noise (drawing)_
10. The Double Boston (drawing No. 2)	_10. Forms and color sound of The Double Boston (drawing No. 2)_
11. Sea = Dancer (study)	_11. Sea = Dancer (study)_
12. Speed + noise (study)	_12. Dynamic continuity of a tram in rapid movement_
16. Sea = Dancer (study)	_13. Sea = Dancer (study)_
17. Sea = Dancer (study)	_14. Sea = Dancer (study)_
	15. Sailboats = Sandwich Men (drawing)

Number 15 is my latest drawing which I will send or carry to Sprovieri. Among these 15 works only the first numbers one through seven are paintings, the others are drawings. I do not have any large works, and if you think it useful and possible, instead of a drawing (for example No. 13 Sea = Dancer) you could send the Bal Tabarin _which is, I think, at Carrà's._

Do as you want to, taking into account the homogeneity of the exhibition.

I hope to see you tomorrow in Rome, since today, Saturday, I expect your telegram

mathematical symbols. The following catalogue titles differ slightly from those in the letter:

2 (47) Forms and colour-tone in the Argentine Tango
6 (50) Dynamic decomposition of the portrait of the poet Marinetti
7 (51) Dynamism of the 14th July
8 (53) Forms and colour-tone in the Argentine Tango (1st sketch)
9 (52) Light — Speed — Noise (sketch)
10 (54) Forms and colour-tone in the Double Boston (2nd sketch)

3 Francesco Cangiullo, Futurist painter, writer and composer of "words-in-freedom." Active Futurist who frequently published in _Lacerba_ and gave readings of his poetry. This letter indicates that such a reading is scheduled for the following day, 24 February 1914, probably at Sprovieri's gallery where a Futurist exhibition was then on view. For "words-in-freedom," see Hanson 1983.
4 A friendly joke on the name of Luigi Russolo, artist, musician, author of "The Art of Noises," and inventor of Futurist sound-machines known as _intonarumori_.

*without which I will not move, although I am aware of the reading with Cangiullo that
is scheduled for tomorrow Sunday.*³

*I have various things to tell you aside from the manifesto and I am counting on
speaking to you.*

*Most affectionate greetings to you, blond and great Noises Russolo, which you will
fraternally divide with the no less great and blond Luigi Intona.*⁴

I embrace you all.

<div align="center">yours　Gino Severini</div>

[in pencil, written sideways along the page] *I am sorry that there is no photograph of a
work more recent and more important than the 14th of July. You could have warned me
in enough time to provide some photographs — Rome. In catalogues I always have repro-
ductions of recent works, at least from the past year, and this bothers me very much.*

LETTER 39

<div align="right">Anzio 31-3-14 [1914]</div>

Dearest Marinetti,

*I waited in vain for your telegram and did not move fearing some sudden change
of date....*

*I am very displeased that I did not get to see you because if we go on like this my
manifesto will end up being anticipated and I'll get stuck.*

*Remember that I am following the current artistic movements in Paris from here
and that I am most furious at being so far away. Furthermore, I have been forced to give
up every type of activity through which I could make my presence felt in my circles, where
I do not want to be forgotten; that is, I cannot write any articles about painting before the
publication of the manifesto. Do you understand my situation?*

Thus please tell me as soon as possible:

*1. If you plan to go back to Rome soon and whether, therefore, it will be possible to see
each other.*

*2. If you think it necessary or useful that I send you another copy of the manifesto with
the few changes I have thought it necessary to make to adjust the form and make it more
precise and more clear.*

———————

I have sent you the list of works for the London catalogue. When will the exhibition begin?

———————

*In a postcard to me Madame Paul Fort announces that Giannattasio does not want to be
included "dans notre chapelle" and that he has sent in his resignation from Futurism....
Is it true? It seems that Ciacelli*¹ *has imitated him.*

Two fewer idiots in the way will not be a problem, on the contrary.

———————

1 By this time, both Ugo Giannat-
tasio and Arturo Ciacelli had lost
interest in Futurism.

2 This letter involves unfinished
business concerning the exhibition
of the painters for *Lacerba*, from
November 1913 to January 1914.
Severini is anxious to receive
money owed to him by Ferrante
Gonnelli, director of the Galleria
Gonnelli, via Cavour, 48, Florence,
and needs Marinetti's help. See *La
Vita* 1983, 153.

Did you choose the sketch for the Rome poster?

———————————

I need a great and urgent favor from you. Gonnelli has always made me suffer to get the money from his sales, but this last time has been worse than ever.[2] *I have managed by placing all of our many clocks at the pawn shop, and also thanks to some little sums coming from* Letteratura, *but at this point I am reduced to having a most desperate need for that money. On the 4th I have to pay 2 months' rent, that is 100 lire, and I have 5 francs.... Gonnelli has been promising me 100 lire for at least two weeks. He owes me 360 lire. Boccioni wrote to me saying that he is completely honest (and I don't want to have any doubts about that) and that I should be patient if he puts our paintings up for sale without telling us, because he is a friend....I find this reasoning ludicrous. A number of times I have been down to my last penny when (after I had asked repeatedly), the money or an installment of it came, accompanied by a laconic and mysterious "the rest is coming soon." This time I really am in a hopeless situation because I no longer have even the few objects of value from which I could get immediate use. And after all this I have to ask him for my own money like a beggar....Because, according to him the paintings have not been paid for, therefore he promises me payments which he does not send. I don't understand this at all. I am terribly bothered by it. I don't know if your rich grandfather psychology will allow you to understand all these situations, and the nausea they cause....*

I beg you to send me an advance for as much as you can, reimbursable on these 360 lire (but right away, I do not ask except in cases of most pressing need because I am not ignorant of your innumerable commitments) and then I beg you to act so as to make Gonnelli pay the entire sum as soon as possible.

I am counting on you and I greet you affectionately

your Gino Severini

[upper left margin, sideways] *P. S. I have waited until this morning 1 April, but no news from Gonnelli. Please provide immediately.*

··

LETTER 40

Have paper sent to me s.v.p.!

Anzio 9-4-14 [1914]

My dearest Marinetti,

I have received your wonderful book that realizes in literary terms the dynamism and the communicative warmth that I want to put in my paintings. It is the most beautiful literary work ever to appear until now.

Thanks for the book but not for the word passatista *that, even as a joke, I cannot bear to hear applied to myself....*

I hope that before you go to Paris you will want to define and decide about the publication of my manifesto, which is becoming increasingly urgent.

Even judging from the newspaper accounts of the Indépendants I think the moment is propitious, but we must not wait around, on the contrary it would be better if it were already published, since it has been ready for more than a month.

Write to me about this as soon as possible; I hope that since the last one I sent was in Italian, it will do well as far as order and clarity go.

I know that all my painter friends are in Paris and I envy them.

If in going to Rome you pass through and stop in Florence, go see Gonnelli (to whom I wrote 10 days ago and am again writing even more firmly today) and tell him to send me the money from the two dancers + the percentage on the entrances.

I have exhausted all my resources and we are living on the money from our pawned clocks....

The doctors find that my pulmonary lesion is now closed, but prudence is still necessary and the sea [air] as much as possible.

But I hope to take my place next to my friends next winter, which, with precautions of course, I will be able to spend in Paris.

I have a feverish desire to work....

I cannot even write because before the publication of the manifesto it is better not to let the latest conclusions slip out.

Write as soon as possible, remember that I am most anxious to decide this issue.

An embrace from your

> *Gino Severini*

LETTER 41

Anzio 22 April 1914

Dear Marinetti,

I waited for your telegram to no avail.

You must have undoubtedly decided that it was useless to give me an appointment in Rome since I could not move....

I will tell you right away that you have painfully surprised me.

The friendship that you have shown me on other occasions authorized me to hope for a more generous, spontaneous, and affectionate action on your part in this most painful circumstance, which is decisive for my life and my art.

Fortunately others have given me those proofs of brotherhood and solidarity that none of my best friends have given, except Russolo.

Since I see that at least temporarily it is difficult for us to meet I am sending you the definitive copy of the manifesto. I think that I have expressed with clarity and exactitude my latest conclusions on plastic art; I have nonetheless left a small margin for your eventual comments.

Please examine the slight modifications and the small but important additions I have thought it important to make for the purpose of precision.

If you should believe it necessary to make changes I would ask you point them out to me as soon as possible, so that we may be ready to have it come out finally before the end of May.

Boccioni is already talking about plastic analogies in his book even though (according to what you told me at the Aragno) they had never been mentioned before that very morning when I brought you the manifesto; moreover, at the Indépendants, there were sculptures that were actually colored as I specified in the manifesto: colored by <u>all</u> the colors of the prism arranged <u>in a spherical expansion</u>.

All this has led me to be more precise, so all the better.

I have expanded all the ideas of the manifesto in a lecture. I am waiting for the former to come out before publishing the latter.

Let's hope for complete success and sales in London.

A handshake from your

Gino Severini

LETTER 42

Anzio 26 April 14 [1914]

Dearest Marinetti,

<u>*I understand and I agree with no qualifications: Futurism above all.*</u>

I did not have any illusions about the profits from the evenings, which I never thought of (the 50 francs that came from Florence were a surprise).

I know and can imagine all the great expenses that you incur for Futurism in general and for painting in particular. Your way of spending your money causes admiration, affection, gratitude in me.

I know you, of course, and know that you do have a heart, but your uncompromising and indefatigable will to push everything forward makes your action so swift that it pre-vents you from evaluating the instincts and affections that are a great part of our interior richness, and to which we must occasionally submit ourselves, even at the cost of having to accuse ourselves of being weak.

Moreover I was only asking for an advance installment on the money Gonnelli owes me, which he would surely have given back to you since he does all he can to pay me in installments.

This service would not only have saved me from worries and anxieties that are terrible for my health (the great Futurist activity that I can and must contribute depends on this),[1] *but it would also have spared me moments of painful uncertainty caused by your temporary indifference.*

1 The words in these parentheses are written in an italic style as if for emphasis.

I sent my definitive manuscript of the Manifesto at the same time as my letter, I hope that you receive it before your departure for London.

Here are the approximate prices…

		English pounds or Sterling
No. 1 = *luce + velocità + rumore ecc.*		£ 25.
No. 2	*Forme e colori - suono del tango*	" 35.
No. 3	*Mare = ballerina*	" 35.
No. 4	*Espansione sferica luce*	" 10.
No. 5	" " "	" 10.

No. 6 *(your portrait), (since you like it I would like it to become your property, not as a reimbursement, etc. (do you understand?…) but because I promised you and have owed you a work for a long time, and this one that I am offering you repre-sents one of my first attempts at painting-sculpture, which I will develop into complex plastic colored ensembles as soon as I am back in a studio in Paris.)*

From No. 8 to No. 15 are pastels or drawings the price of which can vary from 5 pounds (125 francs) to 6 or 7 pounds — depending on each case.

Let's hope for a sale that I need so badly. If you see that tiresome moron Gino Calza Bedolo whom I met in London, who mocks us with idiotic frequency, you would do well to break his enormous nose, more enormous than mine, which bothers me!…

If you see Nevinson give him all my greetings: he is a good Futurist and a dear and affectionate friend.

I thank you for the Milan newspapers where I saw with great pleasure that you have remained unharmed and that you have dealt quite a few blows. Tell me whether you intend to give lectures in Berlin, because it would be necessary to act energetically with Walden who has stolen all 29 of the works that I exhibited at his place.

Believe me, also, to be your affectionate friend

G Severini

POSTCARD 43 [1]

Anzio 14-5-14 [1914]

Dear Marinetti,

I got the 35 francs and thank you. Let's hope that Walden continues. Alas Gonnelli is not doing the same and I have decided to call a bailiff. It seems that Walden has also sent me my 29 works, at Sprovieri's, since he is asking for the titles by telegram from Naples.

1 Picture postcard, *The Nord-Sud Railway* (F130), Marlborough Gallery, apparently mailed in envelope. No stamp, address, or postal cancellation.

I hope that he has reached an agreement with you and with my friends because, if all the works were to be exhibited in Naples, there would be a great lack of equilibrium between my contribution and that of the others. For which I do not want to be held responsible. On the 20th or 21st I will be in Rome because I am leaving Anzio. I would like to meet with you. Write to me about the manifesto, which we must agree on definitively.

[written on face of postcard, over the image] I have heard about your lectures etc. in London, all the better, and let's hope for greater triumphs. Write. Or visit, which would be better.

 Greetings to all and to you affectionately

 your Gino Severini

POSTCARD 44[1]

 Montepulciano 4-7-14 [1914]

Dearest Marinetti,

 You would do me a favor if you sent that little sum to <u>Montepulciano</u> *(Post) (Prov. of Siena). I will go through Milan in the beginning of September. Please tell me whether this time is definitively convenient for the meetings we scheduled in Rome. If you want me to send you another copy of the manifesto with the slight modifications I mentioned, write me.*

 Affectionately yours,

 Gino Severini

1 Picture postcard, *The Motorbus* (F129), Marlborough Gallery, apparently mailed in envelope. No stamp, address, or postal cancellation.

POSTCARD 45[1]

 20 July [1914]

Dearest Marinetti,

 I am working on two paintings for Moscow that I will send you.

 I got your registered letter today.

 I wrote yesterday to Carrà about the drawing published in Lacerba.[2] *The formulation* <u>Drawing or painting of words in freedom</u> *is fine. I asked Papini to put "Pictorial literature" at the head of the drawing but I don't know what he did because I have not seen the newspaper that reproduced the drawing. Thanks for the money order for 30 lire. Thus I had 95 lire.* <u>We will thus see each other on or around 10 September</u>. *I will send you the manifesto soon. Very affectionate embraces to all and an embrace to you from your*

 G Severini

1 Picture postcard, *The Nord-Sud Railway* (F130), Marlborough Gallery, apparently mailed in envelope. No stamp, address, or postal cancellation. Dated by reference to Carrà drawing published in *Lacerba*.
2 In *Lacerba*, 1 July 1914, Carrà published a free-word drawing (*parole-in-libertà*). Severini's *Serpentine Dance* (F216) appeared in the same issue.

Montepulciano 6-8-14 [1914]

Dearest Marinetti,

The copy of the manifesto is ready, a little late, because I wanted to finish a painting that I had started and then I was taken by a high fever. But after the latest European events, which will absorb your attention and make you slip off to who knows where, I think it useless to send it to you. Please write to me about this, in any case it is at your disposal.

What do you think of the events? The slowness with which Italy is getting ready to confront the situation that will inevitably occur is exasperating.

I am very unhappy to be so isolated from the world and completely unable to reach the great centers where the most restless and intense life is being lived at this moment. Consider me morally close to you in all the attitudes that the events may suggest or impose.

In the meantime I am explaining my activities as well as I can. I am organizing an event on the 15th or the 20th [August 1914] in which I will explain especially the origins and the psychology of Futurism. If you can, send me some manifestos in Italian.

Naturally no one knows anything about our London exhibition and the one in Moscow is now out of the question. The German will take advantage of the situation to suspend payments. If by any chance he sent the quota for August, please send me my share, since the events are making my situation, which was anything but rosy, even worse.

Did a crate of drawings arrive in Milan from Rome, whence it had been sent in April by Walden? It should contain 23 drawings and I would be sorry to lose them. That swine Gonnelli does not want to hear anything about paying up so I will sue him!…

Most affectionate greetings to all my friends and an embrace to you from your

Gino Severini

Answer right away.

Montepulciano 19-8-14 [1914]

Dear Marinetti,

I received your letter and the beautiful book of manifestos with pleasure.[1]

I hope that the first of the second series will be my own, which was conceived 9 months ago, like a newborn.

In these moments that are so serious and interesting I think it is useless to send it to you and talk to you about it, and so I will leave this subject for later, if we are still alive!

What do you think of Italy's attitude? I think this neutrality is a little too long, and I am afraid that a French victory will prevent us from throwing ourselves on that side and against Austria, without the aspect of having taken advantage, with cowardice, of the latter's defeat.

1 Severini left Montepulciano for Rome arriving 20 December 1914, see *La Vita* 1983, 161. The book mentioned is Marinetti 1914.

If neutrality has been a diplomatic act of the first order, to continue it at this point seems to me a loss of precious time.

Jeanne and I are living in the most terrible state of anxiety for the destiny of our France to whom we are attached by all the ties that you know. Recent demonstrations of sympathy toward Italy, although far from disinterested, make me forget past incidents.

Write to me about what you are doing and plan to do.

We are not getting any more letters from anywhere. Let me know if during your last trip to Paris you saw Paul Fort or his wife. We know that he had to leave, perhaps they put him in some Office, or he has already gotten himself killed.

If you know something please let me know immediately. [underlined in red pencil]

Could you send the 1 August issue of Lacerba? *I did not get it; they only send it to me when they remember.*

I am trying all avenues to get to Rome since with no resources in a little town like this it is terrible.

Write and warmly greet all my friends.

An embrace from your

GinoSeverini

P.S. *When you can, inform me about the contents of the crate*

LETTER 48

Montepulciano 1 Sept. 1914

Dearest Marinetti,

I am writing you a business letter:

I thought it useless to tell you more about my credit with Gonnelli, but now I have to tell you what things have come to. After I wrote many letters from Anzio, I succeeded in getting three installments of 50 lire each on the 400 that he owed me. So he still had to give me 250 lire less the 10% which is his, i.e. 210 lire.

I used all methods to get this money, and as long as I had 5 francs in front of me I was patient and I waited for him to fulfill his promises.... But he really didn't give a damn about me in the least, and so I turned to a lawyer here, to whom I have given full power.

There was an exchange of correspondence between my lawyer and the one he called to represent him; he had him offer me a promissory note which I did not accept because I need money and not paper; but he thus let a little more time pass uselessly, as it was from December to today....

Therefore my lawyer put into effect the threat he had communicated to him though his lawyer, that is, he pressed charges with the Magistrate. I was called in to verify the charges.... I cannot describe the sense of repulsion and disgust that I feel at these gestures that are so deprived of beauty.... I would prefer to spit in his face and leave him his 210 francs....

But my financial situation is terrible. Because of him I am forced to live a banal and infernal family life in this most disgusting town. I don't know whether you know that in London some young artists raised a subscription in my favor, that allowed me to leave Anzio: with Gonnelli's 200 francs I could have had just the sum to go away to the mountains and recover completely. Instead I was forced to come here, and I have sadly lost almost everything that I had acquired at Anzio.

Therefore I really must return to Rome as soon as possible, also because a little Futurist will be coming into the world and this complicates things not a little. In Rome there are appropriate institutions which we will use, whereas here the most sordid and loathsome and <u>glaring</u> misery menaces us.

Therefore I have decided to act most energetically with Gonnelli; that money is the only way out for me.

Before things became irreparable I wanted to inform you; since the consequences of pressing charges will be very painful. Gonnelli can go to prison for up to 1 year, plus pay a fine, and, if by any chance (although I think it unlikely) it came out that the two paintings were sold for more than 400 lire, then things would get even worse.... I think it unlikely, but so many people have been playing these kinds of tricks on us that anything is possible. My lawyer and I have letters from Gonnelli that prove his debt.

I have thus warned you of this step I am about to take and I am proposing something, if you wish to or think it useful to avoid it.

I will forward this credit of 210 lire to you, and you will send me that sum. If this makes me save time and facilitates my move to Rome, it also saves Gonnelli from a graver difficulty.... Do as you think best.

I await your answer by return mail; once the time needed for the travel of two letters has passed, I will go on with the charges against Gonnelli. I am very saddened by this, but my situation is too painful for me to have the luxury of being compassionate toward others.

My lecture here was a good Futurist success.

Greetings to all my friends and an embrace for you

 from your Gino Severini

LETTER 49

 Paris 28 Nov. 1914

Dear Marinetti,

Coming back home from the studio I find the letter that you wrote to Paul Fort and, having read the passage that concerns me, I am taking advantage of this short free time to answer your registered letter. I too, like my friends in Milan, am working formidably. The Futurist atmosphere in which I live has renewed my plastic knowledge of reality completely. I began to achieve a less abstract realism, which had some points of contact with the reality of vision, but from this to making a jump all the way back to Post-Impressionism is

quite a distance. First of all one should know what my friends mean by advanced Post-Impressionism it is likely that there are diverse opinions on this point and in any case it is unimportant.

I am working with faith, sincerity, and without any sort of worries, as always; it is the best system to adopt when there is gunpowder around.

If you want a drawing for the journal that you mention, tell me and I will send it; but I have my doubts about its arrival at its destination.

Insofar as the exhibitions are concerned, we will have a chance to talk about them later. I don't think the war will go on for 10 years. Germany and Austria could not resist economically and this war is essentially economic.

When calm is restored at least in Western Europe, we will have to deal with French chauvinism which will reach fantastic heights with victory (which is by now certain). . . . Especially if an Italian intervention were to come late, too late, as an expert friend of mine writes from London.

I understand and participate in your impatience and anxiety.

I can announce with pleasure, given the great interest that all of you have shown for my health, that that famous tuberculous lung (the reason for so much pain) is definitively healed. I am gaining weight regularly and I see my physical strength being reborn in the robustness of my work.

Please excuse the delay in my answer to you (usually I answer my friends completely and immediately) and consider it a result of my work.

I clasp your hand

 your Gino Severini

LETTER 50

Paris 1 January 15 [1915]

Dear Marinetti,

Cascella[1] came and I showed him my drawings. He likes all of them (or so he says) and especially an infantry soldier, a little color sketch, which he would like to reproduce as is.

Concerning Paul Fort, he is very happy to contribute to the journal; but he pointed out to me that his Poèmes de France *and two other books that are now ready but not yet in circulation mean that he is a little short of* unpublished *stuff. Since only a dozen subscribers know the* Poèmes de France *in Italy, why don't you pick whatever you like from the* Poèmes, *whenever it suits you?*[2]

Or he can send some stuff that will appear in the Poèmes *later.*

This is the case of the poem I am sending you, "Les Cosaques" which will appear on 15 January.

1 Italian painter working in France. He was the son of Basilio Cascella who directed the review, *La Grande Illustrazione.* See below, Letter 52.
2 Paul Fort, *Poèmes de France,* nos. 1–24, December 1914–November 1915. Bi-monthly. Available by subscription; also sold at R. Helleu, 125, Boulevard Saint-Germain, Paris.
3 See fig. 30.
4 *Fregnaccismo* (pomposity) implies a propensity for looking

As Cascella wanted, I made a small drawing that will be reproduced and printed above Paul Fort's poem thus:

> *This drawing*
> *is a quick sketch*
> *for a painting*[3]

It should be reproduced in the same size, or <u>slightly</u> smaller than the original.

About the other drawings, they told me at the post office that they do not in any way guarantee their arrival. We could try to send the soldier in color (which is small) between two pieces of cardboard. For the others, we could make the photographs here in Paris: sending photographs is safer, and the reproductions can come out well anyway. But I must tell you that sadly I do not have the slightest sum available to make these photographs (at least two need to be made) and my photographer will not extend me credit. Moreover, as you yourself stated, <u>even if only a little</u>, I hope we will get paid.

Paul Fort would like, if possible, if there is time, to correct the proofs of the poem himself, given the great number of errors they usually make in his work; if this is impossible, go over it yourself, with great care, I don't even need to say it....

So to sum up, tomorrow 2 January I will send you Paul Fort's poem and my drawing. I am expecting Cascella, who will have a poem by D'Annunzio, in the morning, maybe we will mail everything together.

I have to say that young Cascella has already made and sent two drawings (which I have not seen), and that, judging from the way he talks, he seems to be gifted with peasant cleverness and with an instinct above all for speculation. Perhaps he has some coarse intuitive richness, but how full of Italian pomposity![4]

Beware.

The other day he got himself arrested for spying (as usual because of that Italian mania for the sketch from life) even though I had cautioned him peremptorily not to draw in the streets. He was in serious trouble and was freed by D'Annunzio. I think his confidence is rather shaken.

Answer me right away. Paul Fort sends his greetings. Greetings and best wishes to all from your

> *Gino Severini*

6 rue Sophie Germain Paris

P.S. *I am forced to fold the drawing in two. You will have to have it fixed with a hot iron to get rid of the fold.*

out for oneself, and the presentation of self as more than is truly there; it has both a positive and a negative quality.

POSTCARD 51

Paris 2 Jan. 15 [1915]

Dear Marinetti

I gave Cascella Paul Fort's poem and my drawing; he is taking care of mailing it as required.

Please tell me of the arrival, which you surely will be informed of.

Ciao your Gino Severini

LETTER 52

Paris 22 January 1915

Dear Marinetti

Paul Fort has asked me to send you this issue of the Poèmes de France *because of some small modifications that should be made in the printing of "Les Cosaques," if we are still in time.*

Maybe the issue of the Grande Illu. [Illustrazione] *has already come out; in this case we would ask you to send us a few copies.*

Cascella intimated that his father was no longer the head of the magazine, which will be directed by a Marquis X..., businessman. I got the impression that this fact will change the spirit of the magazine which will have much more illustrazione italiana....

Thus I ask that you not count on my collaboration for the coming issues. Concerning the drawing I sent to illustrate Paul Fort's poem, I hope that it will be reproduced according to my indications.

Please accept the warmest greetings from your

Gino Severini

6, rue Sophie-Germain.

LETTER 53

Paris 1 March 1915

Dear Marinetti

I got your letter with pleasure, and the gracious words for the birth of my little girl. Although my material circumstances are very difficult, as you can imagine, I do not want you to take the little sum that is owed me for the drawing in the Grande Ille *out of your own pocket.*

You did not show such generosity in moments that were much more terrible, and I don't see why you should start showing it now. I hope you understand that it is much better if our business relationship remains as is.

But I would be very grateful if you watched over and solicited the payment for the aforementioned drawing from the Grande Ille. *In any case, if they do not pay, I will not send anything else.*

I received the first issue of this Grande Ille: *it is a real salad of the worst taste, as I predicted.*

I like Delmarle's drawing very much.

I hope that you will send the second issue as soon as it comes out, and I thank you.

I read about your battles in the newspapers; let's hope they are useful; I am awaiting, like everyone, a decision, which cannot be very far off, to go to war.

Greet all my friends and accept a handclasp from your

Gino Severini

Gino and Jeanne Severini on their wedding journey, 1913.

Gino Severini: A Chronology ELISE K. KENNEY

1883–98 Born 7 April, Cortona, in Tuscany, the son of Antonio Severini, a functionary, and Settimia Antonini Severini, a dressmaker. Shows early interest in the theater and especially *commedia dell'arte*. Expelled from all state schools for a juvenile offense. Matilde Luchini, an amateur artist, encourages him to paint.

1899 Goes to Rome with his mother. Attends evening drawing classes but works as a bookkeeper to make a living. A stipend from Monsignor Passerini, a prelate from Cortona, enables Severini to direct all his energies toward his art.

1901 In Rome Severini meets Balla and Boccioni. Balla, newly arrived from Paris, teaches them the principles of Impressionism and Italian Divisionism. Attracted to socialism, Severini reads Schopenhauer, Nietzsche, Bakunin, Marx.

1902–03 Initially influenced by Balla, Severini gradually develops a personal style. Produces mostly portraits and landscapes. Henri Bergson's *Introduction to Metaphysics* is published.

1904 Severini exhibits two works at the autumn exhibition of the Amatori e Cultori: *Al solco* (F17) and *Siesta* (lost).

1905 The Amatori e Cultori jury refuses most works by Boccioni and all by Severini. Boccioni then organizes the first exhibition for the refused artists (*rifiutati*) in the foyer of the Teatro Nazionale. Severini's first patron, Van Lanschot, a Dutch banker, buys *Al solco* and *Come le foglie* (F17 and F28).

1906 Draws for *L'Avanti della domenica,* a socialist newspaper. Arrives in Paris on a "grey and rainy," late fall day. Moves into a tiny hotel near rue Vavin and shortly to 36 rue Ballu, near Place Clichy. Modigliani befriends him. At Le Lapin Agile, he meets young painters and writers, among them, Dudreville, Max Jacob, and André Salmon. Sees Impressionist works at the Musée du Luxembourg.

1907 Visits Italy in mid-autumn. Makes portraits of his mother and father. Severini returns to Paris; his studio is on rue Turgot overlooking the courtyard of the Théâtre de L'Oeuvre. Lugné-Poë, its founder, introduces Severini into his circle of friends, among them Félix Fenéon.

1908 Shows oils at the Indépendants and the Salon d'Automne. Summer with Pierre Declide and family at Civray, near Poitiers. Paints landscapes and portraits. *La Vie unanime* by Jules Romains is published by the Abbaye de Créteil press.

1909 *Manifeste du futurisme* by F. T. Marinetti appears on the front page of *Le Figaro*, 20 February. At the Closerie des Lilas Severini meets more artists and poets, including Paul Fort. Continues to paint landscapes and portraits.

1910 Publication in Milan, 11 February, of *Manifesto of the Futurist Painters*, and 11 April, of *Futurist Painting: Technical Manifesto*. Both documents signed by Balla, Boccioni, Carrà, Russolo, and Severini. (Balla and Severini have no role in writing them.) Frequents Parisian cabarets and cafés — Le Moulin de la Galette, Le Moulin Rouge, Le Bal Tabarin, Monico's, and Le Lapin Agile. Moves to 5 Impasse Guelma, off Place Pigalle. Braque, Dufy, Suzanne Valadon, her companion Utter, and her son Utrillo are neighbors. At Le Lapin Agile, meets Picasso through Braque. In Picasso's studio, Severini meets Apollinaire. First Cubist works are exhibited at the Salon d'Automne.

1911 To Italy briefly. Aware of Cubist experiments in Paris, Severini urges Futurist colleagues in Milan (Boccioni, Carrà, and Russolo) to visit Paris for direct contact with Cubists' theories and to see works by Léger, Gleizes, Metzinger, Gris, Le Fauçonnier, Picasso, and Braque. Severini meets Ardegno Soffici (probably in late summer), a young Florentine and an equally talented painter and writer. Works on his monumental canvas, *The Dance of Pan Pan at the Monico* (F 97). Cubists' works shown at the Salon des Indépendants and the Salon d'Automne.

1912 5 – 24 February, first major Futurist exhibition at the Bernheim-Jeune gallery, Paris. With Marinetti's aid, the exhibition travels to the Sackville Gallery, London, and major European cities. Apollinaire declares Severini's *Pan Pan* to be "the most important work…by a Futurist brush." Severini finishes *The Bal Tabarin* (cat. 6; F 107) in Pienza that summer. To Paris in the fall.

1913 In London, on 7 April, first solo exhibition at the Marlborough Gallery is well received. On 28 August, Severini marries Jeanne Fort, daughter of the poet Paul Fort — a landmark event in Parisian artists' circles. The couple soon departs for Pienza to meet Severini's parents. In poor health, he remains in Italy. Encouraged by Marinetti, Severini works to complete a publishable manifesto. Apollinaire's manifesto *L'Antitradizione futurista* comes out in *Lacerba*.

1914 World War I is declared. Severini and his wife Jeanne return to Paris in October. Despite his growing reputation throughout Europe, his work does not sell and he desperately needs money. His health remains poor; he consults Picasso's doctor in Barcelona.

1915 Birth of Severini's first daughter, Gina. Italy enters the war. Boccioni, Marinetti, Russolo, Sant'Elia, and other Futurists enlist. Marinetti urges Futurists to focus on war subjects. Severini sees trains of wounded troops and war supplies from his studio window. In San Francisco, Panama-Pacific International Exposition takes place in summer; Futurist works are exhibited in the Annex.

1916 Deeply saddened by the death of his infant son Tonio, 10 October, and by Boccioni's accidental death on 17 August. Sant'Elia is killed in war. Has solo exhibition at the Galerie Boutet de Monvel, Paris. Recent war subjects are included. *Mercure de France* publishes Severini's "Symbolisme plastique et symbolisme littéraire." He experiments with figurative and abstract styles. Gris introduces Severini to Léonce Rosenberg, director of the prestigious gallery L'Effort Moderne. Severini meets Ozenfant and Matisse.

1917 In March, first solo U.S. exhibition, *Drawings, Pastels, Watercolors, and Oils of Severini* at Stieglitz's "291" Gallery in New York, is successful. Marius de Zayas and Walter Pach had helped plan the exhibition. (To save money, the works had left Paris with another load, in October 1916.) Summer with Declide family in Civray. Meets Lhote, Cocteau, and Diego Rivera near Arcachon. To Paris in the autumn. "La Peinture d'avant-garde" by Severini appears in *Mercure de France.*

1918 In Savoy, at Le Châtelard, he paints both landscapes and still lifes. His paintings reflect his new theories but also show the influence of Gris and Picasso. Apollinaire succumbs to influenza.

1919 Severini contracts for exclusive representation at Rosenberg's L'Effort Moderne; also in his stable are Braque, Gris, Léger, Lhote, Matisse, Metzinger, and Picasso.

1921 Severini's book, *Du Cubisme au classicisme,* is published. His theoretical ideas about compositional order, divine proportions, and numbers make an important contribution to avant-garde theory.

1921–22 Paints *commedia dell'arte* characters for Sir George Sitwell's residence in Tuscany.

1923 Close friendship with Catholic philosopher Jacques Maritain who is helpful in acquiring commissions. Severini becomes interested in religion.

1924–35 Does murals for churches and public buildings in Switzerland, France, and Italy. In 1931, France awards him the Legion of Honor. At the 1935 Quadriennale, Rome, he receives the Grand Prize for Painting.

1936–46 Birth of a second daughter, Romana, in 1937. Returns to France in 1946. Publishes *Tutta la vita di un pittore*, his autobiography.

1949 Begins a new phase of research in abstraction and motion.

1961 Has important solo exhibition at the Palazzo Venezia, Rome, and participates in *Futurism*, a group exhibition at the Museum of Modern Art, New York.

1966 Dies 26 February at home, 11 rue Schoelcher, Paris. Interred in Cortona. The Musée National d'Art Moderne, Paris, holds a retrospective exhibition in 1967.

List of Exhibitions, 1912–1917

For a complete bibliography of exhibitions, the reader should consult Pacini, *Esposizioni* 1977, and Fonti 1988, "Esposizioni."

P12 Paris, Bernheim-Jeune, 5–24 February 1912, *Les Peintres futuristes italiens* (group show). 8 items, nos. 28–35. "Les Exposants au public," 1–14; "Manifeste des peintres futuristes" [Technical Manifesto], 15–22. Exhibition went to more than fifteen venues sometimes in abbreviated form.

L12 London, The Sackville Gallery, March 1912, *Exhibition of Works by the Italian Futurist Painters* (group show). 8 items, nos. 27–34. (The catalogue numbers differ by one digit from P12 and B12 because a Russolo has been inserted in the list as 26B.) "Initial Manifesto of Futurism," 3–8; "The Exhibitors to the Public," 9–19; "Manifesto of the Futurist Painters" [Technical Manifesto], 28–36.

B12 Berlin, Der Sturm, 12 April–31 May 1912, *Zweite Ausstellung: Die Futuristen* (group show). 8 items, nos. 28–35. "Manifest des Futurismus" (February 1909), 3–9; "Die Aussteller an das Publikum," 10–22; "Manifest der Futuristen" [Technical Manifesto], 30–39. (The closing date in the catalogue overlaps the published opening date of BR12.)

BR12 Brussels, Galerie Giroux, 20 May–5 June 1912, *Les Peintres futuristes italiens* (group show). 8 items, nos. 28–35. (No. 27, a Russolo, has been deleted from this catalogue without substitution.) "Les Exposants au public," 1–14; "Manifeste des peintres futuristes" [Technical Manifesto], 15–22. (The opening date in the catalogue overlaps the published closing date of B12.)

R13 Rome, Galleria G. Giosi, Ridotto del Teatro Costanzi, from 11 February 1913, *Prima esposizione: Pittura futurista* (group show). 6 items, Severini nos. 1–6. Untitled essay ["Les Exposants au public," with added introduction, signed by five Futurists], 3–17.

RT13 Rotterdam, Rotterdamsche Kunstkring, 18 May – 15 June 1913, *Les Peintres et les sculpteurs futuristes italiens* (group show). 6 items, nos. 30 – 35, same works as R13. "Les Exposants au public," 3 – 12, Ardegno Soffici added to list of signers. "Première Série de Tableaux futuristes" (1912), 13 – 16; "Prix des Oeuvres," 35 – 36.

L13 London, Marlborough Gallery, 7 April 1913, *The Futurist Painter Severini Exhibits His Latest Works* (solo exhibition). 30 items, nos. 1 – 30. "Introduction," (in English) by Severini, 3 – 7.

B13 Berlin, Der Sturm, June – 15 July 1913, *Sechzehnte Ausstellung Gemälde und Zeichnungen des Futuristen Gino Severini* (solo exhibition). 30 items, nos. 1 – 30. "Vorrede" [*sic*] (essay by Severini in French), 1 – 5. This exhibition is the same as L13 above except for the substitution of two works numbered 24 and 25.

F13 Florence, Galleria Gonnelli, November 1913 – January 1914, *Esposizione di pittura futurista di "Lacerba"* (group show). 10 items, Severini nos. 1 – 10, 5 works of 1912 from RT13, 5 additional works of 1913. Untitled essay ["Les Exposants au public," with untitled introduction], 5 – 17. Soffici's name added to essay and title page.

R14 Rome, Galleria Futurista (Giuseppe Sprovieri), February – March 1914, *Esposizione di pittura futurista* (group show). 19 items, Severini nos. 1 – 19. Untitled essay ["Les Exposants au public," with modified introduction announcing a permanent Galleria Futurista in Rome], 5 – 20.

L14 London, The Doré Galleries, April 1914, *Exhibition of the Works of the Italian Futurist Painters and Sculptors* (group show). 14 items, nos. 46 – 58, from R14, the five items removed from R14 were sent to N14. "Initial Manifesto of Futurism," 4 – 7; "The Exhibitors to the Public," 8 – 16; "Sculpture: Ensembles plastiques," by Boccioni, 17 – 22.

N14 Naples, Galleria Futurista (Giuseppe Sprovieri) May – June 1914, *Prima esposizione di pittura futurista* (group show). 38 items, Severini nos. 1 – 38, 30 works from B13, 5 from R14, plus *Polka* and *Waltz*. One work sold and not sent. Untitled essay ["Les Exposants au public," with extended introduction], 5 – 21.

SF15 San Francisco, Annex to the Palace of Fine Arts, Summer 1915, Panama-Pacific International Exposition (group show). 14 items from L14. Severini nos. 1164 – 1177. "The Italian Futurist Painters and Sculptors," by Boccioni, in Trask and Laurvik 1915, I, chap. XXVIII; list of Futurist works, II, 273 – 74.

P16 Paris, Boutet de Monvel, 15 January – 1 February 1916, *Gino Severini: Première Exposition futuriste d'art plastique de la guerre et d'autres oeuvres antérieures* (solo exhibition). 37 items, nos. 1–37, no overlap with N14. No essay: list of works and invitation to lecture only.

NY17 New York, Photo-Secession Gallery (Alfred Stieglitz), 291 Fifth Avenue, 6–17 March 1917, *Drawings, Pastels, Watercolors and Oils of Severini* (solo exhibition). 25 items, 13 or 14 from P16. Works shipped to New York, October 1916. No known published catalogue. There are two unpublished lists of the works in this exhibition, one in French, numbered *toiles* 1–11, *pastels* 1–3, and *dessins* 1–11; and one in English numbered consecutively 1–25 (see figs. 31, 32).

Works Frequently Cited

For a comprehensive bibliography to 1988 see Fonti below.

..

OEUVRE CATALOGUE

Fonti 1988 Fonti, Daniela. *Gino Severini: Catalogo ragionato.* Milan: Arnoldo Mondadori Editore, Edizione Philippe Daverio, 1988. Catalogue of paintings and many large drawings. Individual works are identified throughout *Severini futurista* with F followed by the Fonti catalogue number.

UNPUBLISHED CORRESPONDENCE

Marinetti Papers Letters and postcards from Severini to Marinetti, 1910–15. F. T. Marinetti Papers. Beinecke Rare Book and Manuscript Library, Yale University.

Stieglitz Archive Correspondence, 1916–17, concerning Severini's exhibition at the Photo-Secession Gallery, New York. Stieglitz Archive, Yale Collection of American Literature. Beinecke Rare Book and Manuscript Library, Yale University.

PUBLISHED WRITINGS BY FUTURISTS AND THEIR CONTEMPORARIES

Apollinaire 1944 Apollinaire, Guillaume. *The Cubist Painters: Aesthetic Meditations 1913.* Translated by Lionel Abel. Bibliographical notes by Bernard Karpel. The Documents of Modern Art, edited by Robert Motherwell, Vol. 1. New York: George Wittenborn, Inc., 1944. Revised edition, 1949. Orig. French ed., *Les Peintres Cubistes — Méditations esthétiques.* Paris: Eugène Figuière, 1913.

Apollonio 1973 Apollonio, Umbro, ed. *Futurist Manifestos.* Translations by Robert Brain et al. The Documents of 20th-Century Art, edited by Robert Motherwell. New York: Viking Press, 1973. Orig. Italian ed., Milan, 1970.

Archivi I, II Drudi Gambillo, Maria, and Teresa Fiori, eds., *Archivi del Futurismo,* 2 vols. Rome: De Luca Editore, vol. I, 1958; vol. II, 1962. Still an important source on the Futurist movement. Includes numerous letters, documents, and illustrations known at the time of publication.

Critica d'Arte 1970 *Omaggio a Severini.* Special issue, Piero Pacini, ed. *Critica d'Arte* 17, no. III (May–June 1970): 3–76. Letters to and documents by Severini, including "Appunto sull'orfismo (April 1913)," 20–21; "Préface à l'Exposition de New York (1917)," 50–53; and his 1917 essay, "Considérations sur l'esthétique picturale moderne," 57–72.

Écrits 1987 Severini, Gino. *Écrits sur l'art.* Edited by Serge Fauchereau. Paris: Diagonales, Éditions Cercle d'Art, 1987.

Flint 1971 Flint, R. W., ed. *Marinetti: Selected Writings.* Translated by R.W. Flint and A.A. Coppotelli. New York: Farrar, Straus and Giroux, 1971.

Lacerba *Lacerba.* Original journal published in Florence, 1913–15. Facsimile reprint. Edited and Introduction by Raffaele de Grada, 2 vols. Milan: Mazzotta, 1980.

Lista 1973 Lista, Giovanni, ed. *Futurisme: Manifestes, Proclamations, Documents.* Lausanne: Éditions L'Age d'Homme, 1973. Transcriptions of Futurist manifestos and other writings, in French. Introduction by Lista.

Marinetti 1914 Marinetti, Filippo Tommaso. *I Manifesti del futurismo: lanciata da Marinetti, Boccioni, Carrà, Russolo, Balla, Severini, Pratella, De Saint-Point, Apollinaire, Palazzeschi.* Florence: Edizioni di "Lacerba," 1914.

Marinetti 1980 Marinetti, Filippo Tommaso. *Le Futurisme.* Preface by Giovanni Lista. Lausanne: Éditions L'Age d'Homme, and Milan: Arnoldo Mondadori Editore, 1980. Orig. ed., Paris, 1911.

Mercure de France 1916 Severini, Gino, "Symbolisme plastique et symbolisme littéraire," *Mercure de France,* 1 February 1916. Also published in *Témoinages* 1963, 41–54; *Écrits* 1987, 61–70; Lista 1973, 210–15.

Pacini, *Esposizioni* 1977 Pacini, Piero, ed. *Esposizioni futuriste,* 2 vols. Florence: Edizioni Scelte. Vol. 1 (1977) includes facsimiles of 24 original catalogues and two invitations for Futurist exhibitions from the years 1912 to 1918; vol. 2 (1979) includes one catalogue of 1913 and one of 1914, and 24 from 1918 to 1931.

Témoignages 1963 Severini, Gino. *Témoignages.* Rome: Éditions Art Moderne, 1963. Preface by Georges Borgeaud.

La Vita 1983 Severini, Gino. *La Vita di un pittore,* with biography by Maurizio Fagiolo dell'Arco and "Parigi, O Cari," by Filiberto Menna. Milan: Feltrinelli, 1983. This book has

two parts: "La Vita di un pittore," (Severini's life to 1917), and "Tempo de L'Effort Moderne" (Severini's life 1917–24). Previous editions: *Tutta la vita di un pittore.* Milan: Garzanti, 1946 (Severini's life to 1917). *La Vita di un pittore,* with introduction by Lamberto Vitali. Milan: Edizioni di Communità, 1965 (Severini's life to 1917). *Tempo de "L'Effort Moderne": La Vita di un pittore.* Edited by Piero Pacini. Florence: Vallechi, 1968 (Severini's life 1917–24). English edition: *The Life of a Painter: The Autobiography of Gino Severini.* Translated by Jennifer Franchina. Princeton University Press, 1995.

OTHER AUTHORS

Brinton 1916 Brinton, Christian. *Impressions of the Art at the Panama-Pacific Exposition.* New York: John Lane Company, 1916.

Burke 1986 Burke, Margaret. "Futurism in America, 1910–17." Ph. D. diss., University of Delaware, 1986.

Caruso 1991 Caruso, Rossella. "La Mostra dei futuristi a Londra nel 1912: recensioni e commenti." In *Futurismi in U.S.A.* Special issue, *Ricerche di Storia dell'Arte,* no. 45 (1991): 57–63.

Hanson 1983 Hanson, Anne Coffin, ed. and curator. *The Futurist Imagination: Word + Image in Italian Futurist Painting, Drawing, Collage and Free-Word Poetry.* Exh. cat. Yale University Art Gallery, New Haven, 1983.

D'Harnoncourt 1981 D'Harnoncourt, Anne. *Futurism and the International Avant-Garde.* Exh. cat. Philadelphia Museum of Art, 1981. Essay by Germano Celant.

Lukach 1971 Lukach, Joan M. "Severini's 1917 Exhibition at Stieglitz's '291.'" *The Burlington Magazine* 113 (April 1971): 196–207.

Lukach 1974 Lukach, Joan M. "Severini's Writings and Paintings, 1916–1917, and His Exhibition in New York City." *Critica d'Arte* 138 (November–December 1974): 59–80.

Martin 1968 Martin, Marianne W. *Futurist Art and Theory, 1909–1915.* Oxford: Clarendon Press, 1968.

Martin 1981 Martin, Marianne W. "Carissimo Marinetti: Letters from Severini to the Futurist Chief." *Art Journal* 41, no. 4 (Winter 1981): 305–12.

Martin 1983 Martin, Marianne W. "The Futurist Gesture: Futurism and the Dance." Kunst, Musik, Schauspiel 2, CIHA, Vienna. 4–10 September 1983, 95–113.

Pacini 1973–78 Pacini, Piero. "Percorso prefuturista di Gino Severini." *Critica d'Arte* 128 (March–April 1973): 41–58; 129 (May–June 1973): 39–56; 139 (January–February 1975): 45–61; 140 (March–April 1975): 47–60; 157–59 (January–June 1978): 177–94.

Pacini 1990, 1991 Pacini, Piero. "Gino Severini, L'unanimismo di Jules Romains et le danze cro-matiche di Loie Fuller I." *Antichità Viva* 29, no. 6 (1990): 44–53; "Gino Severini, L'unanimismo di Jules Romains et le danze cromatiche di Loie Fuller II." *Antichità Viva* 30, nos. 4–5 (1991): 57–64.

Quinsac 1972 Quinsac, Annie-Paule. *La Peinture divisionniste italienne: Origines et premiers développements 1880-1895.* Paris: Éditions Klincksieck, 1972.

Rudenstine 1985 Rudenstine, Angelica Zander. *Peggy Guggenheim Collection, Venice, The Solomon R. Guggenheim Foundation.* New York: H. N. Abrams, 1985.

Scudiero 1986 Scudiero, Maurizio. *Futurismi postali: Balla, Depero e la comunicazione postale futurista.* Exh. cat. Rovereto: Longo Editore, 1986. Essays by Enrico Crispolti, Tullio Crali, Maurizio Scudiero, and Enrico Sturani. Excellent illustrations of letterheads, postcards, etc.

Taylor 1961 Taylor, Joshua C. *Futurism.* Exh. cat. Museum of Modern Art, New York. New York: Doubleday and Co., Inc., 1961.

Taylor 1967 Taylor, Joshua C. "Gino Severini, A Self Portrait." *Museum Studies* 2, The Art Institute of Chicago (1967): 50–61.

Thibaudet 1926 Thibaudet, Albert. *La Poésie de Stéphane Mallarmé.* 6th ed. Paris: Galllimard, 1926. Orig. ed., Paris, 1912. References are from 1926 edition.

Trask and Laurvik 1915 Trask, John E. D., and J. Nilsen Laurvik, eds. *Catalogue De Luxe of the Department of Fine Arts Panama-Pacific International Exposition,* 2 vols. San Francisco: Paul Elder and Company, 1915. Includes essay by Boccioni, vol. 1, 123–27.

Photography

Most photographs have been supplied by the owners of the works reproduced. Additional credits: David Allison (cats. 3, 7, 22); Courtesy of Aquavella Gallery (cat. 1); Oscar Balducci Productions (cat. 16); The Baltimore Museum of Art (fig. 13); Beinecke Rare Book and Manuscript Library, Marinetti Papers (figs. 1, 2, 3, 4, 7, 18, 28, 30), Stieglitz Archive (figs. 30, 31, 32); Oliver Baker (cat. 14); The British Newspaper Library (fig. 11); Courtesy of Jennifer Franchina (frontispiece); The Solomon R. Guggenheim Foundation (fig. 16); Helga Photo Studio (cat. 11); Courtesy of Laura Mattioli (fig. 5); The New York Times (fig. 26); Courtesy of Piero Pacini (fig. 10); Sotheby's (cat. 12); Dedra Walls (cat. 9); Yale Audio Visual Center (figs. 6, 12, 15, 17a, 22a, 24, 25, 27, 29).

Editor Elise K. Kenney
Design & Typography John Gambell and Julie Fry
Production Supervision Yale University Printing Service
Printing Hull Printing Company
Binding Mueller Trade Bindery